Praise for
Dances With Fire

"In Joseph Campbell's, *The Power of Myth*, the hero leaves the safety of his tribe and ventures into the wilderness where he encounters forces that challenge the essence of who he thinks he is. Kate Hamberger's story is such a journey. For young people, it shows how transforming and empowering firefighting can be. For those still in the game and those remembering, this account will verify all the good things to be found in one of America's last great true-life adventures."
—Murry A. Taylor, author of *Jumping Fire, A Smokejumper's Memoir of Fighting Wildfire*, and three novels, *More or Less Crazy, The Rhythm of Leaves*, and *Too Steep and Too Rough*

"Fire is a shaping force, fierce in its destruction, leaving in its wake a fertile landscape. In her memoir, Kate Hamberger tells her origin story as a young firefighter facing some of the largest wildfires in the Pacific Northwest as well as the existential questions that pierce all our lives. Who am I? What am I capable of? How will I shape my life? She puts herself and her readers through a gripping conflagration. She faces tests of strength and forges an extended family with her fellow firefighters, finds love, and suffers heartbreaking loss. *Dances with Fire* is a gripping and inspiring tale of a woman discovering her own power and grace."
—Natalie Serber, author of *Shout Her Lovely Name*

"A bracing account of a young woman forcing herself to grow up and face difficult challenges."
—*KIRKUS REVIEWS*

"Hamberger's wonderful memoir is a true page-turner. *Dances with Fire* is an honest, heartfelt account of the challenge—and rewards—in her wildland fire adventure that will beckon her back, even after her remarkable life's path veers away from the fireline. For those who have never laced up a pair of fire boots, Hamberger brilliantly puts you into those boots. We are *there* through her vivid and powerful first-person accounts to celebrate 'the beauty and mysteries of nature.'"

—Paul Keller, Writer/Editor for the Wildland Fire Lessons Learned Center and former ZigZag Hotshot

"This book instantly transported me back to the fireline… the smoke through the trees, flames running through the forest, and most of all the kinship of a fire crew. This is an unflinching account of bravery, fear, and loss for a woman… in the unconventional role as a wildland firefighter. *Dances with Fire* made me want to don a Nomex shirt and grab a Pulaski once again. Part poetry, part grit, this is a story of overcoming…"

—Mary Ellen Emerick, author of *Fire in the Heart* and *The Last Layer of the Ocean*

DANCES WITH FIRE

Kate Hamberger

Lessons in Life, Faith & Firefighting

STORYARCHITECT
YOUR STORY | TOLD WELL

Dances with Fire: Lessons in Living, Faith & Firefighting

Copyright © 2024 by Kate Hamberger

Published in association with Story Architect. www.booksandsuch.com

All rights reserved. No part of this publication may be reproduced, stored in a retrieval system, or transmitted in any form or by any means—electronic, mechanical, photocopy, recording or any other—except for brief quotations in printed reviews without the written prior permission of the publisher.

The "Holy Smokes" poem is reprinted courtesy of Kim Stafford.

The website addresses recommended throughout this book are offered as a resource to you. These websites are not intended in any way to be or imply an endorsement on the part of Story Architect, nor do we vouch for their content.

Some names or details have been changed to protect the identities of the persons involved. Some events are recorded by memory and may be flawed.

Unless specified otherwise, all photographs are the property of Kate Hamberger.

No AI Training. Any use of this publication to "train" artificial intelligence (AI) technologies to generate text is expressly prohibited.

Scripture quotations are taken from the Holy Bible, New International Version®, NIV®. Copyright © 1973, 1978, 1984, 2011 by Biblica, Inc.® Used by permission of Zondervan. All rights reserved worldwide. www.zondervan.com The "NIV" and "New International Version" are trademarks registered in the United States Patent and Trademark Office by Biblica, Inc.® Scripture quotations marked "KJV" are taken from the Holy Bible, King James Version (Public Domain).

Book Cover Design by Lisa Davis

Print ISBN: 978-1-962845-09-0

Printed in the United States of America

Dedication

*To former and future wildland firefighters…
and to my great big family.*

Behold, how great a matter a little fire kindleth!
James 3:5 KJV

Contents

Chapter 1: Hamberger Down!. 1
Chapter 2: First Fire 15
Chapter 3: My Maverick 19
Chapter 4: Bad Boots & Bladder Bags. 25
Chapter 5: Early Influencers 35
Chapter 6: Wrong, Wrong. 41
Chapter 7: Cowboys 49
Chapter 8: Cinderella 55
Chapter 9: Brothers In Arms 65
Chapter 10: Femininity. 75
Chapter 11: Helitack. 83
Chapter 12: Old Faithful. 101
Chapter 13: Cover Girl 111
Chapter 14: White Snake 121
Chapter 15: Bad Bug. 129
Chapter 16: Killing Time. 139
Chapter 17: The Burn 147
Chapter 18: Spain . 167
Chapter 19: Gypsy Girl. 181
Chapter 20: Misfit. 193

Chapter 21:	Bad Moon	207
Chapter 22:	Black Clouds & Brown Bears	219
Chapter 23:	Zion	231
Chapter 24:	Trigger Points	247
Chapter 25:	Modesto	253
Chapter 26:	Goodbyes	265
Chapter 27:	Blessings	277
Chapter 28:	Lightning Strikes	287
Chapter 29:	Passion	309
Chapter 30:	Wonders	317
Afterword		325
Glossary		327
End Notes		329
Photo Credits		337
Acknowledgments		339
About the Author		341

Holy Smokes

By Kim Stafford, Poet Laureate of Oregon

Downwind from where the forest burns
We inhale the cindered souls of trees
That in a whoosh became particulate
And rode the wind to enter us. With
This breath take in the spirit whisker
Of a mouse, incinerate wren's cry
Clenched and tumbled from the sky,
Moss that leaped from green to nothing,
Flailing leaf that in a fiery gasp
Rushed through charcoal into dust
Inside the billow flame that roiled and—
Holy, holy, holy, became the smoke-smudge
Pall that smuggled mountains into us.

Now freighted for life with dusky mist,
Even as we help sustain our neighbors
Who lost everything but life, we survivors
Are the walking shrine of little lives. We are them,
Are earth mind suddenly, to weigh by human choice
What's best for upward yearning seed of cedar,
Footfall of the mouse, wingbeat of the wren.

Prologue

JUNE 1990. The fire transformed into a monster in a matter of seconds. Four years as a wildland firefighter told me this was a dangerous situation. Halfway down a canyon on the Mogollon Rim, near Payson, Arizona, ashes fell like snow. Increasing gusts of hot wind blew the lightning-sparked fire uphill toward us. An eerie orange glow lit the terrain below as smoke darkened the sky. Our crew was spread out along the fireline. As I stood watching for sparks, tree branches and brush waved in different directions from the squirrely gusts.

I didn't have a radio, didn't know what was going on with the fire, but when the hair on the back of my neck stood up, I turned to my rookie crewmate to suggest we move. As we trudged up the hill toward the others, our squad boss ran up the steep slope behind us.

"C'mon let's go!" He pushed on my pack, propelling me up the slope.

"Faster!"

Lung-searing smoke grew thicker by the second. As we struggled uphill, our leg muscles strained against the steep incline while our lungs fought for air. Several men hurried past us, going the other way, striding down into the canyon toward the fire with expressions of grim determination. Two of the men were from our crew. *They're hiking to the fire? Why would they do that?*

As we neared the top of the canyon, panic and chaos set in as other crews joined ours in a hurried trek to the safety zone. Men and women shouted over the wind and roiling flames. A few panicked firefighters broke formation from their crews as they tried to run from the blaze. Part of me wanted to join their mad dash, but I followed the guy in front of me on the dozer line that stretched diagonally up the slope. I trusted our crew leaders to know the best direction to safety.

The fire below roared like a jet engine. I risked a glance over my shoulder to look at the wall of red. I could barely make out our wide-eyed squad boss's mouth forming the words, "DON'T. LOOK. BEHIND. YOU!"

Waves of flame transfixed me. The blaze rose beyond the tops of the tallest ponderosas. Helped along by record high temperatures, flames climbed the slope directly toward us, pushed by gale-force winds. A firestorm. There was no outrunning this. We were going to die.

Adrenaline kept me moving while my lungs competed with the flames for oxygen. How bad would it hurt, burning to death? My knees turned to rubber. I gasped for breath.

Please God! I'm not ready!

My tears from the smoke dripped to the dozer line where the soil was churned to a fine powder. Our fireline was about to be torched and we were still hiking it.

Please, not like this, God … If you would spare me from this, I will… I'll…

I'll what?

My brain searched for an appropriate and appealing action. As if God needed anything from me. As if I could barter with the Creator of the universe.

All I could do was pray.

God, for what it's worth, I'll be thankful.
O God. Have mercy! Please let us live.
Please let us live.

Hamberger Down!
Chapter 1

MAY 1986. It was water that had drawn me to its opposite element, fire.

At college, I enjoyed rowing on the Willamette River with Oregon State University's crew team. At the start of the final race of my first season, adrenaline coursed through my body as I sat motionless on my sliding wooden seat. Intent on the rower's shoulder in front of me, I took deep breaths and listened for the gun to fire. We were racing at the Pacific Coast Rowing Championships in Sacramento, California. The American River lapped against our thin wooden boat. A warm breeze caressed my face. Our boat, mostly comprised of freshmen, floated beside 20 others at the starting line. We were OSU's Varsity Lightweight Eight. Parked next to the women in UCLA's boat, we cast furtive glances at them and their sleek fiberglass boat.

"Look at the size of their thighs," a crewmate whispered.

"Focus! You've trained hard for this. Make it count!" Our coxswain barked.

It was true. At OSU in Corvallis, Oregon, we did 6 a.m. workouts, running the stadium stairs, weight training, or pulling on the rowing machines to move that quivering needle to the rpm's our coach demanded. Oregon's wet winter meant afternoons were spent training on the Willamette River's silty water, swollen by the

melting snow. Our team had logged over 200 hours of rowing in preparation for this 2000-meter race.

In Oregon, it was almost always cold and usually wet at practice. Every day, from September to May, we'd gingerly step into our tippy boat and strap our feet to the footboards. The late winter's fast flow would sweep us downriver toward Albany. In the beginning, we'd row slowly just to stay warm as we cruised along with the current, the shore's landscape speeding by, each of us dreading the hours of long sprints back upriver against the strong current.

Once in place, we maneuvered our shells to face upriver. Then it was on. Over the sound of heavy breathing, our eight seats rolled forward and back with a splash and ripple from our oars as they sliced the water with each stroke. Fighting fatigue, if one of us groaned, we all heard it. We all felt it and our pace slowed. When our boat slowed, the coxswain redirected our thoughts to push past the pain.

Sometimes, after a sprint, Coach Roger had us check our heart rates. If anyone's exceeded 205 bpm, that rower had to trade places with the alternate and ride with the coach in the motorboat. No one wanted to sit by his bullhorn.

By the time we returned to the docks, wet and steaming, we were spent. It was a feat just to pull the long wooden boat from the water and carry it on our shoulders up the ramp to the boat house to hang it up for the night. But we weren't done. Just when we thought we could do no more, Coach Roger would have us do two more sets of 25 jumpies, to push us beyond our perceived capability.

At the time, it seemed cruel and unusual, but Coach Roger's training regimen worked. At the Pacific Coast Championship in Sacramento, we were fast and strong. On the big race day, when the gun fired, our feet punched the footboards and our legs slammed our seats backwards as we pulled oars through deep water. A charge of

energy from the sound of coxswains screaming at 100 rowers racing coursed through us. It was suddenly fun. Hours of daily practice against the Willamette's current had taught us rhythm. The boat surged forward as we slid up in our seats and powered back as one. That familiar burn in my thighs and lungs meant I was rowing at full capacity. Our boat gained momentum. We pulled alongside UCLA. Then, to our astonishment, we pulled away from them.

It occurred to us—all at once—that maybe we could win this PAC-10 regatta. With single focus, we passed all but two boats. Nose to nose with the University of Oregon, we were only half a boat behind the leader, University of Washington. Digging deep, we used all our remaining strength to power across the finish line. Our coxswain shouted with delight while we went limp, breathing in great gulps of air while all our heart rates hit 200 bpm. As our boat floated near the shore, our coach waded out to us with a wide smile, our 3rd place medals clutched in his raised fist.

"3rd place? You were seeded at 13th! Well done, ladies. Well done!"

He placed the medals around each of our necks, and we celebrated what felt like victory. Later, buzzed with the highs of extreme exertion and elation, Coach Roger came to congratulate us again. He talked with and hugged each of us. Handing me a paper cup of Gatorade, he asked the question that altered the course of my life:

"You're coming back next year, right Hamberger? We've got a helluva' team, and we're just getting started!"

"I am, if I can find a summer job with good pay."

Coach Roger smiled. "Well, I happen to know of one. You ever think of working on a fire crew? Maybe even the hotshots out of Prineville? Ever been there?"

"Yeah, I grew up in Prineville," I said, wondering, *What in the world?*

Years prior, I had read an article in the local paper about the hotshots and their fitness training. They seemed to enjoy pain and suffering. It didn't appeal to me, but Coach Roger said he knew someone in the Forest Service who hired college kids fit enough to be firefighters. He assured me the pay was good. That got my attention. Willing to try it, I drove back to Prineville after spring semester's final exams. As it turned out, I wasn't the only one. Three men and two other women rowers were hired to work on Prineville's fire crews that summer.

I was about to embark on a journey fraught with intense challenges and life lessons.

The first time I entered the fire station, muscled men wearing heavy-heeled boots and forest green pants brushed past me, busy with station work. I was eighteen and didn't know much about hotshots, forest fires, or how to fight them. But I had showed up as requested, for my first day.

The US Forest Service's website defines hotshots as "highly trained, specialized wildland fire hand crews that perform some of the most demanding and hazardous tasks in wildland firefighting. They provide an organized, mobile, and skilled workforce for all phases of wildland fire management. Hotshots complete many hours of training, adhere to high physical standards, and are generally placed in the most rugged terrain on the most active, difficult and/or priority areas on wildfires."[1]

They are called IHC's, (Interagency Hotshot Crews) because they work with state, local, and federal agencies such as the US Forest Service (USFS), Bureau of Land Management (BLM), National Park Service (NPS), and the Bureau of Indian Affairs (BIA). They spend their summers traveling across the country, moving from one fire to the next. Currently, the US has over 100 hotshot crews.

After days of hard-core physical endurance training as well as training in fire behavior, fire suppression, and safety procedures, the hotshots seemed like a 20-person athletic team with special training in all subjects related to fire.

With no previous fire experience, I was extremely lucky to be hired as one of the few rookies. This was thanks to my coach's recommendation. At the time, I didn't know how fierce the competition was to land a hotshot position, or that I was hired over much more qualified men because I was a woman. Turns out that the US Forest Service needed to hire more women. It wasn't fair, but I did my best to earn my right to be there.

Standing before the boss on my first day, I was asked to show him my boots. He frowned at my bargain boots, but they were judged adequate. I would soon learn how important leather boots with a thick, fire resistant Vibram sole were to this job. I had entered the men's wear department at an outdoor store in Corvallis and spent all my mom's cash on thick wool socks and what looked to me like logger's boots. While they felt fine for the 30 seconds that I had walked around the store wearing them, they were half a size too big. In my naivete, I had thought that having a little extra room would be a good thing. I was wrong—and I had no idea how much grief those boots would cause me in the future.

After getting my footwear semi-approved, my squad boss then led me to the supply room where I was issued my new summer uniform: green pants and bright yellow shirts. I promptly handed them back.

"I can't wear these. They stink," I said.

"They all stink. It's Nomex."

I stared at him blankly.

"What's Nomex? The chemical smell's giving me a headache."

He rolled his eyes. "Nomex is fabric designed to resist burning." he said. "You *have* to wear it."

He checked the boxes on his clipboard as I stood there with my hand over my nose, not wanting to take the clothes he shoved at me.

"Does it all smell this bad?"

With an audible sigh, he set the clothes down and walked to the end of the aisle. Stretching to reach the top shelf, he pulled down an older set and passed them over to me. The pants had a worn, slippery feel, like nylon with almost no smell. The shirts were faded and had sweat stains under the arms and the smell was tolerable.

Looking around the hall at the older men, I was comforted to see four women among this group of strangers. When my high school classmate, Jon Kelso, entered the room, I knew I'd be okay. He had been my neighbor in 3rd grade. We had ridden bikes together, were classmates throughout high school, and both of us were students at Oregon State University. His friendly and familiar presence lent a sense of security which I needed, as I was the youngest crew member.

During the first two weeks of training, I wondered what all the hard-core exercise had to do with extinguishing a fire. Varsity rowers are serious athletes, but this training was beyond anything I had done before. Our days began with two hours of intense physical training (PT). After almost an hour of running, we "circled up" for an hour of regular push-ups, military push-ups, diamond push-ups, sit-ups, and pull-ups. While we worked to defy gravity, I discovered I was capable of 100 push-ups. The pull-ups were the hardest. On the rowing team, I was pleased to do seven pull-ups, but seven was not an impressive number for a hotshot. It was a shock to find myself the weak link.

One day as my stomach churned from the morning's effort, we boarded an old school bus for a drive into a nearby high desert to practice constructing a fireline. As we drove, some of the guys began to compare the number of salt stains on their dirty t-shirts. Apparently sweat stains were a status symbol: you were *really* working if you sported salt stains on your shirt.

Jon was the proud winner that morning. He modeled his dirty blue tee with its pattern of white streaks. He turned to me smiling.

"Hey, Hamberger! Show us your salt stains, Rookie!"

I rolled my eyes, shook my head, and feigned indifference, hoping it would end there. Nope. Eventually, I unbuttoned my fire shirt to show a lack of salt stains on my t-shirt. Suddenly, my name was SLACKER! (*And I thought Hamberger was bad.*)

"C'mon! You been slackin'! We better see you workin' out there today. You ain't gettin' back on this bus 'til you got salt and dirt on your shirt!" Jon teased.

"Hey, Kelso? I seem to recall my purple bike with the pink banana seat beating yours once upon a time," I said, hoping to staunch the humor at my expense.

"No, sir. That's a figment of your imagination," he cracked back.

"How long have you guys known each other?" A crewmate asked.

"Long time. I still have our 5th grade photo from Mr. Brock's class." I answered.

"Wait, so you were a Cowgirl?" another asked.

"Yep. Crook County Cowboys and Cowgirls. Our school mascots."

"Did you wear Wranglers? Chase cows? Were you a cheerleader?" Several crewmates laughed.

Introverts don't make good cheerleaders. I pulled a book from my pack and pretended to read. *How do I get salt-stains?* Hot, dusty air blew through rattling windows and with each passing mile, hours of hard labor loomed ahead. It was speed-line day. We had to construct 20 chains (approximately a quarter of a mile) of fireline every hour, for several hours, or return next week until we did it.

I looked at my hands calloused from rowing. Blisters had formed under the callouses. There was nowhere on my body that wasn't sore. The last two weeks had been brutal. I marveled at the

strength of the other women. Did they wonder like I did how they were going to work through the unusual triple-digit heatwave? Not wanting to be a complainer, I didn't ask. The first rule in a boat of rowers was, "Don't complain! It brings down the whole boat." I assumed it was the same for a fire crew.

Heat enveloped us as we exited the bus. The scorching sun was almost directly overhead. We grabbed the tools. I winced as my blistered hands gripped the Pulaski, that half-axe, half-hoe essential I would carry for the next four months. Sweat trickled down my spine under Nomex and the 25-pound pack on my back. The next five hours were going to be rough.

Out came the stopwatches as we tried to beat time while we cut, scraped, and dug our way across the plateau through the high desert sage brush, tumbleweeds, and scraggly juniper trees. In the previous weeks, I had learned that constructing fireline is the best way to stop a fire if there isn't ready access to water. To do that, we removed all burnable material (fuel) from the edge of the fire and scraped a line of dirt, usually about a foot or two wide, down to mineral soil, the inorganic matter that does not burn. Once a fire reaches the line, it has no more fuel and burns itself out.

Heavy breathing joined the chink and thunk of tools striking the ground between bursts of engine whine coming from the chainsaws. Somehow, we made it to lunch break. Unlike the vultures circling above, I had no appetite. We hunkered in the shade of a small juniper. Crew members encouraged me to eat, but slamming a ham and cheese sandwich as hot as I was didn't seem like a good idea. Grossed out by the film of dirt on my neighbor's teeth, I wiped the sticky film off my own teeth before pulling on a tepid canteen of water. More experienced crew members had filled and frozen their canteens the night before; by lunchtime, it had melted into cold water. I kept forgetting to do that.

Lunch ended all too soon. Time to dig again. With shoulders rubbed raw from pack straps on sweaty skin, I faltered. *I can't do this. How do they do this all day? Three more hours?* I commanded myself to take a step. Swing. Take a step. Swing. *Go faster. Breathe. How in the world did I end up here? This is torture! Utter madness.*

Sweat dripped down the inside of my sunglasses and mixed with the dust until it was hard to see. I whacked at a root in the line. The blade hit the embedded boulder next to it. A loud chink sounded, and a spark flew off the rock. The other Katie, digging beside me, was quick to help.

"Hey, watch it Hamberger! We're putting fires out, not starting them!"

"Move up!"

"Move!"

"Go!"

For three hours, hotshots yelled at me from both ends of the line. I worked on angry energy, realizing I was trapped in wretched, miserable work. Collecting a few choice words for my rowing coach, I imagined just how I'd tell him what he could do with this job.

At last, we finished. Staggering into the bus sweaty and panting, I collapsed onto my seat. But we were not done. We drove to the base of a butte, unloaded, and the boss barked an order: "Gear up! We're hiking to the top!"

Seriously?

We lined up, and the boss picked up his tool to set out. Beyond the blue line of hard-hatted heads, the top of the butte looked far away. Once there, we'd practice taping tools, wrapping saws, and loading in and out of the helicopter assigned to our region. Licking my salty lips, I looked at the hill we had to hike and reached deeper into my reservoir of endurance.

My reservoir was empty. Not long into our mile march, I lagged behind. It was still hot, but I had stopped sweating. I had nothing

left. I was dizzy; my heart raced. I couldn't inhale enough oxygen. *Is this what heat stroke feels like?* That's when my knees buckled, and I went down.

To my horror, the person in front of me yelled, "Hamberger's down!" Then the next person echoed, "Hamberger down!" I heard it over and over, eighteen times, as the message passed to the front of the line: *Hamberger failed. She's not strong enough. She can't do it.*

It was like a bad dream. The entire crew stopped and turned to watch me come unhinged as I gasped and giggled on my knees. I looked up to see the crew boss standing over me, leaning on his shovel. Staring up at him through my pink-framed drugstore sunglasses, I said between breaths the two words I couldn't wait to say.

"I quit!"

He took a deep breath and cleared his throat:

"Well. You still have to hike to the top of this hill."

After more tearful chuckles and choking down another canteen of hot water, I finally staggered to the top of the butte and saw a helicopter. Its rotors gleamed like angels' wings as it waited to fly us back to the bus. The rest of the crew was already busy taping tools together and wrapping saws, eager to leave the plateau's shadeless oven.

Climbing into the helicopter, I told the pilot I'd never been in one before. He smiled as I struggled to fasten the seat belt, my fingers shaky from fatigue. After lift-off, the pilot glanced back at me, and dove off the rim-rock, flying straight down the butte. Butterflies fluttered in my stomach. I let out a whoop, laughing with delight. We banked a hard left until my face was parallel to the ground with a bird's eye view of the Crooked River Valley. I was flying! Soaring with the vultures! I loved it!

Back in the bus, I peeled off the grimy fire shirt to let the breeze cool my skin and dry my sweaty t-shirt.

"Hey! You got some sweat stains on your back. It's about time!" Kelso said, pointing to me, cheerful as usual.

I glared at him, annoyed at his dimples and ruddy cheeks. My own were streaked from tears and dust. We rode back to the station in a stupor of fatigue and relief. I remembered the motto on the poster in the rowing team's training room: "Sweet is the pleasure after the pain." The poster was an aerial view of a boat of rowers collapsed after they had crossed the finish line. A more accurate depiction might be a crew of firefighters after digging line in the heat all day.

Stiff and stinky, we returned to the station ready for a day off after the brutal training period. And there was a bonus: it was payday. Glancing at my paycheck, my jaw dropped. *So much money!* Mowing lawns and babysitting had been the extent of my prior paid labor experience. Jubilant, I was all smiles when the boss approached to discuss my resignation. Clenched in my hand was a check for more money than I'd ever earned in my life. I'd get to fly in helicopters, and I was working in nature's beauty. *I'd be crazy to walk away from this!*

"No way am I quitting! I'll see you Monday." I smiled and gave my boss a thumbs up.

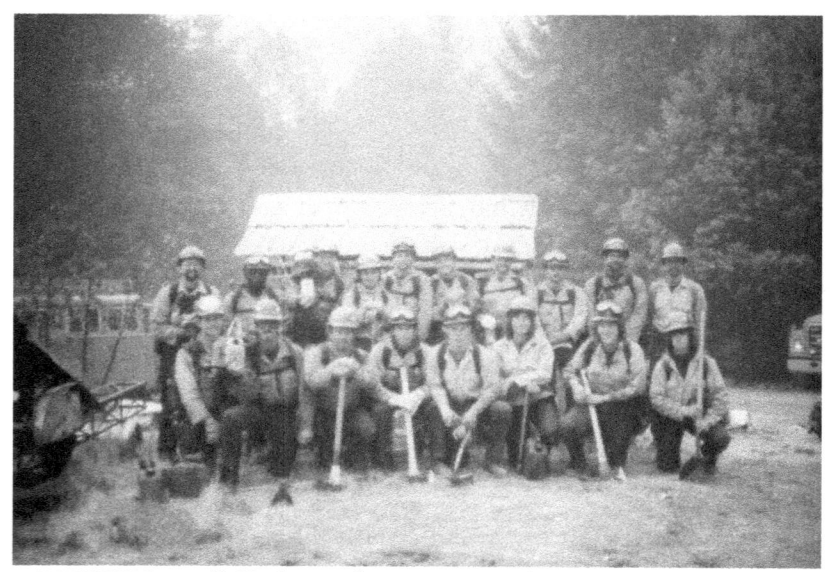
1987 USFS Prineville Hotshots: with crew Superintendent Darrell Schulte (Back left)

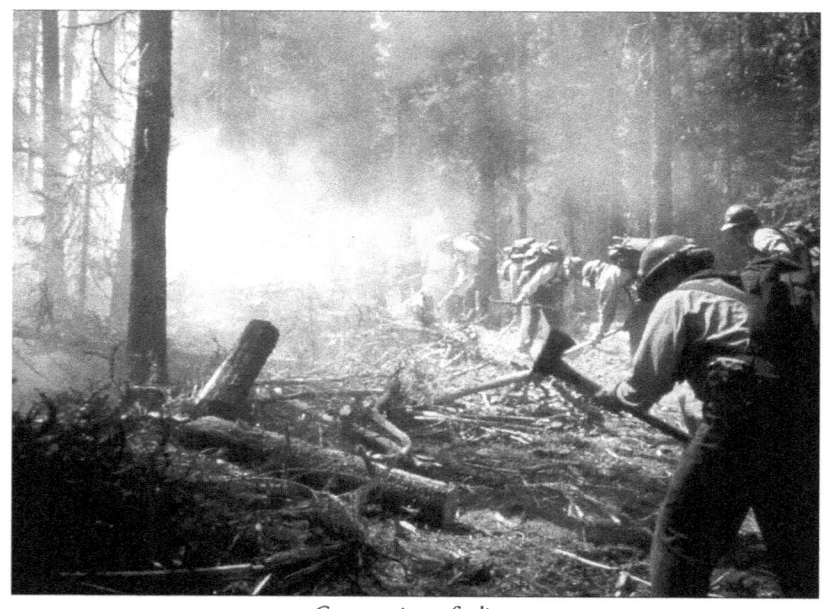

Constructing a fireline

First Fire
Chapter 2

I stood in awe. Hot smoky wind blew at my back as bright flames roared through black smoke. Face to face with my first forest fire, the pungent smell of burning wood brought fond childhood memories of campfires and fishing trips. Now, when the wind blew in our direction, the smoke was so thick it made my eyes tear and burned the back of my throat.

I pulled the bandana tied at my neck over my nose. The sound of the fire surprised me; it was like a white-water river exploding through a narrow channel. Heat and energy quivered in the air. With a pounding heart and shaking hands, I heard a great searing noise and watched as flames devoured a nearby stand of ponderosas.

"We're supposed to stop this?" I wondered aloud. Perhaps due to my age or rookie status, but up until this point, I had entertained only a vague sense of the power and danger of a fire.

As my crewmates geared-up, I searched for signs of fear. There were none. Only smiles. The guys high-fived, eager for the paycheck this fire's overtime and hazard pay would provide. We had been waiting for this.

While we waited, we mended fences or cut brush to line eroded creekbanks. After days of work in the Ochoco National Forest, the call to a local fire finally came. We hurried to load into our rig as the driver inserted his cassette tape.

Classic rock blared over the bounce and clatter of our old, converted school bus. We sped over wash-boarded gravel roads while Boston's "Smokin'" set the tone for the view out the windshield. I was mesmerized by the ominous brownish plume on the horizon that reached toward the sky. We drove through the Ochoco Mountains toward the tiny town of Paulina, Oregon, where ponderosas towered over sagebrush and juniper trees. The fire was still small— less than ten acres—but hot and moving.

We arrived just before sunset. Burning wood hissed and crackled as flames crowned another group of tall trees nearby.

A crewmember yelled, "Woo-hoo! It's time to rock n' roll! This is more like it!"

Almost bursting with adrenaline, the sawyers fastened their saw chaps and hoisted Stihl chainsaws to their shoulders. We strode single file toward the fire's flank. A rusty bulldozer screeched as it scraped a fireline along the fire's far side. The crash of trees falling to the forest floor stopped any talking. An air tanker flew low above us to unleash its spray of fire's poison. The liquid fire retardant knocked down the flames and left a red streak near our fireline.

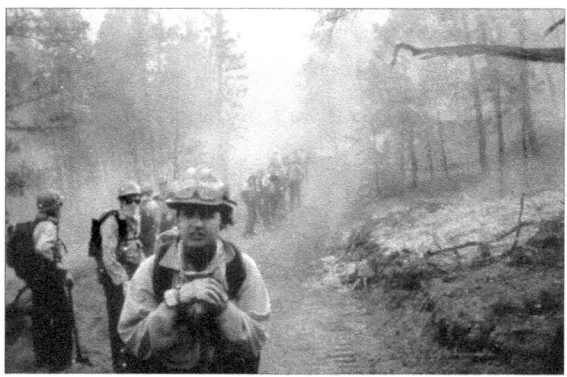

Me standing in smoke at my first fire in Oregon

At our anchor point, the chainsaws revved. We bent to work, cutting, chopping, and scraping a line two feet wide down to bare

soil. Scoring the earth with each step like a worm, we inched toward the fire's head to pinch it off and contain the spread.

We finished our line around the fire before midnight. By that time, the temperature had dropped, the humidity had risen, and the flames were laying low. Orders came to spread out along the line and watch for sparks crossing the fireline. Without wind, sparks were not a threat, but the light breeze made the boss wary. Ever vigilant, I plodded up and down my section of the fire, singing Patsy Cline songs to stay awake. After the second round of "Walking After Midnight," I took a break.

I sat on an old log and pulled a squished peanut butter and jelly sandwich from my pack. After the excitement and the long day, the warm glow of red embers. The hypnotic flicker of blue flames made my eyelids heavy. Surrounded by quiet darkness, my head bobbed. The half-eaten sandwich fell out of my hand as I slept.

I awoke to a tickling sensation on my arm. I swiped at it. Then felt it again on my neck and legs. Suddenly wide-awake, I switched on the headlamp to see big, black carpenter ants crawling up my shirt. The rotten log I sat on was vibrating with a million angry ants. I screamed and flew off my seat, slapping at my arms and legs yelling "Get 'em off!"

A crewmate came running.

"Get a grip, Hamberger! I ran up this hill thinking someone was attacking you!"

Flicking off the last of the ants, I mumbled about being eaten alive as I re-tucked my shirt. There was no dozing after that. In the hours before dawn, I used my Pulaski to chop out burning stumps and spread embers to cool.

Earlier, I had commented to my squad boss that I thought Pulaski was a strange name. He informed me that Pulaskis are named after "Big Ed" Pulaski, a forest ranger who saved 40 firefighters from certain death. Known as "The Big Blow Up," the devastating Idaho

fire in August of 1910, burned over 3 million acres in two days and killed at least 86 firefighters.[1]

Fed by high winds, the fire had erupted. Trees on fire became blowtorches. Heavy smoke and fire surrounded Pulaski's crew. Not knowing which way to run, the men were on the verge of panic. But Pulaski was familiar with the area and directed them into an old mining shaft. He insisted they lay on the ground, face-down, in order to breathe the air with the least amount of smoke.[2] That was a life-saving detail; the two horses they had stood with their noses four feet from the ground and both of them died from smoke inhalation.

Big Ed packed a pistol and threatened to shoot any man tempted to panic and run from the tunnel. As flames passed by, he covered the mine's entry with a wet blanket and suffered burns on his hands and face. He also inhaled super-heated air that damaged his lungs and temporarily blinded him. The next day, survivors, thankful to be alive, led Pulaski back to the town of Wallace, Idaho. With bandages over his eyes and hands, he rejoined his wife and daughter who had prayed through the night for the safety of him and his crew.[3] That fire destroyed enough timber to build 800,000 houses.[4]

After my squad boss finished the Pulaski story, I viewed my tool with a new appreciation. But I had listened with the invincible ears of youth. In my mind, it was an isolated incident in history. A tragic fire like that would never happen to us.

That morning, local engine and hand crews arrived to relieve us and mop-up the remaining fire. Exhausted, but victorious, we had done our job well and nature had cooperated.

Our efforts to fight this fire were successful, but they wouldn't always be.

My Maverick
Chapter 3

"*H*ighway to the Danger Zone..." sang the guys as they strutted out of the movie theatre. To celebrate our first fire of the season, a group of us had driven to Bend in high spirits to watch Maverick, Goose, and Iceman duke it out in the skies in *Top Gun*. I was 18 and wanted to be cool, classy, and smart like Charlie, the movie's flight instructor and Maverick's love interest.

"My boyfriend is a jet fighter pilot," I announced to everyone and no one, as we walked toward our cars. Suddenly I had everyone's attention.

"Well, at least, he will be when he finishes flight training. He's in the Navy."

They were quiet for a few seconds. Then they laughed like I had told a good joke. I chose not to elaborate, but thought back to when I had met my "Maverick," the handsome, young Navy lieutenant who would be a part of my life throughout my summers of fire.

I was fifteen when I read an article in the local newspaper about a couple traveling to Nuevo Leon, Mexico, with a group of local high school students. They were going to build a youth camp. I remarked to my mom that it seemed like a noble venture, the type of thing I'd like to help with one day. She playfully suggested I call them. I took it as a dare and called. They invited me to come and meet the group. That's when I met Paul.

I was immediately attracted to his manner, not just his looks, although to me, he resembled the young movie star Sean Penn. He had gorgeous, jade-green eyes and friendly smile lines. I was fascinated by the way his mouth turned down at the corners when he spoke. At first, I barely made eye contact with him, but I watched him as he talked to other people.

Paul was sixteen and had traveled from out of state to join the church group as the electrician. He had learned all things electric from working with his dad, who was a master electrician. I was amazed at his skill at wiring the electricity for the whole camp. I watched him climb poles and attach wires to give us light in our dark adobe dorms. For most of the summer, when he wasn't wiring, he and I worked together stacking adobe blocks, placing rebar, and pouring foundation cement as part of a bucket brigade. When I finally drummed up the courage to talk to him, we became friends. He had a hilarious knack for impersonating quirky people we knew in a playful way that kept us all laughing. He was also kind and as a high school kid far from home, kindness was a precious commodity. I wanted to be with him all day every day.

Some nights, if we weren't too tired from slinging cement, we'd sit around a campfire while our leader played guitar. Paul had a great voice and when he and I sang a duet, the others listened. He was romantic, too. One of the last notes he wrote to me in Mexico, he signed off with "*P.S. Yo te amo!*" No one had ever said they loved me in Spanish before ... or in any other language.

I'm the youngest of six, and a lot younger than my five siblings. My parents joked that I was an accident. My four brothers could sing, and three of them played guitar. My sister is ten years older than I and sang harmony. Sometimes they sang John Denver's "Country Roads" for Mom and Dad. I never tired of listening to their cover of Simon and Garfunkel's "The Boxer," and sang the soulful three-word chorus with them.

But we did not hear or say, "I love you." Words of affirmation were foreign in our household. It never bothered me: I thought our family was normal. I heard love in our voices when we sang together. I felt it when we played flag football at the park on some Thanksgivings, or when we played charades some nights after dinner. When I read Paul's words, I treasured them, wondering what he meant. *Did he love me like he loved ice cream? Or did he want to be my boyfriend forever?*

The day we left Mexico, I sat quietly next to Paul in the van when suddenly he jumped three feet off the seat and grabbed his leg below the knee. In a calm voice, he explained that a huge cockroach was crawling up his leg under his jeans. The driver had no place to pull over on the narrow, winding road. Paul sat very still, holding his pant leg so the huge arthropod couldn't climb any further. The only signs of his duress were the intensity of his quietness and the sheen of sweat across his forehead.

When we finally stopped, he hopped out, pulled off his boot and shook his leg until the enormous bug fell to the ground while the girls screamed. Paul smashed it with his boot, and calmly climbed back into the van. One can tell a lot about a person by watching their reaction to stressful situations. He had confided earlier that he wanted to be a pilot. I was sure that as calm and collected as he was, he'd be an excellent military pilot.

We crossed the border into muggy McAllen, Texas, to spend the night at a church before driving to the airport the next day. On our last night without parents, a keen sense of anticipation left us restless. All summer, I had wanted to kiss him, but thought it would be wrong to initiate it. I watched him shoot hoops in the stuffy gymnasium while I sat on the floor, fanning myself with a book. Suddenly, he dribbled the basketball right to me, dropped to his knees, grabbed my face and kissed me. My first kiss.

I thought it would be a heart-stopping, special moment. And it was. But I was a little distracted by the beads of sweat dripping down his face. By the end of that kiss, my face was all hot and wet. I smiled, but used my shirt to wipe my face when he turned to shoot another hoop. *Maybe we could try that again when we are not in Texas.*

By the time we returned to the US, I was as certain as a fifteen-year-old can be that he was the one for me. He was handsome, kind, funny, faithful, patient, loyal, handsome…and I liked his parents. But my first love was gradually checked by doubts over the years because… he didn't even live in the same state… because his plans to join the Navy meant he'd be gone for years… and because high school loves rarely last.

And yet over the next eight years, love kept drawing us back together. As his girlfriend, I hoped to measure up to his high standards. I visited him a few times when my sister married and moved to a town near where he lived. On several occasions, he drove with his mother in his family's station wagon to pick me up for visits at his house.

I admired his mother from a distance. She was kind, poised, confident and matter of fact, encouraging me to sit up straight. It seemed like she asked a lot of questions, and I wasn't sure if this was friendly inquisitiveness or interrogation. Once I remember answering with a "Yeah," and she corrected me with a "Yesss." I suspected she thought her son could do better.

Returning to my sister's house after these visits, I talked too much. At the time, my sister was suffering from all-day morning sickness. While she was sick in the bathroom, I sat next to her, perched on the counter telling her all about my Paul. She glared at me, but I was oblivious as I handed her a wet washcloth.

When I made the boyfriend announcement to my crew, three years had passed since our summer in Mexico. I hadn't actually seen

him in over a year. With all my insecurities, I didn't have much faith in letter-writing and had prepared myself not to be surprised if he wrote one day to tell me our relationship was over, that he had met someone else. Someone who lived near him that he could have lunch with, who had better posture, and said yes instead of yeah. I would not have believed that for the next five years, we would remain in a loose, letter-filled, long-distance relationship.

Looking back, I'd point out to my younger self the ridiculousness of comparing the realities of an eighteen-year-old faced with pimples and poverty with the glamorous life of Tom Cruise's fictitious girlfriend and remind myself to lace those fire boots tight.

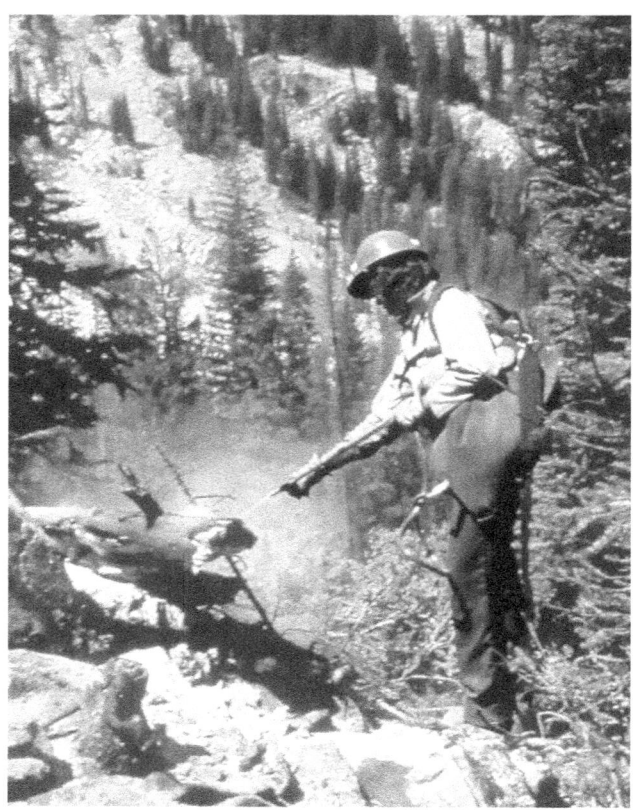
Bladder bag used to extinguish a burning log in the wilderness

Bad Boots & Bladder Bags
Chapter 4

"So how do those boots fit?" Bryan Scholz, my squad boss, asked.

He must've noticed I was walking funny, with my weight on the outsides of my feet.

"Okay, I guess, considering the store didn't have any women's size 7.5 in fire boots. They're a bit too big."

During my phone interview for the job, I was informed that I needed a pair of stout boots. I was told what to look for, but I should've waited for more direction. *How was I supposed to know how fire boots should feel?* While Scholz stared at my boots, he continued his questioning, "Why'd you buy such cheap boots? Every hotshot worth his salt knows to buy Whites or Westcos."

"Obviously not every hotshot knows! Anyways, I'm not gonna' spend half my paycheck on a pair of boots! Who knows if I'll even make it through the summer with this job."

Scholz took this opportunity for education.

"Well, you get what you pay for. You paid for cheap material and shortcuts on design. Thing is, when we're on the line, and the fire decides to blow up, we're gonna' have to hustle to the safety zone. If your feet are blistered, you won't be going anywhere fast."

Bryan was good at his job and fair. I trusted his motives and respected his professionalism. His piercing blue eyes and Chicago accent got more intense as he finished his lecture.

"If those boots slow you down, you'll be slowing down the whole crew. Don't jeopardize nineteen other lives with bad boots. Better figure out how to make 'em work!"

I didn't want to let Bryan down. Thoroughly schooled, I shouldered my pack and wondered how to fix my blistered feet before the next fire call. Since I couldn't return my boots, I tried adding inserts.

Days later, dry lightning strikes hit the forests in the Blue Mountains of Northeastern Oregon. We were sent to the John Day Wilderness Area southeast of Ukiah, a town of 163 people. "Wilderness Area" means no roads. No roads equals a lot of hiking. Miles and miles of hiking, with a blister the size of a quarter under my big toe. When we finally arrived at the fire, we were relieved to see it was small. We lined it and removed the fuels near the line within hours. Lucky for me since my feet were in bad shape.

That night we slept in what's known as a spike camp, the designated sleeping area in the middle of nowhere. Larger fires have fire camps. Fire camps offer firefighters shower trailers, a first aid tent, and a camp kitchen, as well as big tents and trailers where fire managers meet to plan the operations and the logistics of the fire suppression. At a spike camp, the food comes (if we're lucky) in boxes and metal canisters, and the water is delivered in five-gallon plastic containers we called cubies. It's all dropped near our camp in giant rope nets by helicopter. With no roads nearby, the luxury of port-a-potties and the privacy they afford were not available. Nor did we use tents. After unrolling our sleeping bags on the ground for the night, I rummaged through the first aid canister looking for help for my poor feet.

A bottle of Absorbine Jr. designed to ease sore muscles stood out as possible relief. In desperation, I drenched my burning feet with the minty green cooling liquid. Sigh. Better. Lying on top of my sleeping bag amid the sparse vegetation of the ridgetop, I looked at the starless night sky, my bare feet propped on a log, enjoying the exquisite pleasure in each pine and sage-scented breeze that caressed my feet. The rock poking at my back under the sleeping bag refused to relent, but I was too tired to move it.

Instead, I listened to the rumbles of distant thunder that followed the flashes that lit the sky. I smelled the tang of ozone in the air, but no rain. This was dry lightning. If even half of those lightning strikes started a fire, tomorrow would be busy. I applied bandages to the blistered areas of my feet and heels and covered them with two pairs of thick socks. I didn't want to be a burden or slow anyone down if we had to hurry to a safety zone.

At dawn the next morning, we sat around a warming fire trying to eat the government-issued Meals Ready-to-Eat (MREs), food packages designed by the government to last indefinitely without refrigeration. I'm sure if I were starving, I would tear into those MRE's, but when merely hungry, I looked for other options.

"Hey Kelso, gimme your packet of peanut butter and I'll give you this tuna casserole."

"Okay, but I want some of your trail mix too… heavy on the M&Ms."

"Okay, Jon Boy," I teased, knowing he didn't like the reference to the character on the old TV show, *The Waltons*.

"Here. I'll give you all the blue ones." I offered.

"What's wrong with the blue ones?"

"They're bad for you… hard to digest. Imagine the energy required to turn blue into yellow."

"Oh, brother!" He rolled his eyes.

He stuffed a handful of trail mix and blue M&Ms into his mouth, chewed it to a pulp, and turned to me with his mouth opened wide.

"Gross! Kelso, knock it off!" I growled and shoved his laughing face away.

Stiff, hundred-year-old peanut butter spread over stale crackers was savory. Crunchy, freeze-dried peaches were flavorful. Washed down with hot cocoa mixed with campfire coffee, it was a breakfast of champions. We made campfire coffee using the metal holster of our green plastic canteens. Fill the holster with brackish canteen water, add instant coffee and cocoa mix, and heat in hot coals. It worked well without wind. When a breeze picked up, ash flew everywhere.

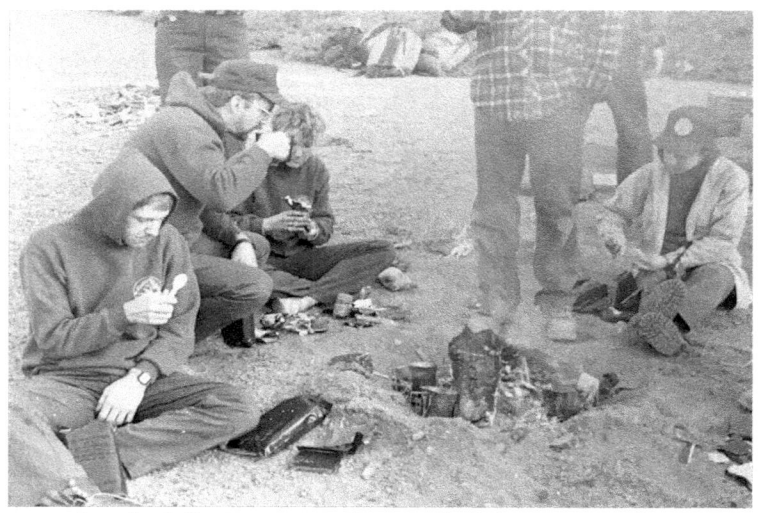

Campfire Coffee: L to R: Jon Kelso, Darrell Schulte, Katie Mergel, and me

Sometimes I'd look down at my hot beverage wondering, Is that a melted miniature marshmallow or ash? I'd start to fish it out with my finger until I noticed my black, grimy fingernails. My hands

were often filthy from the previous day's work, especially if we were cold-trailing through ashes checking for hidden heat.

Pulling out our protein reserves of sardines or beans and weenies, someone new to the crew risked opening a can of Spam. Before long, someone was giving a hilarious performance of Monty Python's Spam advertisement. Most of us drew the line at Spam, agreeing we'd have to be literally starving to eat it.

While picking ash out of our coffee, we listened to radio chatter from the fire lookouts who were constantly scanning the horizon in search of "smokes," the first stage of a fire. When lightning hits a tree or other fuel, it will smolder in the morning until the humidity drops and the temperature rises along with any afternoon wind. Then smokes become flames. The sooner we reached a smoke, the easier to put out a future blaze. Because of the number of lightning strikes we had witnessed the previous night, the airwaves crackled with excitement.

Kelso and I, along with most of the crew, walked to the edge of a rocky bluff for a view of our surroundings. Counting seven smokes below us in the early hour, we knew it would not be an easy day. In fact, it turned out to be a blur of fast hiking in steep, rocky terrain. The crew split into squads to divide and conquer. Navigating through sometimes thick brush to reach a smoke, we'd put a line around it, remove the fuels, and hurry on to the next one.

At one point, my squad boss handed me an empty bladder bag, also known as a piss pump. It's a rubber bag with a metal squirt gun attached that is used to spray embers in a spot fire. A little water strategically placed on a hotspot can be the difference between a fire going cold or eventually blowing up. It was a novelty to me. Thinking it would be fun to use, I volunteered to fill it down at the creek.

I wasn't thinking about a few pertinent details. A gallon of water weighs eight pounds. The rubber bag holds five gallons. I didn't

consider how 40 pounds of sloshing weight strapped on top of my regular pack would affect my balance as I climbed the steep slope. Nor did I consider the chafing on my shoulders and neck from two sets of nylon straps rubbing against sweaty skin. That afternoon, I swayed back and forth across the slope wearing my "fun" bladder bag. The ease of dousing hot embers with a squirt of water instead of chopping them off the burning wood and the fun of spraying crew members was not worth the trouble or the extra weight. After that, I thought twice before volunteering to pack it again.

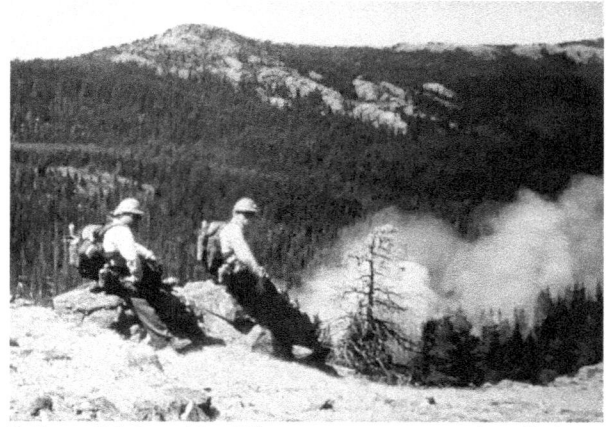

L to R: Bryan Scholz and Jon Kelso survey a growing number of lightning fires

A few days into chasing smokes and small fires, one of the unreachable ones grew into a fire. As afternoon winds increased, the fire started to move. We spent hours constructing fireline until mid-afternoon, when the sawyers stopped their relentless sawing. In the ensuing quiet, we could hear the fire gaining momentum, like the rumble of a passing freight train. A dense plume of smoke filled the sky, shading our surroundings. The fall of ash quickened. Fire behavior manuals warn how these conditions shout "Watch Out!" On word from the boss, the sawyers abandoned their cutting. Never

a good sign. Then they shouldered their saws and started down the hill toward the safety of the meadow.

"Reverse line order and move out!" yelled our squad boss.

Despite our fatigue, we hiked faster than I'd ever seen us move. It wasn't panic; it was determination. Striding down the slope, trying not to trip, turn an ankle on the rocks, or be whacked in the face by branches, we blasted through the trees. It didn't matter how blistered my feet were; adrenaline blocked the pain. Every atom of my being was focused on breathing and moving. Within minutes, we saw the meadow below us.

Arriving at our safety zone, I finally understood the wisdom of spending hours on physical training every day. I finally understood the importance of wearing quality boots. The sunny meadow grew dark, shaded by smoke. It created a surreal afternoon twilight. A day's work literally up in smoke. When a fire burns that hot and fast, there's nothing to do but move out of the way.

That fire soon graduated to a larger category. *The New York Times* reported that over 500 fires were started by dry lightning strikes in remote northeast Oregon, Washington, Idaho, and western Montana in that second week of August, 1986. Less than 200 miles east of us, in Boise, the governor declared a state of emergency for several fires that threatened homes and ranches. Forty-three Idaho National Guard trucks, six water tankers, and eighty-six guardsmen were dispatched by the governor to assist firefighters.[1]

For our fire, more hand crews were ordered. The next day, a fire camp was established.

We had worked enough days for a mandatory day off. Our days of "rest and relaxation" (R & R), usually meant a day of driving to the nearest laundromat to wash filthy clothes, make phone calls, and rest our sore feet. This time our boss surprised us to include a bus ride to a nearby hot spring. When I stepped into that soothing mineral water, my skin rippled with goose bumps. Oh, the bliss!

After days of carrying heavy packs and equipment up and down steep slopes, we were all stiff and sore. Shedding hard hats, fire shirts, t-shirts, fire pants, boots, wool socks, and bandanas, we hurried into swimsuits. Aches and pains melted away in weightless pleasure. The pool filled with floating firefighters high on one of life's simple joys. A crew member standing next to me saw why I was smiling.

"Now there's a sight you don't see every day!" she said, pointing at the flotilla of firefighters.

Unlike a lecture on the consequences of ill-fitting boots, discovering the pleasure of a mineral hot spring was something to relish. But I was about to learn a life lesson in humility.

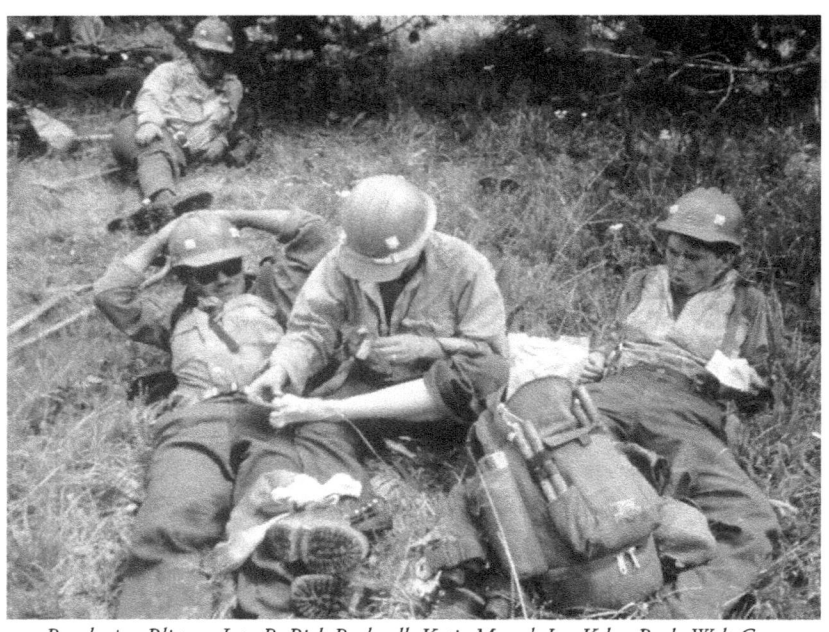

Bandaging Blisters: L to R: Rick Bushnell, Katie Mergel, Jon Kelso. Back: Walt Carter

Early Influencers
Chapter 5

We left that fire in Northeastern Oregon and returned to Prineville late at night. Not owning a car, I had to bum a ride home from the station. Along with several other crewmembers, we crammed into a hotshot's big truck with the super-sized tires, loud stereo, and louder mufflers. I commented that I was going to wash my government-issue sleeping bag. After working in the wilderness day-after-day, sleeping on the ground in a spike camp without showers, our sleeping bags reeked. Most of the crew lived in crowded, run-down apartments and had to drive to the laundromat, but I was house-sitting in a nice house for friends of my parents. The homeowners were on a long road trip. At work, some of the men teased and called me princess because of the "palace" in which I lived.

Near midnight, I was dropped off at my house… along with five extra sleeping bags to wash. As I waved goodbye, the guys' jacked-up truck zoomed out of the dark neighborhood, waking the dogs who reacted with a cacophony of barking, up and down the street.

The next morning was a day off and I set to work loading sleeping bags into the washing machine and then laying them out on the lawn in the backyard to dry. By noon, I'd spread half a dozen on the grass. The nosy neighbor from across the street took his daily walk past the house. He thought I'd had a wild party with so

many people sleeping in the house that they'd spilled out into the yard. He called the homeowners to report me and my wild party. They cut their trip short and were home by the time I returned from work the next day.

I explained that there was no party, but they were livid and wanted me gone. I did not protest because I felt guilty. Weeks prior, while dressing to go to the movies, I saw a cute pair of pale pink capris the woman had left on the dryer. They were a perfect fit—a nice upgrade from my old Levi's. I borrowed my sister's clothes all the time and didn't think twice to borrow the woman's capris, certain the homeowner would never know. When they returned early, her pants were with my laundry. Busted and embarrassed, I left in a hurry.

Not sure where to go and trying not to cry, I pedaled away on my 10-speed bike. I wished my parents had not moved 150 miles away. While asking Jesus for a new place to live, I wandered the aisles of the grocery store, the closest public building with air-conditioning. I didn't know what to do or where to go. I was staring at the ice cream when I heard a friendly voice behind me.

"Katie, is that you?"

I turned to see an English teacher from high school. I knew him then as Mr. Stoller. Smiling his generous gap-toothed smile, he looked happy to see me. Seeing him smiling was disconcerting after what I had just been through. And I remembered that I had been unkind to him when I was a junior: after yawning through a few days of his journalism class, I transferred out without a word. I couldn't see past his shirt pocket protectors and his eternal joy. He was too nice. He smiled too much; it couldn't be genuine. Or maybe he was out of touch with the real world. Here he was, smiling again, but now I appreciated it.

He asked about my summer and tears welled in my eyes as I professed to being homeless. With a sideways hug, Roger invited me

to stay at his house. He said he and his wife were empty nesters with plenty of available rooms.

Though I didn't know it at the time, this was the first of many times in the coming years that my prayers would be answered in exceeding abundance and sweet surprise. As I grew older, and the heaviness of life threatened to unbalance me, again and again, I would turn to prayer. Again and again, the results and circumstances would defy coincidence.

I knew the Stoller family. Roger's wife had been a cook at the high school before she retired. Like her husband, she had a quick smile. His daughter always ran ahead of me on the cross-country team. They were a family of runners with a penchant for charity. They lived in the country on the opposite side of town from our fire station. When I voiced my concern about pedaling to the station in a hurry, Roger said I could drive his truck to work instead of riding my bike. I could hardly believe his generosity. There was one catch. I had to learn how to do a rolling clutch start. The old truck's starter didn't work. That rickety Datsun pick-up had to be rolling in first gear. Once it had enough momentum, I could slowly draw out the clutch until the engine caught. Fortunately, the Stollers lived on a hill with a steep driveway.

Roger took me for a drive to demonstrate the technique. It seemed simple enough, but the first time he and I rolled down his driveway with me behind the wheel, I almost gave him whiplash. We laughed out loud as the truck lurched and skidded down the gravel lane. As long as I remembered to park it facing down the hill and set the emergency brake, I'd be fine.

The trick was starting the truck when it was parked at the Forest Service station. I had to ask the guys to give me a push. Since I had to steer, I'd watch through the rear-view mirror as they grimaced. Amid grunts of labor, I'd yell out the window, "Just a liiiii-ttle faster…"

Sometimes the Stollers would leave me to housesit while they traveled, but when they were home and I returned from a fire, they wanted to hear all about it. At the end of my first season, they invited me to return. I came and went from their house for the next two summers. Sometimes they housed other firefighters, as well. By the third summer, as the truck became more unreliable, Mr. Stoller would toss me the keys to their family car. In his kind, soft-spoken way, he showed me that his smile reflected a life-long faith in his loving God and his consequent peace of mind. It seemed like he took Jesus's admonition to love our neighbor to heart. He was one of the most generous people I have ever known.

Mr. Stoller was just one of the great teachers I had in high school. I hit the jackpot with many. It was a public school, but our principal also served as my Sunday school teacher at our local community church. He wore a tie every Sunday. As he looked around the church's classroom at each of us, he'd say we had big things ahead. By big, he meant difficult. He encouraged us to stay close to God through hard times.

My biology teacher was also my track coach. With his Clint Eastwood style, he was not someone students disrespected. I ran the races he thought I should run until he suggested I try the 800-meter race instead of the 400. "I think the 800 is your race!" he said, pointing his finger down at me.

My refusal was immediate. To sprint around the entire track was hard enough, but to do it twice? Inconceivable. Maybe it would've been my race, but I stubbornly refused to run it because it was *too hard*. After my summers with the hotshots, I can only shake my head at the irony of that sentiment.

Besides being my senior AP English teacher, Walt Bolton also became my friend after high school. In class, he constantly dared his students to think and act beyond our comfort zone. When students walked into his classroom and saw "Appearance vs. Reality" scrawled

across his chalkboard, we knew we were in for an uncomfortable discussion that stretched our narrow way of seeing things. He once took my senior English class on a field trip to watch Shakespearean plays and encouraged us to consider attending the University of Oregon, his alma mater, as he thought the school fostered curiosity and challenged its students.

He also worked during the summers as a wildland firefighter for Prineville's Bureau of Land Management (BLM). After I became a hotshot, I'd visit him occasionally to share fire stories. When he retired from teaching, he became a scuba instructor in the Caribbean. Between deep dives with his wife amid dolphins and whale sharks, he taught himself to play the banjo.

As the epitome of one who, to borrow from the poet Thoreau, "sucks out all the marrow of life," Walt continues to live with a contagious joy and spirit of adventure.[1] In high school, I had the impression he believed in me more than I believed in myself. Later, I would take a college and career path similar to his own.

My teachers influenced me more than I realized at the time. The phrase *Appearance vs. Reality* lingered in my mind long after high school as I navigated the coming difficult predicaments of life.

Wrong, Wrong
Chapter 6

Standing on top of a steep, rocky ridge in 100-degree heat, I couldn't bear to look down at the boaters on Oregon's Detroit Lake. From where I stood, the water shimmered emerald green. Jealous of the water-skier far below, I swigged hot canteen water. It did nothing to quench my thirst.

I read that long ago Native American distance runners sucked on a pebble to relieve their thirst. Looking down at the hot gravel around my boots, I wasn't quite desperate enough to try it. Applying more lip balm, my gaze shifted to the pile of hose I had to carry farther up the mountain and took a deep breath before reaching for my burden. The terrain was so steep, we were happy to stop this lightning fire of approximately 80 acres, thanks to the easy access to water, a lack of wind to fuel flames, and adequate boots on the ground that allowed us to catch the fire while still small.

Thirty-three years later, in 2020, the Beachie Creek Fire, which ignited not far from the burn where we had worked at Detroit Lake, was a far different story. That lightning-sparked fire was first spotted on August 16th. Record low humidity and a rare high wind occurrence, which began on September 7, caused this fire to blow up and surround the lake and town of Detroit, Oregon. At midnight, without previous warnings, officials issued a Level 3 (Go Now!) evacuation order in the nearby communities of the Santiam

Canyon. The raging fire destroyed 486 homes. Five people died. By September 13, when fall weather finally arrived, the fire had burned 190,069 acres. That same day, in Oregon's Willamette Valley, the air quality index was well over 500, making it the worst air in the world.[1]

At the '86 fire, our crew camped in one of the campgrounds along the lake. When our work for the day ended, the cool, deep water was the only thing on my mind. Not alone in my thinking, most of the crew stripped out of dirty, sweaty clothes and made for the shore. Floating on my back, I watched as stars appeared in the glowing sky and wished every fire were above a lake. I savored the extreme contrast between the hot work under the sun's glare, and cool, effortless floating in the twilight.

Big changes were ahead. At the end of September, I returned to Oregon State to resume my studies. I focused on schoolwork and spring's rowing season. But there was a problem completely unforeseen the previous spring.

During my first fire season, the physical demands of the job had caused me to grow an inch and added at least ten pounds to my frame. I returned to school the next fall for my sophomore year strong and solid. As the year progressed, however, it became apparent to both my rowing coach and me that weighing in under 130 pounds for spring racing season would be nearly impossible. During winter workouts, while the rest of the team did muscle-building circuit training with weight machines, Coach Roger pointed me toward the stationary bike or the stadium stairs. I couldn't gain another pound.

As the first spring rowing regatta approached, I was still ten pounds from race weight. The more I told myself I couldn't eat, the hungrier I got. If I heard the word diet, my mouth watered. One sandwich wasn't enough anymore. My hypothalamus reset

itself and my mind worked against me. So did the so-called media experts who touted the low-fat diet for weight loss. Those magazine articles couldn't have been more wrong. It's not protein and fat that causes weight gain. It's the carbs and the sugar.

Some girls in the dorm had a fail-proof weight-loss plan, but vomiting didn't come easy for me. On the rare occasion that I was sick and forced to throw up, I had visions of volcanic eruptions.

"It's easy! Just stick your finger down your throat," said a bulimic dorm friend.

"EASY?! There's nothing easy about it! And it's gross!"

"Well, if you change your mind, be sure to brush your teeth afterwards or you'll get cavities."

I would not put myself through that self-inflicted torture. In desperation, I tried one of those humiliating weight-loss clinics, but I hated paying a small fortune for the privilege of eating a tiny portion from the company's cardboard cuisine. I already lived with enough rules and self-discipline. At our final meeting, I suppressed the urge to say unkind things to the stranger behind the scale and stormed out the door. It wasn't the stranger's fault. I resented this new obsession with food and calories.

I hated myself for worrying about numbers on the scale. There were much, much more important things with which to be concerned. Like when we watched the Chernobyl Nuclear Power Plant explode. Deadly radiation forced over two hundred thousand people to relocate in the Ukraine.[2] Would those radioactive particles ride the jet stream to land on our soil?

Juggling schoolwork, rowing, and dieting, the fight against my weight increased. This stressed me out more, which made me hungry, which made me tired and irritable. One can eat only so many celery sticks. In March, with weigh-ins for the varsity lightweight boat only a week away, I stepped on the scale. My body fat percentage was at an all-time low, but I still had seven pounds

to drop in seven days. I wasn't sure it was even physically possible, never mind my still being strong enough to row on race day. I went for another run hoping to sweat it out.

As each mile passed on the lonely country road, the stabbing pain from shin splints increased until I turned back and slowed to a walk. Later, I sat in the gym's sauna hugging my knees. I needed to study, and I needed to eat, but could do neither. Exhausted and dripping, tears slid down my face. I realized that I had set myself up for failure. Generally a joyful person, I'd lost my joy. Miserable and still four pounds away, I had nothing left to lose. I couldn't do it. I wouldn't do it.

Too big for the lightweight boat and too small for the open-weight boat, I had to get out of the boat. On a hungry, sleepless night just before the first race of my second season, I decided to quit rowing. I felt horrible letting my coach and teammates down, but I was in the wrong boat and didn't see another option.

I would miss the early morning practices. Sitting inches from the water's surface with only a thin curve of wood between us and the water, we rolled our seats forward and back in a steady working rhythm that freed our minds to enjoy the beauty around us. At dawn, our long boats of eight would quietly drift through the mist rising off the dark water. Breathing in the sweet scent of cottonwoods and verdant farmland along the shore, we whispered past the blue herons eyeing us from the shallows. Red-winged blackbirds sang to us while kingfishers flew silently beside us. Ravens and ospreys watched from the treetops as we pulled and pushed, feathering our oars in unison.

The sport I had so enjoyed, rowing on the Willamette River with the birds and my teammates, had become twisted with unreasonable and unreachable requirements. Someday, I promised myself, I would return to the birds and the water, maybe even to

rowing. However, I refused to live under the pressure of a scale. Having come to that conclusion, I was at peace with letting it go.

But I had another problem. At Oregon State University, I had chosen to pursue a career in the medical field—after all, the school was known for its strengths in science and math. That wasn't working out either. Throughout my entire freshman year, I had struggled with chemistry. I took copious notes and stayed up late studying, but was never able to master the equations. It was like I was dyslexic when it came to chemistry equations. Sitting with every tutor the study hall offered, I still couldn't grasp them. At the end of my freshman year, right before final exams, I finally approached the professor.

"Hi, I'm in your morning Chem class, and I've tried, but I can't understand it."

She looked my number up, saw my attendance was regular, that I turned in my assignments, and completed the labs, all with low scores, but the rest of my grades were good. She looked at me and sighed.

"All right," she said as she rubbed her eyes. "I have a daughter who struggles in the same way. She switched to a Liberal Arts major… maybe you should move in that direction. In fact, promise me you won't go into the medical field, and I'll pass you."

She might've been joking, but I didn't make promises lightly. Sadly, it seemed all things healing hinged upon understanding chemistry. My mom graduated from nursing school after having six kids. *How did she do it?* My dad grew up wanting to be a doctor, but his parents directed him to business school instead. Some dreams are deferred.

I liked making people and animals feel better. Growing up, I rubbed my mom's aching legs after her long shifts at the hospital. Every day, I brushed my horse and cleaned his stall. Not squeamish

about blood and needles, I found the art and science of the body intriguing. But a medical career apparently wasn't for me.

I had faced up to my inability in chemistry the previous May. Now, with my having to leave the rowing team, I wasn't sure what to do or where to go. I needed a course correction. In March, right after I had made the hard decision to quit rowing, I made the equally hard decision to quit school.

I called my mom early the next morning to tell her. She mentioned she was planning a trip to England to see her cousin. I brightened and asked if she wanted company. Absolutely, she said. As I explained my predicament, she seemed to understand the pressure I was under and my desperation to free myself from it. My mood lifted abruptly.

A trip to England with my mom felt like exactly the right thing to do before my second fire season with the hotshots. I promised myself I'd consider transferring to a liberal arts school and hoped two wrongs would eventually make a right. I had a history of going after something once I knew what I wanted.

Like when I decided I wanted a horse.

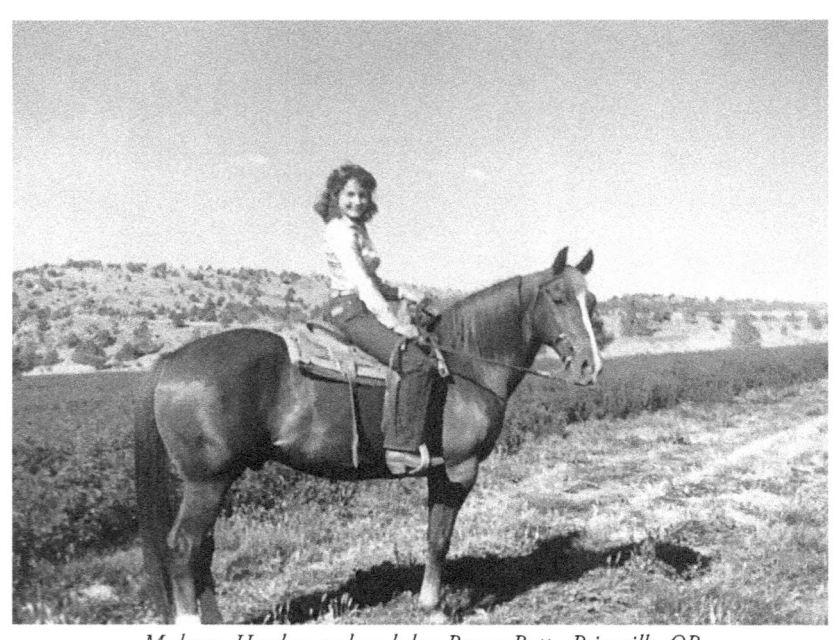

My horse, Hombre, and me below Barnes Butte, Prineville, OR

Cowboys
Chapter 7

JUNE 1987. Mom and I never made it to England. Due to passport delays, we toured Tijuana instead. Returning with bottles of Kahlua and vanilla, it was one of several daytrips Mom and I took when we went to visit her sister and my cousins in Los Angeles. LA seemed like another world, and after visiting Disneyland, Sea World, and the beach, I was ready for work.

Returning to Prineville to start my second season with the hotshots, I noticed a few new faces and approached the men to introduce myself.

"Hey, which way to McDonalds?" they asked, laughing at my name.

Two of the new recruits were from Compton, a rough neighborhood of Los Angeles.

"There's no McDonalds. Welcome to small-town America."

I pointed out the town's Tastee Treet on the corner of 3rd and Elm. The local burger joint that would survive decades of economic recession despite its spelling issues.

How these two guys ended up in Prineville was a mystery. They wore kerchiefs on their heads, and one wore a diamond stud in his ear that sparkled against his black skin. Since they were in cowboy country, they wanted to be cowboys. Maybe start by riding a horse, I suggested. I took it as my duty to introduce them to the horse

world. I had connections. The new owners of my horse let me ride him when I was in town.

Once I saddled Hombre, the big Morgan gelding I had ridden for years, one of the guys decided his cowboy experience ended with the boots and belt buckle. The other took up the challenge. The big man timidly approached the horse, fully aware that his 250-pound frame was nothing to Hombre's 1200 pounds. He respected the size ratio. Easing into the saddle, he asked me to take a picture to show his family. Joy radiated from his face as he galloped through the sagebrush for the first time.

There's a continual, mostly peaceful conversation between a horse and his rider. Occasionally, it's a lively debate regarding what the rider wants to do versus what the horse wants to do. As a kid, after watching the movie, *The Black Stallion*, I had asked Hombre to walk into the irrigation pond until he was swimming. I was sure he'd argue about swimming with me on his back, but he didn't. I laughed as he stretched out his neck, tilted his nostrils up and paddled like a dog, while I held onto his mane and flutter-kicked beside him.

Once, while herding cows, Hombre and I took off after a runaway calf. Hombre was running so fast through the sagebrush that neither of us saw the badger hole hidden by a tumbleweed. His leg disappeared almost to his knee and in an instant, we both went flying; the horse flew one way and I the other. When the dust settled and I struggled to my feet, I was shaken by what could have happened. Somehow Hombre did not break his leg. Somehow, we both came out of the fall without a scratch. After that, I rarely rode a horse at a run.

I don't think of myself as a big risk taker. Apart from seasonal firefighting, I tried to avoid danger unlike my trick-rider friend, Torri Talbot. Riding with her in a parade once, I sat with my seat solid in the saddle, while she stood with a foot on the back of each

Palomino, Sterling and Marvelous. We didn't wear safety helmets back then. Balance, trust, and two thin strips of leather in her hands were the only things separating her from a fall. I didn't know what drove her to such daring deeds. I didn't have the same drive.

Neither Torri's parents nor my own were property owners, but because of our love of horses, we both found a way. I had knocked on the door of an old woman who lived alone on five acres near my house. Her pasture was empty. I asked if I could fill it with a horse. She said yes and didn't even charge a boarding fee. I learned later that she had been worried about a brush fire and wished for a way to keep the grass down. Both pleased with our arrangement, the woman and I became friends.

The horses Torri rode weren't hers; they belonged to an old man who lived on the outskirts of town. Claude Puckett was once well known in Central Oregon for his traveling horse show. In his younger years, one might see him at a county fair in his golden chariot dressed as a Roman Centurion charging through the arena pulled by four of his beautiful palominos. Decades later, he still kept a rusty chariot next to his old silver bullet trailer. He also kept a chest filled with faded satin horse costumes all vestiges of glory gone.

When I knew Claude, he looked to be eighty-years-old; had white hair and wore a long, scraggly beard. His trailer was parked wherever his horses were. It didn't seem to bother him that he didn't have power or running water. I once heard him say the two things he lived for were his horses and his faith in God. In Prineville, he was like a magnet to struggling kids who needed a purpose. Helping Claude care for his herd of horses filled that need.

Years before the badger-hole incident, a bunch of us kids sat on the fence after a morning of feeding and grooming Claude's herd. Someone suggested that I ride the Appaloosa stallion, Tahoe. I was told this stallion was the fastest, smoothest horse I'd ever ride

(except Red Cloud, and only Torri could ride him). Fourteen at the time, I had never ridden a really fast horse.

The horses grazed in a harvested hay field on the banks of the Crooked River. I approached Tahoe, secured a bridle, and jumped onto his bare back. With the slightest leg pressure to his side, Tahoe eased into an easy gallop. It was effortless to stay on him because this little stallion was smooth. Taking a deep breath, I leaned forward and loosened the reins. Tahoe took off, stretching into a run. I twisted my fingers into his mane and held on. We were moving so fast my eyes watered; I laughed out loud as we flew by the scenery. With pounding hooves, the wind rushing through my hair, and Tahoe's breath blowing hard, we raced for the fun of it.

Several years later, I shared a ride with a fellow hotshot. On that day, Brad and I rode double on Hombre through freshly cut alfalfa fields below Barnes Butte. The sun was setting behind the Three Sisters Mountains, coloring them in bright hues of red and gold. Quail and pheasant called as they settled in for the night. Pulling up, we dismounted and climbed to the top of a haystack. Sitting close, we watched the full moon rise in a midnight-blue sky. Stars appeared and I gazed at the Big Dipper. Sweet and spicy aromas of juniper, sage, and alfalfa perfumed the evening air. After weeks of breathing acrid smoke, the contrast was a delight. Crickets chirped while Hombre chewed the hay below us. *Shalom.* Peace.

I wanted to press pause on that evening. It wasn't a date, but it was perfect. I didn't know it then, but I was about to experience an actual date with a real prince beyond my wildest dreams.

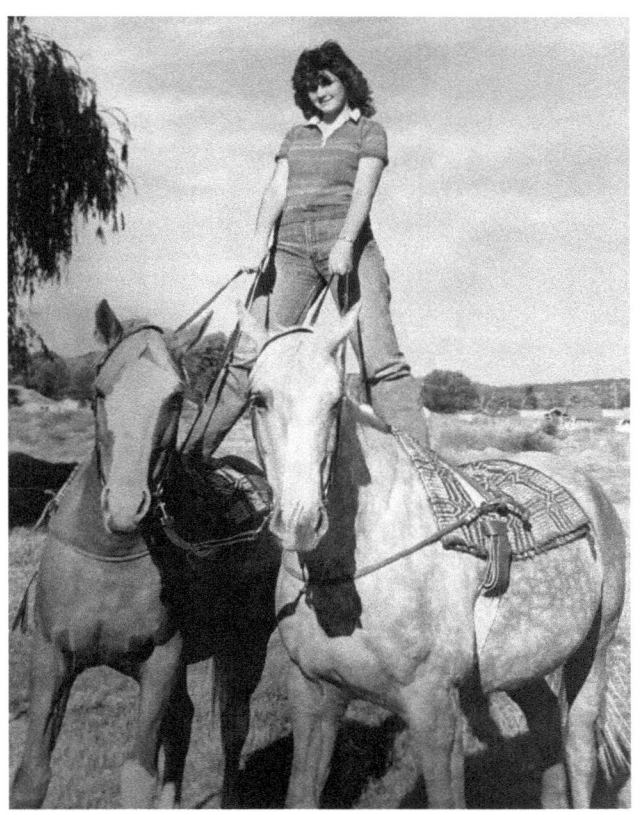
Trickrider Torri Talbot riding Sterling and Marvelous

Cinderella
Chapter 8

AUGUST 1987. *Once upon a time ...* my handsome pilot called. I happened to be home for a few days between fires when the phone rang. Hearing his lovely low voice, I twined my fingers through the phone cord and tried to remember the last time we had talked. It had been months... maybe longer. For a moment, my mind wandered back to our last visit, and I lost concentration.

"I'm sorry, what were you saying?" I asked, a little embarrassed to be caught daydreaming... about him.

"I said... I was hoping you'd join me for the Officer's Regimental Ball here in Florida."

While in training, he and the other would-be pilots enjoyed periodic black-tie events. For a solid minute, I savored his invitation. He even offered to pay for my flight. Then reality hit. I steadied my voice to tell him I was pretty sure I couldn't. It was August. Fire crews from Canada to Mexico were on high alert for the dry lightning storms hitting the West. Even if I weren't a hotshot, for me to take four days off during peak fire season was out of the question. I told Paul I'd ask for time off, but my crew boss would probably say *NO WAY, JOSE!*

But that's not what happened. I sat in his office after work the next day and explained about my phantom boyfriend. He leaned back in his chair and ran his fingers through his close-cropped hair.

"Hamberger, do you realize the position this puts me in? If we're called to a fire while you're gone and we can't find an alternate in time, we can't go!" (Hotshots generally didn't travel out of state without a full crew.)

I told him I understood and got up to leave.

"Sit down!" he growled, absently scratching under his beard. "Having said that, I'm also a dad. I recognize this is a big deal—and I'll not be the one that keeps you from it. You get four days. Go, before I change my mind!"

"Thanks, boss!" I called over my shoulder as I rushed out of the room.

Two weeks later, I boarded a plane bound for Pensacola. I sat next to a suited man wearing black alligator skin cowboy boots. He wore a big gold ring on his pinky and a fancy gold watch to match. With a Texas-drawl, the businessman asked where I was headed. After my lengthy explanation, he proclaimed me a "mover and a shaker." I've never forgotten the stranger's offhand comment. It wasn't how I saw myself, but liked that he had that impression.

As the plane landed, I took a deep breath. My heart raced the way it did when I approached a wildfire. Spending the weekend with my boyfriend at a fancy occasion was way outside my comfort zone. I didn't want to think about where we were going to stay. I worried instead about the clothes I brought. I wanted to look good for Paul, but was short on pretty clothes. Working in the woods, I wore ugly government issued clothes with my hair shoved under a hard hat. Even when not on the job, my sense of style was more miss than hit. I had proof to back that up.

As a senior in high school, I was elected to be a princess for the prom. I needed a dress, but there weren't any local stores in which to shop. I asked my sister if she'd sew a dress for me. She agreed to drive the three hours from her house to mine to help me. She spent an entire weekend sewing at our kitchen table, while I sat next to her

dipping Oreos in my milk. I handed her the scissors and kept the records playing while we sang goodbye with Elton John to Norma Jean and the Yellow Brick Road. We also sang to every ABBA and Neil Diamond record we owned.

The dress looked like pink satin. It had a ruffle and flower designs on the shiny fabric. When I chose the pattern and material, I hadn't considered that with my olive skin, that particular pink was not "my color." Neither were ruffles and flowers my style. Taking my "look" one step further, I decided it'd be a good idea to get some color on my skin. There weren't any tanning beds in Prineville, so on prom day, I slathered my face, shoulders, and arms with baby oil and wore a tank top to go horseback riding. That night our photos showed bright tan lines across my shoulders—that and a red face that matched my pink dress. Accessorizing with white nylons and white pumps ... I don't know what I was thinking.

I certainly wasn't thinking I'd walk away from the dance as prom queen. The girls on either side of me stood with more poise and fashion sense. Also, I was not in the popular circle. Even calling to invite my date had me sweating. Sweethearts in the fifth grade, Don and I attended the same school and church, but now he was our student body president. He escorted me for old time's sake and our picture for the yearbook was taken as he was telling me I might be voted queen. I didn't believe him, but later that night I danced among my peers wearing the crown. I wished I weren't shy. It was fun being a princess with the others, but to stand out as the queen was too much. We tried to dance to Prince's "Purple Rain." Looking back, the Huey Lewis hit song "Hip to Be Square" might've been more appropriate.

Now, two years later, I was about to attend another formal event. My sister helped me once again. She sewed the dress I would wear the night before the ball, but I wondered if the dress I brought for the ball itself fit the occasion. When we arrived at the palm

tree-lined hotel, Paul and I were surrounded by his friends and their girlfriends. Everywhere I looked it seemed like couples were in make-out mode. Awkward.

Kissing did not come easily for me; I wasn't used to public displays of affection. Not that I didn't like to kiss—I did—but to go from trying to blend in with the guys at work to being glamorous and affectionate was disconcerting. I had missed Paul and it was easy to hold his hand. He seemed not to be in a hurry for anything more while I got used to my surroundings.

As I stood fidgeting with the straw in my cup of soda, I glanced at the other groups of couples clustered in the big hotel lobby. Keila, one of the girlfriends, struck up a conversation. She was from Ohio. She asked about my job. When I said I was a hotshot, she nodded, blinked, and sipped her soda. Blonde, beautiful, and stylish, this girl knew how to wear pink satin. She wore a stylish pink satin dress the night before the big ball. She was friendly and invited me to join her at the beach the following day while the guys were in meetings.

Lying on the beach in our bikinis, I listened to her talk about her plans to marry her man and marveled at the contrast between her life and mine. Hers was a life without push-ups, except maybe when it came to lingerie. I looked forward to that day; having the option to wear silky summer clothes and enjoy more balance in my life and a few less callouses across my palm.

As we lay stretched out on the sand sunbathing, a hat covering my face, I listened to the slow waves rolling on and off the shore. I thought about my future and concluded that I had to return to college in the fall. I would change my major and attend a school with a great liberal arts program, maybe even the University of Oregon. I had to finish college. Going forward, my plan was simple: fight fire, pay for college, study hard.

In my favorite movie, *Out of Africa*, actress Meryl Streep plays the writer Isak Dinesen who looks at the compass her friend Denys gave her and muses:

"Some say God made the world round so we can't see too far into the future ..."

I had difficulty seeing beyond surviving the summer and then enduring another year of school. I had cried at the end of the movie. I wanted it to have a happier ending. Movies had taught me to expect happy endings, but life experience teaches differently.

The dress I bought for Saturday night's ball was royal blue satin. Floor-length, it was plain without ruffles or flowers. I learned years later that hue of blue is considered a "universal" color. Lucky for me. Rhinestone earrings and the matching necklace given to me by Paul's parents completed the outfit. Paul wore his Navy dress whites. Given the dirty environment I worked in, it was strange to see so many men dressed in white.

Before the event, we strolled the beach boardwalk at sunset. Through the thick, humid air, I smelled the brine of salt water and was surprised by the soft waves. Oregon's ocean waves pound the beach with a constant dull roar. The waves of the Gulf of Mexico sounded like the lapping of water on a big lake. Our surroundings were beautiful, but neither of us spoke. My shoulders were tight just wondering what the evening involved. As an introvert, I wondered how big the crowd would be and how many names I might have to remember. *If Paul asked me to dance, how would I avoid stepping on my dress and tripping?* I was about to ask him when I stumbled and he caught my fall. I stood balancing on one foot with my hand on his head while he knelt to pry the heel of my shoe from between the wood planks without breaking the heel.

"Maybe I should've worn my fire boots. I wouldn't stumble in those," I joked. We both laughed, easing my tension. After that, I hung on his arm and watched where I stepped.

It was a night of pomp and circumstance. We arrived at the Mustin Beach Officer's Club like celebrities, sitting on the ivory leather seats of a classic convertible with the top down. Stepping from the car, I liked how Paul directed me through the doors of the hall with his hand at the small of my back. The gesture seemed to communicate, *She's with me.*

Everywhere I looked, men were saluting each other, shaking hands amid laughter and much backslapping. Canned music played in the background while we sipped champagne and posed for photos in front of the Blue Angels jet permanently parked at the

Keila Fallon and I posing in front of the Blue Angels jet in Pensacola

club. Through the elegant dinner, I smiled at Paul, proud of his hard work, proud of him accomplishing his goals. Later, a group of us went to a bar on the boardwalk and with Long Island iced teas, toasted to pursuing dreams.

A weekend like ours could've ended like a steamy romantic movie scene. The reality looked more like lying on the hotel bed together sharing peanut M&Ms. We watched TV while trying to ignore what was happening in the other rooms. In a few hours, I

had to catch a plane, so there was that, but also Paul and I had a unique history.

Years prior, we sat through a seminar at the Portland Memorial Coliseum that both our churches encouraged us to attend. The presenter had a lot to say about abstinence before marriage and why God requires it. It was a convincing argument based on God's principles from the Bible. I tended to be a black and white rule follower and didn't see any other way to interpret the words on the page. It seemed like an impossibly tall order. In fact, I learned decades later the speaker destroyed his own career and personal life by not practicing what he preached. But we actually signed a contract at the end of the seminar's workbook agreeing to abstinence until marriage.

I remember looking sideways at Paul during the seminar and must've had a curious look on my face because he raised an eyebrow at me.

"What?" he leaned over to whisper in my ear.

"I was thinking I might marry you one day and what that might look like," I whispered back. After I said it, I realized the statement's boldness. Both his eyebrows shot up and he caressed the back of my neck bringing on an unexpected rash of goosebumps and flushed face.

Back in the hotel room, contracts or not, my piety was helped along by stomach cramps. He may have noticed an increased shyness or reserve and wondered about the mixed signals. Taking my cue from my mom and sister who never talked about such things, I didn't tell him, and he didn't ask. A few years later, I had lost such shyness. But on the rare occasions when we met, it was always the same: just as we started to relax and enjoy each other, it was time to part ways again. True to form, I kissed this officer and gentleman goodbye at the airport. We both had work to do.

On the long and lonely flight back to Portland, the plane bounced ominously through the turbulence of lightning. Tired from an exciting weekend, I sank into the seat, relaxed by the momentary

lack of expectations. News reports at the airport showed thunder and lightning storms across the West. A fire call was inevitable. I enjoyed the rest while the plane flew west.

The next day, I walked into the station to find crewmates gearing up for a fire. Within hours, I boarded another plane, this one bound for California. Confident, capable, and knowing my job, I was back in boots, trudging toward the flames through cinders and soot.

California's rugged terrain

Brothers in Arms
Chapter 9

When hotshots fly to California wildfires, they expect to be gone for weeks, not days. Always hot, dry, and often fueled by Santa Ana winds, the steep terrain is usually covered in thick, dry brush. Fireline construction in California is a hard-fought battle.

In the early fall of 1987, we flew from Redmond, OR, to a small airfield in a little valley north of Redding, outside the town of Yreka, California, just south of the Oregon border. The plane descended, gliding past the rugged Klamath Mountains we'd soon be climbing. I still had almost a month to work before school started. Weary from the busy season, the Salmon Forks Fire would push my endurance to the breaking point.

After landing on the small airstrip, we boarded a bus which drove us up a steep, narrow, winding road for several hours. We passed through a settlement called Hamburg and I had to point it out to all my crewmates. Resting my head against the bus window, I wondered about the cumulative effects of smoke inhalation and exhaustion after three months of chasing fires.

Friends asked me why I returned to such a demanding, difficult job. The obvious reason was the paychecks paid for college, but it was more than that. Besides the epic adventures, there was a sense of community with other firefighters that I didn't always feel with family. Our imperfect families sometimes

fail us. The night of my prom, for example, I got home eager to show Mom my queen's crown and tell her about my night. Dad was away on a trip and she was in bed, asleep. I gently shook her shoulder almost bursting to share my news. When she opened her eyes, I grinned and pointed to the crown on my head. She mumbled something like *That's nice*. She fell back to sleep.

The joyous moment I'd imagined was gone. I left the room and walked to the kitchen suddenly hungry. Empty beer cans littered the counter. Scanning the fridge for comfort food, I got out a carton of eggs. The fried egg sandwich was hard to swallow with the lump in my throat. The crown on the table seemed to mock me until I got up and put it in my backpack before going to bed.

Looking back, my mom did the best she could. She didn't intend to be emotionally absent, but times like that made me appreciate the community presence of the hotshots. I had considered other jobs, but aside from the outstanding paychecks, I loved to work outside with others as a team. I might even be more comfortable working in smoke and dirt than dressing for a formal social event. By the end of this long summer, however, I would long for a life somewhere between the two extremes.

Arriving at fire camp, a makeshift sign read "Welcome to Happy Camp. Population 4000." There were more firefighters than local residents of the Happy Camp community. These mountains of Northwestern California were known unofficially as the illegal pot-growing capital of the country. Despite jokes about the nature of the smoke, firefighters walking past the bus looked anything but happy.

The blood red sun hung in a smoky brown sky. A camp bulletin board warned the air we breathed was equal to smoking four packs of cigarettes a day. Ironically, it was not uncommon to see firefighters smoking cigarettes; that shot of nicotine being their only solace on a grueling day.

September is cold at night in the mountains. That night, I shivered in my sleeping bag which I had stuffed inside a disposable paper sleeping bag for added warmth. I slept fully clothed with my extra sweatshirt serving as a pillow. The longest, hardest day of the Salmon Forks Fire began the next morning before five. The boss gave us ten minutes to slip on boots and pack our bedding in the dark. We ate the camp kitchen's rubbery scrambled eggs, then waited hours for our assignment and transportation. To stay warm, we clutched Styrofoam cups of coffee and clustered around the heat waves emitted from the smudge pots.

In time, old army trucks arrived, and we loaded into the back and traveled an agonizing 30 mph up a dirt road pocked with potholes. We huddled together for warmth, trying not to be bounced off rickety wood benches. I felt sorry for the old diesel engine as the driver ground the gears, shifting lower and lower as the road got steeper and steeper.

Once the trucks reached the top of the ridge, we unloaded, donned our packs, grabbed our tools, and circled up to hear the boss's instructions. Our assignment was to hike to the bottom of a canyon and construct line along the unburned ridge on the far side. The further we descended, the steeper and more somber our surroundings became. The air was thick with tiny particles of ash suspended in prisms of suffused light.

Even when quiet, a forest is never silent. There's the buzz of insects, or the whisper of a breeze flowing through needles of countless fir and pine. The call of a bird or some sound is ever present. This noiseless canyon was a ghost of the green forest it had been the day before. Like a bomb's blast, the hellish landscape was covered in grey ash and charred remains. Devoid of life and steeped in shadow, its silence was eerie. Our voices rang out unnaturally loud. We rarely spoke.

The treacherous hike took all our concentration. Besides stepping over large, exposed roots and boulders, we crossed pockets of shale where, with each step, we slid several feet in loose rock and ash. We kept watch for "widow-makers" or snags, trees that are mostly burned through and hollow near the base. They often fall silently but hit the ground with a thunderous boom. Even in daylight, they're deadly as they fall without warning. At times, crews can't work at night because of the silent killers.

Deadly Snag

Hours into line construction, the temperature and wind level rose, and the humidity levels fell. At one point that early afternoon, my partner and I hiked back to see if the fire had jumped our line. To our dismay, it had burned right up to the edge and wind-driven sparks had started spot fires beyond. If we didn't extinguish these spots, they'd burn together and start a run past our line.

We scratched quick, temporary lines around each spot while more ignited around us. Our boss, who had hiked up with us, radioed for help. Dripping sweat, my face stung from the heat as I threw shovelfuls of dirt at the base of flames. A spark melted a small hole in the sleeve of my fire-resistant shirt.

"The winds are against us," said our boss. "It's no use. We need to leave.

We scrambled to rejoin our crew at the safety zone. Disheartened by the futility of our efforts, we watched as the green we had tried to save turned orange and then black. We might have quelled the fire with air support, but an inversion layer of thick smoke had grounded the helicopters. Defeated, we trudged to the next ridge to start again. Hiking along, we kept our ears tuned for gunshots. It was the opening of hunting season and according to California's Fish and Game Department, 238,000 hunters would travel into the forest with their rifles while firefighters constructed fireline in many of those same hills.[1]

At one point, we stopped to look at the booby traps our boss had spotted: clear fishing line had been strung from trees across a deer trail. Fishhooks were tied into the line at neck and face level. This was the devious work of local pot growers attempting to detour hikers away from their crop. The forest's dense canopy and remoteness, which made it hard to see from the air, also made it an ideal location for cultivating cannabis. For the rest of the day, we enjoyed creative banter about what we'd hear if firefighters stumbled unawares onto a burning pot field: "Dude! Break out the corn chips, man. I've got the munchies…"

The sun set before we stopped digging line. Hiking to the pickup point just before dark, we waited for our ride in the chilly twilight. Still damp from the day's sweat, I moved in place to stay warm. We boarded the army trucks for the slow drive down the

dusty dirt road back to camp while the pink remains of sunset faded to black.

Upon arriving, we refilled water canteens and the saws' fuel canisters. After a quick face, neck, and arm wash, we stood in line to eat. Minutes after I finished, I crawled into my sleeping bag and switched on my flashlight to record my day. Aching with fatigue, I prayed for strength for the next day's work, no matter how futile. I hoped we'd soon contain the fire. Exhausted, I switched off the light and pressed play on my Walkman, falling asleep to the Dire Straits' songs "So Far Away" and "Brothers in Arms."

When constructing fireline, the diggers at the back determine whether the line will hold. They watch for burnable material like roots, leaves, moss, or layers of dead pine needles. They make sure the line is scraped to mineral soil. Usually, the actual line is only a few feet wide, but trees and brush must be cut and cleared in a five to twenty-five-foot-wide swath, depending on the fuels, winds, and terrain.

The sawyers are the rock stars. At the front of the line, they cut trees and brush to clear the way. Day or night, all they do is cut, sharpen their saws, and cut some more. The strength and stamina required to do this always amazed me. One minute a big tree is standing, and the next, it's lying on the forest floor. Whenever I used a chainsaw, I felt its lethal power and purposely made slow, deliberate cuts.

There's always the danger of trees or branches twisting and falling toward the sawyer. They dread misjudging the tree's lean. If it pinches the saw's bar, they must insert wedges to free it before the tree falls in the wrong direction. Sometimes a skinny tree limb wedges itself between the bar and the saw teeth, snapping the chain off the bar. Then the sawyer must stop and reset the chain, wasting precious time.

A certain knowledge from experience teaches them how to cut irregular trees or trees leaning at weird angles against a steep slope. During long nights when four or five chainsaws cut as fast as they can with only light from the men's headlamps to see by, all manner of things can go wrong. Yet they rarely do. I never saw a chainsaw accident on any of my crews.

Positioned toward the back of the line, I worked to perfect it. Cutting roots was the hardest part. Inevitably, these roots are wrapped or wedged against big rocks. When we "ground-pounders" hit rocks instead of roots, our blades chip and dull, making it harder to cut the next roots. Instead of one swing, it takes three or four. If we're able to stop for a short break, instead of resting, we pull a file from our pack to file out the chips and sharpen the blade. It takes great mental stamina and the capacity to daydream to inch forward with miles yet to dig.

Sometimes the job's greatest challenge is working 24/7 with difficult personalities. A good crew eventually felt like family, with brothers and sisters who teased mercilessly, but also watched out for each other.

Once at a fire, we took a shortcut to reach the flames, using a compass to bushwhack through the forest. We were stopped by a twenty-foot rock cliff blocking our progress. We studied the rock, desperately searching for a climbable route. None of us wanted to backtrack through the brush and boulders.

Our hotshot rock climber navigated a route for us with enough toeholds and handholds that we could all use it. When my turn came, I started out okay, but near the top, I couldn't reach the final handhold. I saw the protruding root other women had used to pull themselves up and reached for it. Grabbing it, I started to climb, but the root gave way and I fell backward.

A crewmember, kneeling at the top, was adjusting something in his pack when he saw me grabbing for the root. The instant I

started to fall, a hand grasped my forearm and pulled me over the top.

"Wow, Hamberger!"

"Yeah! That was close!"

My voice cracked in agreement. My hands shook as I brushed off my scraped knees. I uttered a quick, "Thank you, Jesus!" and heard the crewmember snort.

"Yeah… I'm not Jesus… but you're welcome."

We got in line to continue the hike. I blew the dust off my sunglasses and wiped the lenses with my bandana. Several guys laughed at something someone said, while I gave my shaking legs a shake. I didn't hear the joke. When I asked, no one would repeat it.

After days or weeks working on massive wildfires, the cumulative oppressive fatigue was mind-numbing. I focused on doing the tasks I needed to do. There wasn't enough energy to think about much else. But as we plodded toward the fire, I was thankful for my fellow firefighters and their helping hands.

Coda: The Salmon Forks Fire started on August 31, 1987. It was the result of one of the 11,000 lightning strikes that flashed over the western states at the end of a very dry August. 187 fires were started in the Klamath National Forest. In the first week of September, 1,274 firefighters fought one over 20,000 acres. By the time it was contained in its eighth week, over 8,000 firefighters had constructed 490 miles of fireline around 33 major fires in the Happy Complex, scorching a total of 258,764 acres.

During that time, three firefighters were killed. The fire was also infamous for its extremely heavy smoke that caused lung irritation, respiratory infections, and sore throats among firefighters and those who lived in the region. The Klamath National Forest Supervisor, Robert L. Rice, who had worked 30 years for the Forest Service and fought scores of previous forest fires, stated that he had "never seen

fires of this magnitude."² The Happy Camp Fire Camp actually sold pins calling it the "Fire Siege of '87."³ The Prineville Hotshots worked that fire for several weeks before we were sent home.

Our weary crew was then reassigned to the Silver Fire in Southern Oregon near Grants Pass. It, too, was started by lightning. It would burn from August 31, until November 2 and consume 96,240 acres in the Kalmiopsis Wilderness and Rogue River-Siskiyou National Forest. Oregon's Silver Fire was the largest of more than 550 Oregon fires that year.⁴

Since then, two major lightning fires have reburned this area: The Biscuit Fire became the largest fire in North America in the 2002 fire season and in Oregon's recorded history. It burned half of an entire national forest.⁵ The Fire started in July, was fought by 7,000 fire personnel, burned a half-million acres, and was not declared out until December 31.⁶ In 2017, the lightning-sparked Chetco Bar Fire forced the evacuation of the town of Brookings and other nearby communities. That fire destroyed seven homes, burned 191,000 acres, and was not contained until November 4.⁷

Me, catching 'zzz's after a hard night shift

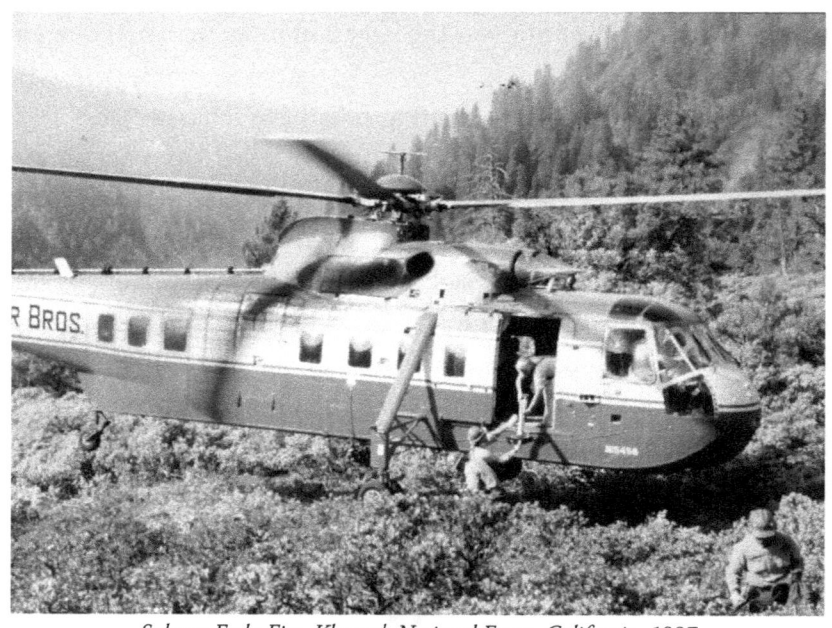

Salmon Forks Fire, Klamath National Forest, California, 1987

Femininity
Chapter 10

On fire crews, I usually wore loose shirts with my frizzy hair pulled back in a ponytail tucked under my hard hat. A co-worker had a name for when one's hat-hair was so dirty and oily it layered itself in chunks— she called it *Onionhead*. On big fires, where we worked for weeks, I longed for hair that didn't smell like smoke and looked okay ... to be feminine again.

On a day of R&R in the middle of a California fire, I rode into town on the shuttle for a haircut and style. Stiff and sore, I walked into a salon looking forward to a few minutes of what my mom called fussing. As a walk-in with no appointment, the only stylist available looked younger than me and wore a sloppy ponytail. *If her own hair looks like this, what will she do to mine?* I checked to see if the other stylists were almost done, but they weren't, and there was no time to wait. Maybe she would pleasantly surprise me.

Pleasant surprises are rare. Years prior, I was pleasantly surprised to come home from school and find that my mom had bought me an expensive new shirt. This white and blue striped polo shirt sported a little alligator sewn above my heart. Back in the '80's, these were cool. Popular kids wore them. It fit well, and I didn't want to take it off, not even when I went out to feed my horse. In a good mood, I jumped onto his back, riding him with only a halter and lead rope.

Hombre seemed in high spirits too, so when I got to the end of the pasture, I opened the gate, and we jogged along the alfalfa fields below Barnes Butte. When we turned back, Hombre picked up his pace and moved into a lovely, smooth lope. Just enjoying the ride, I didn't try to stop him when the canter turned into a gallop. When he stretched out his neck for a full-on run, no way was I stopping that barn-sour horse. I clung to his neck. It was almost fun except that I had no control over what he decided to do next.

As we approached the fence at the end of the field, Hombre showed no signs of stopping. I had to choose: fly over his neck and into the barbed wire when he sat on his haunches to stop, or voluntarily jump from his back for a slightly softer, less bloody landing. I jumped. Launching myself off the racing devil, I slid several feet across the lush alfalfa. When I stood up, the entire front of my new shirt was stained bright green.

I grabbed that lead rope and smacked him hard yelling, "Bad Horse! Rotten Horse!" He looked appropriately chagrined and calmly walked with me back to the barn but there was a mischievous glint in his eye, like he would do it again if given the chance. He wasn't a bad horse. He was an excellent horse. I could do flips off his back, but on that day, I would've sold him for a dollar.

Creeping back into the house, I hoped Mom was out in her garden, but there she sat at the kitchen table visiting with a friend. She took one look at me and my new shirt and slowly shook her head. It was my turn to look chagrined, but I wasn't faking it. I don't recall how many times we scrubbed that shirt to get the green out. I still wore it to school despite its slightly less-cool, stained condition. Some surprises start out pleasant, but don't end that way. The point is, I should have known better than to let the girl with the ratty ponytail cut my hair.

So it was as I settled into my stylist's chair. Tired and quiet, we didn't chat. She observed that my hair smelled like the smoke

outside. That should have been a warning. Thinking it obvious, I failed to point out that I had curly hair with lots of cowlicks. Anyone with curly hair knows if it's cut wrong, the poor recipient has a 70's style 'fro. While she chomped her gum and snipped away, one eye on the TV, I glanced through a *Vogue* magazine. I should have been paying attention, but instead, when I thought no one was looking, I was busy ripping out the pages that had those scratch and sniff perfume samples and shoving them into my pockets.

Before I knew it, she announced she'd finished. I guess she had better things to do than dry my hair. Looking at my new cut in the mirror, I couldn't tell if I liked it as it was still wet. I walked out, chilled by the air-conditioning and my wet hair. Back at fire camp, my hair now dry, I looked in the sideview mirror of a parked rig. Too late, I realized I should have walked out of that salon when I had the chance. Far from looking better, my shorter hair had grown exponentially in fluff and frizz. Sure enough, I saw a few smirks, and then the comments started.

"That's some haircut, Hamberger!"

With a grimace, I grabbed my crew cap, and shoved it down over my fluffy hair. I found the beat-up Louis L'Amour paperback that had been circulating and burrowed into my sleeping bag to rest before our nightshift. For times such as these, reading or listening to my Walkman was the best way to escape. UB40's version of "Red Red Wine" spoke to the longing in my heart, even if I didn't drink wine. Then, oblivious to the constant thrum of helicopters flying overhead and the group of guys noisily playing Hacky Sack behind me, I did some mental traveling to forget about the wasted effort, time, and money of a lousy haircut. While cocooned in my sleeping bag, I remembered the pages I swiped from *Vogue*. I reached into my pocket for a pilfered perfume ad.

Some days, I just needed to smell something sweet and civilized. Something other than eye-watering smoke, acrid armpits, or rotten

feet. On those days, I'd get out one of those perfume samples; Obsession was my favorite. I'd rub that sample on the edge of the sleeping bag next to my face or on the collar of my fire shirt.

It wasn't just perfumed ads I used. At one California staging area, a few crewmates rolled their eyes when I used my knife to cut gardenia blooms from the bushes and put them in an old Coke can beside my sleeping bag. Pretty, their fragrance almost covered the Eau de Nomex wafting through fire camp.

Not all unpleasantness could be covered with perfume and flowers. Later that summer, we had a long, chartered bus ride to get home from a fire. I sat by the window, an empty seat beside me. Almost asleep, I felt someone nudging me. A person with some authority sat down next to me and I thought it odd he chose that seat as we previously had little interaction. I didn't say anything, but closed my eyes again and started to doze when I felt his head rest on my shoulder. *Why didn't he get his own window seat?*

I dozed again. Then I felt his hand inching up the front of my shirt under the sweatshirt I was using as a blanket. I sat motionless with my eyes closed. For a few long minutes, I wondered about the appropriate response. *Could he feel my pounding heart? Do I call him out? If I did, would he treat me badly? Would he find a reason to get me fired?*

Finally, I couldn't pretend to sleep for another second. I stood up with sudden inspiration and announced, "I gotta' pee!" I climbed over his knees to look for another seat. I would stand the rest of the way if I had to, but I wouldn't sit next to him again. As it turned out, the incident ended there, and nothing was ever said.

Another time, an assistant crew boss felt the need to teach the crew a lesson that we would not forget. It was a hot day, and we were training at the station. A group of us went out for lunch and suffered through slow service. We got back to the station five minutes late. A couple guys were still chewing the last bites of their burrito when

this boss met us at the entry steps pointing to his watch with a scowl on his face.

"It's clear that you all need to learn some respect for your time on the clock! Assume the push-up position."

I looked at the others, wondering if he was joking.

"Davis, start the count!"

"Down!" said a reluctant Davis.

Once in position, our arms bent, we straightened in unison and answered with the count:

"ONE!"

"Down!"

"Two!"

We did set after set of twenty push-ups on the scorching hot asphalt. At 19, I did what I was told, but this was unreasonable. I could almost hear the sizzle of burning skin on my hands from the pavement. The sweat stung our eyes. Everyone was breathing hard, some exhaled quiet curses, mumbled just out of his hearing. My arms shook so badly I finally collapsed after 200. A couple of crewmates lost their lunch.

With the torture finally over, we shuffled back into the classroom. Now the whole crew was scowling and from the looks of some of the men, that boss might want to watch his back. Nobody likes being on the short side of a power trip. A coworker looked down at her hands. Big water blisters had formed across her palms.

I hoped for her sake that we would not get a fire call that day. Trying to hold a tool with blisters on your hands is pure agony. Thanks to rowing, I still had thick callouses that protected me, but that night, after swallowing several ibuprofens, I stood in the shower unable to raise my arms. My hair would go unwashed. That day, I didn't like my job.

Yet, the abuse that afternoon spurred me to thinking about my job and plans for the next summer. Remembering the helitack crew

that sometimes flew in and met us at a fire, I doubted that they were ever ordered to do 200 pushups on hot asphalt. They had a life of relative ease compared to the work we did. The growing appeal of working with helicopters was worth exploring and I applied for a job for the next season with the local helitack crew.

I could not have imagined that the following summer would find me working with the first helicopter crew to arrive at what would become the biggest fire in seven decades.

In my flight suit atop Black Butte, near Sisters, OR

Helitack
Chapter 11

JUNE 1988. After two grueling summers as a hotshot, I switched to the breezy work on a helicopter crew … and loved the change in perspective. Prineville's Bureau of Land Management had a Bell 206 Jet Ranger that carried four passengers. We were a crew of five men and me, plus the pilot, fuel truck driver and mechanic. Our mission: fly to remote fires and put them out or act as surveillance and transportation support for ground crews at larger fires. We also transported water in a collapsible water bucket, and moved food and equipment using heavy-duty cargo nets.

We all liked our pilot. In fact, every pilot I met that summer could be fun and funny, but when it came to safety, they got serious. Most pilots contracting with the government were ex-military. Some had even flown in Vietnam. They loved their work and if they took a risk, it was only as a last resort to save lives.

One of my crewmates was less likeable. Every sentence from his mouth had sexual overtones. I began to find reasons to be where he wasn't. My crew partner, Scott, who was also new that summer, was a great worker. Since he could and often did debate with anyone about anything, I thought it was his stubbornness that had earned him the nickname "Bull." The *actual* origin of his nickname came when he walked into the station for the first time. A coworker saw him enter wearing his olive-green jacket with the orange liner, like

Crash Davis from the movie *Bull Durham*. From then on, Scott was dubbed "Bull." I often took deep breaths to refrain from further argument with him, but, looking back, I was most bothered by how much of myself I saw in him. Being opinionated and strong-willed was something we had in common.

The other men on the crew were not typical college kids. They were older, in their thirties and forties, and worked like they had served on helitack crews for years, which they had. Experienced as they were with how things worked with a helicopter, it was Scott and I who usually had to drive to fires in the service truck while the others got to fly.

Arriving at a small local brush fire near Warm Springs, Oregon, on a hot afternoon, we hurried to dig fireline through sagebrush in the sandy desert soil. Wind gusts threatened to blow the fire into a run we couldn't stop. In the nick of time, a BLM engine appeared and doused the flames at the fire's head. Then the hose operator, a friend of Scott's, turned the water on us, saving me from heat stroke. It felt almost as good as plunging into a swimming pool on the hottest day of the year.

Todd Schwartz atop his BLM engine

As Scott introduced us, Todd smiled as if he knew something I didn't. I found myself checking my fly, sure that my zipper was down. It wasn't, but I seemed to amuse him. Todd became a friend who occasionally visited me between fire seasons when I was in school.

On one such visit, my girlfriend and I were about to drive somewhere in heavy rain. Before we left, Todd went to the garage and wiped her car's windshield with a water repellent so we could see better. He did things like that. His touching acts of kindness put him on my short letter list. Years later, he sent me the best gift: a large envelope full of every letter and postcard I had sent him. His brief note said, *Katherine Ann, write a book!*

One of my first, most grisly, flying assignments was to search for the wreckage of a smokejumpers' plane that had crashed in a wilderness area southeast of the Ochoco National Forest. The Twin Otter had been returning to its base in Redmond after delivering a dozen smokejumpers to a fire in Eastern Oregon. We found the wreckage almost hidden in the crevice of a steep slope.

When we landed and approached the scene, my stomach flipped. Dizzy from the sharp odor of spilled fuel and the intensity of the crash, I abruptly sat to collect myself. As horrible as the wreckage was, we were thankful the plane was almost empty. Investigators suggested that the pilot might have suffered a heart attack on his way back to the base, but the cause of death could not be determined.

On the grim flight back to the station, I reconsidered my decision to join helitack. Yet even as I did, I found myself loving the view and the sensation of the rotor reverb cutting through the atmosphere. I didn't think I was afraid of death, or being dead. I believed what the Bible said about there being a new earth after death, where there will be no more death, tears or pain. (Rev.21:4) But the actual dying part is another story. Loretta Lynn sums it up

with her old country song, "Everybody Wants to Go to Heaven (But Nobody Wants to Die)."

Besides fearing intense pain, I imagined that knowing one is about to die is the scariest and worst possible feeling. But that fear and pain could happen driving to the grocery store as easily as from a helicopter crash. Since I loved flying, I chose to take my chances and stay on the flight crew.

In early July of 1988, a fire call came from the Gallatin National Forest in Southwestern Montana. Scott and I thought it strange that a fire so far away would request the help of our small craft. The West was suffering from a combination of the worst drought in fifty years and dry lightning strikes. In Montana, fires had erupted all over the state and all of the available local resources were engaged. They were forced to look outside Montana for help.

In forestry lore, the fire season of the summer of 1988 was remembered as the summer of the fires of Yellowstone. The fires would burn 1.4 million acres in the greater Yellowstone Area. More than 25,000 firefighters would be called to contain the blaze; 77 helicopters would be employed; and it would cost $120 million to fight.[1]

It was epic. At its apex, it blackened the light of the sun with its smoke, turning day into night as it raged. Miraculously, there were no firefighter fatalities, but man was not to win this battle against nature. No matter how hard we tried, nothing but snow would stop this inferno.

By the second week of July, when we arrived, the Storm Creek Fire had already burned south across the Montana border of Yellowstone into Wyoming. Forty-five fires were burning in the park; most of these fires went out naturally. The ones that didn't combined with others, eventually creating eight bigger fire complexes: Fan, Storm Creek, Hellroaring, Clover Mist, Mink Creek, Snake River

Complex, Huck, and North Fork fires. These fires burned 95% of the total burned acreage.[2]

Whether or not to practice fire suppression became a hot topic. There were many facts and opinions both for and against it. Those in favor of fire suppression often pointed to the devastation visited upon humans. These advocates would point to the consequences of the Idaho fire known as The Big Burn of 1910, the same fire that made Ed Pulaski a hero. It scorched 3 million acres… in two days. The fire pushed by hurricane force winds, obliterated five towns, killed 86 people, and cost more than a billion dollars of damage. According to the US Forest Service, "The absolute devastation left not only scars on the land, but also lasting and fervent opinions about how forests and wildfire should be managed."[3]

On the other side of the argument, those in favor of the "let burn" policy point to the need for long term forest conservation and maintenance. Fires have always been a necessary part of a forest's ecosystem. Many plants don't regenerate without fire. For example, lodgepole pines that are the primary tree species of Yellowstone, do not release seeds until their cones have been scorched by fire. Other vegetation that regenerates better after fire include sagebrush, aspen, and willow.[4]

For centuries, Native Americans used fire to clear undergrowth to encourage grass growth and improve hunting grounds. They also used fire to clear travel routes and stop epidemics, both of insects and plant diseases such as mistletoe.[5] Fires clear out layers of dead trees, wood debris, and brush referred to as "fuels" on the forest floor. In early July, the "let burn" policy would continue to be the governing principle for the lightning-caused fires … until it was too late.

What awaited us in the park was a deadly combination of circumstances. The moisture content of the park's vegetation had plummeted. A crowded, drought-stricken forest with layers of dead

wood and brush on the ground is a tinder box, just waiting for dry lightning and wind to explode. That summer dry lightning storms were frequent across the region and the winds were unusually high.

Because the National Park's policy to let it burn was still being honored, our helicopter had been ordered for park officials to observe the scope and growth of the fires with daily reconnaissance flights throughout the park. Daily, through the month of July, tourists took photos from afar and we watched as our treasured national park cleared and cleaned itself as it burned.

Initially, it was lonely work for us. Each day our Jet Ranger lifted off a peaceful meadow, carrying park officials to watch the fires. Scott and I were left to sit and listen to bees buzz, while waiting for our helicopter's return. Often, we'd watch through the orange-tinted light while a small herd of elk and buffalo grazed on the far side of our meadow without concern for the smoke plume looming above them.

Working with the 212 helicopter at Yellowstone National Park, 1988

A week later, as fires grew and burned together, another helitack service truck pulled in next to ours. Rock music blared from their

fancy rig, the crew all brash and lively. They had traveled from Southern California and their helicopter was a big Bell 212, used to transport crews, supplies, and dump a lot of water. Officials had begun to worry about the fires' growth.

By mid-July, the Red Fire joined the Shoshone Fire burning hundreds of acres each day forcing worried park officials to change their policy. On July 21, Yellowstone National Park began to suppress all fires rather than just observe them.[6] They ordered fire crews and more helicopters. After pounding a post into the middle of the meadow and attaching an official-looking windsock, we became what I called Yellowstone National Park's first air-base command center.

Once, I sat in the cab of the 212's service truck, visiting with our new neighbors and the radio operations guy who was their official air-traffic control person. When two or more helicopters are involved, the radio operator is an essential source of safety information and flight logistics. It was tricky to orchestrate the coming and going of numerous helicopters. The ability to multi-task, think fast, talk fast, and organize a situation that keeps changing in a high stress environment is required for radio operations ... or deadly accidents will happen.

After hours passing the time and no action in the sky, the Radio Ops Guy announced that he needed to use the port-a-potty. He handed me the radio mic and told me to cover for him, assuring me that he'd be back before either ship returned. Then he left, despite my misgivings.

Alone in the cab, I frantically looked through the windows for another crewmember, but they had all disappeared, maybe for a nap under the trees at the edge of the meadow.

"Well, this is just great!" I muttered.

I sat, trying to relax, realizing that he was right; it was highly unlikely that either helicopter would return before he did. I leaned

back and closed my eyes, listening to a lone meadowlark sing. Minutes passed. Then I became aware of the faint thwopping of rotors. I looked around for Mr. Radio Ops to no avail. The radio crackled to life and an unfamiliar pilot's voice announced his approach. I looked at the windsock and took a deep breath.

"Copy that, Charlie Foxtrot Hotel Thirty-niner. Winds are out of the northwest at five miles per hour. You are clear to land." I used my most professional voice.

"Thank you, radio control… uh, to whom am I speaking?" The pilot asked.

"This is… Hamberger. Covering for Johnson."

For the hundredth time, I wished I had a cool name like Kate Smith. The pilot chuckled as he turned off his mic. Radio Ops Guy climbed back into the cab and I gave him a dirty look, but he said I did fine. When the helicopter's rotors stopped spinning and all the people and gear had been unloaded, the pilot strode to the cab of the service truck.

"I wanna' meet the owner of that sweet voice!" He winked at me.

"Kate Hamberger-with-an-E, at your service." I smiled.

Extending my hand out the window to shake his, he grinned and shook my hand. I had expected a Vietnam vet, but this guy was in his thirties. He had an athletic build, blonde hair, and green eyes. He was good-looking and knew it.

"Well, Hamberger, you can be my radio ops any time you like!"

With that he turned and made his way to the fuel truck while Radio Ops Guy laughed.

"Welcome to the world of pilots!" he said.

I sighed, wistfully scanning the horizon.

"I happen to love pilots." Unwilling to share more, I exited the cab.

After weeks of fighting the expanding fires, several tired looking crews milled about the helibase waiting to be shuttled to their next

line assignment. At least sixty people sat or stood listening for helicopters to return for another load. Between shuttles, we chatted with crews about their experiences on the fire. I noticed one man sitting on a cargo box, slightly slumped and looking uncomfortable. Heavyset, he had a sheen of sweat on his red face and his breathing seemed labored. It was still morning and not yet hot. *It couldn't be heat-exhaustion. Was he suffering from high blood pressure?* I used to watch my mom take blood pressure readings. She even allowed me to do it once, maybe thinking I would follow in her footsteps one day.

When I was about ten years old, I would ride my bike to the nursing home on Saturdays to watch my mom work and have lunch with her and the people who lived there. That's when I watched my mom in her white nurse's uniform taking a blood pressure reading from one of the residents. Sometimes I put my big, brown rabbit in an old diaper bag and carried him with me. Most of the residents brightened when they saw Bunny, especially Cleo, who had what I understood to be old-timer's disease. Bunny sat contentedly on her lap as she stroked his velvety ears and told me that rabbits were her favorite pet as a girl. Bunny made a lot of people feel better. I know he had that effect on me.

Peering closely at the man with the red face, I asked him if he was feeling okay. He gave a noncommittal grunt in response. Remembering there was a blood pressure kit in the service truck, I impulsively asked him if I could take his blood pressure. I went to retrieve the cuff. That's when it occurred to me that I had next to no experience taking blood pressure readings. Frantically searching for directions in the box, I felt my own blood pressure rising. *Maybe I should defer to a medical professional.* Even if I did take an accurate reading, I didn't remember what the numbers meant. Just then a helitack crew guy walked by and I grabbed his arm.

"Hey, do you know how to take a blood pressure reading?"

"Nope." He smiled, shook his head and kept walking.

Shoot.

I cast a furtive glance at the man who now had a small audience standing around him. Unable to think of a way out of my predicament, I determined to make the best of it and approached him with a confident smile to ask him to roll up the sleeve of his fire shirt.

Now a sheen of sweat shone on my own red face as I started pumping the bulb. I had the stethoscope in my ears and watched the dial, listening for the first heartbeat and then the last as I slowly let out the air. I ceremoniously took the stethoscope out of my ears and announced the reading as I ripped the Velcro and pulled the cuff off his arm. Seeing the expectant look on his face, I smiled.

"You're gonna be fine. Don't forget to drink water!"

His face lit up with relief. Striding over to a group of his friends while unrolling his sleeve, I heard him yell, "Mira, hombres! La mujer sabe como leer la presion arterial."

They listened to him, looked at me and slapped their buddy on the back. I smiled, relieved to take the cuff back to the service truck, but another man blocked my way. Before I knew it, he had thrust his arm into the cuff.

"Check mine too, please."

As I took the second man's blood pressure, I prayed that the helicopters would hurry because a line was forming behind him. Meanwhile, the other helitackers relaxed in the shade of the truck watching this charade with glee. To my immense relief, the sound of rotors approached. My nursing days were over.

Sometimes I astounded myself with my own stupidity. On the other hand, as we loaded the crew into the ships, the men smiled and waved as if we were old friends and I saw a new levity in their countenance. A long way from home, these crews worked for weeks in the wilderness and missed their families. We all did. My simple act of caring was maybe just the touch they needed.

But it would be days before I stopped hearing:
"Hey! Nurse Lady! Will you take my blood pressure?"

To my disgust, two of the men on my crew often sat in the backseat of the service truck looking at Playboy magazines while waiting for our ship's return.

"I don't want to be here with you and your magazines so I'm gonna' work with the 212 crew!" I announced. I grabbed my gear and stormed off across the meadow, wondering what Miss July would do if faced with a forest fire. Scott walked with me attempting to calm me down.

"They're just bored. They see it as harmless entertainment," Scott said.

"Really? It's not harmless. I noticed that you aren't enjoying their reading material."

"No, maybe I have a little more self-control in that department."

"I'm pretty sure if the boss flew in, they'd miraculously develop self-control real fast."

Our boss had been assigned to a fire in Alaska when we were called to Yellowstone. In fact, we didn't see him for most of the summer. If he had been with us, Shane's choice of reading material would've been different. I regret that I didn't report Shane. A misplaced sense of loyalty had developed while working with the hotshots that kept me from complaining. I didn't understand then that I could've and should've made the working environment better for the next woman who joined that helitack crew.

I left the guys with the "girlie magazines," as they called them, to join the 212's camp. There was always something to do on the 212 crew. Jackie was the only woman on their crew, and we worked well together. We were both twenty, both from Oregon, and her friendly, easy-going manner made her fun to be around. She commiserated on being two women among all the men. For grins, we shared our pet peeves about masculine mannerisms.

"I hate how they blow their nose by covering one nostril with their finger to blow snot out the other side," I said.

She would laugh, nod and say, "I hate how they scratch their crotches as if no one else can see."

Of course, we had our own obnoxious quirks. None are worth mentioning, but there were plenty of men around to point them out. Despite the peeves, we liked the men we worked with and loved our job. Every day we flew over beautiful Yellowstone. Once I asked the pilot if he would tilt the helicopter when we flew over the Grand Prismatic Spring, the largest hot spring in the US. I wanted to take a picture directly above it. We flew with the door open and I sat on the end of the bench. With such a stunning view, after a few shots, I put the camera down to appreciate the moment, certain that I was the luckiest girl in the world with this job. *How many hues of blue, green, gold, and red can a geyser have?* Nature's artwork continually fascinated me.

One morning, I borrowed a bike and peddled down a deserted trail which crossed from geyser to geyser. When I stopped to watch one erupt, I heard a male voice behind me say "Don't move."

I turned to see a man snapping photos using a fancy camera with a huge lens. A photographer for *Sunset* magazine asked me to stand there to provide scale, otherwise it was hard to show the imposing size of the geyser. I stood for a minute, and we chatted briefly before parting ways. *Interesting job, working for a magazine. Writing stories… maybe I should look into that.* My interest in his job seemed to confirm that I'd made the right decision to apply to the University of Oregon.

By the second week of August, all the fires in the park were accelerating. Some made runs toward towns that bordered the park. Silver Gate and Cooke City were literally in the line of fire. In fact, at one point, residents of these small towns were on high alert with

orders to evacuate as it burned to residents' backyards. Someone added a "d" to the town's entry sign: "Cooked City."

Officials ordered even more fire crews. The National Guard and even the Marines came to help construct fireline. Our meadow helibase now had over a dozen helicopters; there were several other helibases around the park that had just as many. When we weren't shuttling crews, we loaded food, tools, and other supplies into big nets to fly supplies to crews working in remote wilderness areas. When these nets reached the maximum weight, we drew the net together for a hover hook-up.

Always a bit breathless and shaky after a hover hook-up, I did enough of them that summer to get used to it. I buttoned my fire shirt to the collar, shoved my ear plugs in as far as they'd go, snapped on the big aviation goggles, and secured my hard hat with the chin strap. Wearing thick leather gloves helped for this maneuver. That and trust in the pilots.

Holding the metal ring of the cargo nets

Attaching the ring to the helicopter's hook

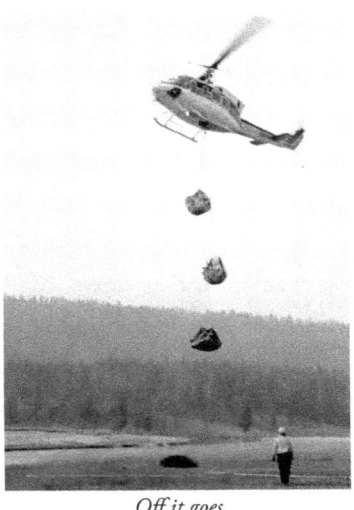

Off it goes

I'd stand next to the cargo nets with my arm extended toward the sky, bracing myself against the dusty wind. Holding the big metal ring high above my head, I'd duck my chin against the dusty wind as the pilot swooped low over me so I could slip the steel ring over the metal hook on the belly of the ship. The rhythmic beat of the rotors vibrated through me while a violent gust pulled at my clothes. Sometimes the helicopter experienced a sudden downdraft, causing an unpleasant konk on the head, but that only happened once or twice.

Once hooked, I crouched and ran out from under the ship to avoid getting knocked down by the net's gear as the pilot lifted his load. What we all dreaded was the occasional shock from the hook's electric catch and static electricity from the dry air, but wearing the leather gloves, my arm only ached for a few minutes if I got shocked.

Another important part of our job was filling out load calculations for the flights. For every shuttle, we calculated the math to ensure that the pilot was not overloaded and that he had enough fuel to return. We kept track of how much fuel each helicopter had, the distance it needed to travel, the elevation, and the current wind speed and direction. Plugging all these factors into the equations, we'd know the weight allowance for each flight. We approached every crew boss for his flight manifest that showed each person's weight and the weights of their tool bundles. Surprisingly, I enjoyed this work and wondered why I had such a hard time with chemistry equations....

While some helitackers did the load calcs, others did safety inspections and reviews. We moved dozens of crews. Many of the fire crews were not hotshots and did not have previous training on helicopter travel. Sometimes I would be the one to instruct them on proper loading and unloading procedures, making sure they all had eye protection, ear protection, sleeves rolled down, gloves on, chin straps fastened, and seatbelts buckled. Sometimes I was the one to

inspect and load their tool bundles and other equipment to make sure they were secure. A sawyer's fuel canisters rolling around near the ship's engine for example, could be a disaster.

About the time we finished our morning crew shuttle, big red and white Columbia Chinook helicopters would begin their massive bucket drops. We had two of these giants stationed in our meadow. These ships could carry an entire 20-person crew of firefighters with all their gear. Each water bucket held 2,000 gallons, or eight tons of water to dump on strategic spots where ground crews needed extra help with flare ups. Meanwhile, we gathered gallons of drinking water, food, and work supplies to fly to crews spiked out on the fire's farthest points.

On the endless days when flights were grounded by thick smoke, reading was about the only thing we could do until the "No Fly" ban lifted. Our helibase enjoyed a public library, which was a communal cardboard box holding a dozen donated paperbacks. Books were the lifelines out of boredom. Browsing through the box, the only title that looked remotely interesting was James Clavell's *Shogun: Novel of Japan*. With limited choices, I lifted the hefty tome. It would suffice for the rest of the summer. I found the ancient secrets of the Japanese culture fascinating. The story transported me in a way that helicopters could not.

Saturday, August 20th dawned with strong morning winds. They howled across the park at 70 mph, knocking over drought-weakened trees that acted as blowtorches sending sparks and firebrands a mile or more ahead of the main fire. Too often they jumped roads and firelines. In some places, crew bosses ordered firefighters back to safety zones to avoid getting trapped between the main fire and a spot fire. The incessant wind pushed fire across more than 150,000 acres in a single day. All firefighters could safely do was stay out of the fire's way. That day lived on in many firefighters' memories as

Black Saturday, as they witnessed fire behavior hit a new level of extreme.[7]

Thick smoke grounded our helicopters that day as we sat helplessly watching the enormous plumes of smoke reach to the heavens like clouds of an atomic bomb and wondered whether anything would survive. Over the next two weeks, the fires would range so far out of control that we realized only nature could beat the firestorm consuming Yellowstone National Park.

Would there be a park left to save?

We could only hope… and pray for rain.

*Firefighters spraying water on Old Faithful Inn.
Image taken by Jeff Henry, 1988*

Old Faithful
Chapter 12

Several days after Black Saturday, a remote fire became especially erratic. Responding to the call, two of us flew to a spike camp to move that crew to a safer fire assignment. At the edge of a meadow, we had already shuttled three loads of firefighters with one remaining as the fire continued to get closer.

Black smoke swirled above us as the 212 lowered for the last group. Loaded with men and their tools, the helicopter had reached its maximum weight limit. My crewmate and I would have to stay and wait for the pilot's return. I looked at the bare, flat meadow and knew we were safe if we stayed where we were. No matter how hot the fire got, there was nothing to burn in the middle of that dried-out patch of earth. However, we might have to wait until morning to get a ride back to the helibase.

The pilot looked concerned at the fire behavior around us, unsure if he could return before dark or before the smoke made visibility impossible. I was more worried about the wildlife that might creep out after dark. A shovel was no weapon against a grizzly bear, a mountain lion, or a pack of wolves. Before he flew away, I had a request.

"Can you please get us outta' here before dark?"

With a sideways grin, the pilot simply waved goodbye. Then they were gone. And we were alone. It was some fire show that

evening. From a distance of about 30 yards, we watched the roaring wall of flame surround the west side of the meadow and burn its edge. It consumed all the surrounding skinny lodge pole pine trees that had dead moss hanging off their branches. Hissing and whistling as thick smoke mushroomed into the sky, acre after acre of forest: here one minute, gone the next.

As the sun sank over the western horizon, my anxiety rose, worrying about what midnight looked like in remote wilderness. I had heard hotshots talk about bears visiting their spike camps at night. *What's scarier, wildfire or grizzly bears?* That night, the answer was grizzly bears.

My partner on this mission was not a talker, so we sat in silence and waited. Quiet settled over the meadow. Blackened trees loomed like specters in the smoky twilight. The stillness was eerie. We watched as the dusky colors faded from the sky, and strained to hear helicopter rotors signaling the return of our ride.

Finally, unable to stand the suspense, I got up and nervously foraged for charred wood to build a bonfire. That's when I heard the whop of rotors. Dropping the charred wood in my arms, I ran for my gear. *Thank God!*

The helicopter barely touched ground. We jumped in and it was off again. We had no time to spare. These helicopters were not equipped with night-flying instruments. We had to be on the ground before dark. I patted the pilot on the shoulder in thanks, grateful that he had come back for us. He asked us to stay alert and help him keep watch as other helicopters were also returning from a last load to the helibase.

Scanning the horizon, I spotted a black Chinook to our left. A 212 flew on our right, and there was a small craft below us. Rush hour in Yellowstone. I asked our pilot if the other aircraft could see us. He clenched his jaw and said that he hoped so.

We landed back in our helibase meadow just as the service truck headlights blinked on. We were grateful to return to our crews and call it a day. With extra firefighters assigned to the fires, we had more support work to do each day, sending and collecting supplies and shuttling crews.

By August 27, far from being contained, the fire was growing larger and more uncontrolled by the day. Park officials made the unprecedented decision to close all interior Yellowstone roads to tourists. With many of the thousands of Yellowstone's firefighters suffering from exhaustion, active-duty forces from the U.S. Army were brought in and the National Guard was called up to relieve some of the burden.

Our helitack team was one of many tapped to support the National Guard who were using the military's black Chinook helicopters. Because of their size, I could load an entire twenty-person crew in one craft instead of having to take three or four loads. The Chinooks have a rotor reach that's low enough in the front to take a person's head off, if one were foolish enough to walk in front of them.

With that in mind, while instructing the crew on loading procedures, I emphasized that no one should walk past the loading door. As the crew loaded, I glanced over at a tall man who had walked past me with his camera in hand. I yelled, but my voice was useless against the rotor noise. Running after him, I yanked on his camera arm and pointed back to the loading ramp. The guy looked toward the pilot who motioned furiously for him to go back. Reluctantly, he gave up his photo opportunity in favor of keeping his head.

That evening, as I recounted the story to helitackers, one of the younger fuel truck drivers put his arm around me and suggested that I needed a night out on the town. Would I go out to dinner with him? I struggled to discern if he was joking.

"Ha! What town? There are no towns around here!" I said.

"How 'bout the Lodge?"

"What? You mean the Old Faithful lodge?" I asked, surprised. "Hadn't it been evacuated?

"Yeah. We can still eat there. They're serving to firefighters."

Now intrigued, I played along, knowing that the Lodge was miles away.

"Right. You're gonna' talk a pilot into flying us there for a sandwich?"

"No, I've got my own wheels!" he grinned, turned and pointed.

Now I was smiling as I looked past him at the semi-truck-sized fuel truck.

"We're going to drive to dinner in that diesel tanker? …Okay." I couldn't even be coy. It sounded fun.

Dressing up in the only non-Nomex clothes I had—old Levi's and a not-too-dirty t-shirt, I climbed up the ten feet to reach the cab. Inside, two tall gear sticks and an enormous steering wheel dwarfed my date as we barreled down the highway to the lodge. Since I hadn't seen the famous Old Faithful Geyser yet or the historic inn, this was going to be a dinner date to remember.

The big parking lot was mostly empty now that the tourists had been evacuated. When fires weren't burning toward the lodge, the park gets crowded with an average of more than a million tourists each summer. That night was way different. Alongside a handful of other fire personnel, we watched Old Faithful erupt, spewing steam and super-hot water 100 feet into the air. I was again overwhelmed by the power and beauty of nature.

As we entered the majestic, rustic lodge, it felt like we'd stepped back in time. Made of huge, milled planks and log framing, the building itself is massive; nearly 700 feet long and parts of it are seven stories high. A plaque on the wall said it was built in 1904. I admired the network of log trusses and the enormous stone

fireplace that stands 85 feet tall, built with 500 tons of rock from a local quarry. A 29-year-old architect named Robert Reamer, built this Yellowstone Park inn to be one of the largest log lodges in the world.[1]

Our conservation-minded presidents, including Abraham Lincoln, who passed a law to protect the Yosemite Valley, and Teddy Roosevelt, who created five national parks as well as several preservation laws, surely would have enjoyed sitting by the fireplace in the over-stuffed leather chairs. Seeing the lodge for the first time, I had a greater appreciation for President Ulysses S. Grant, who made protection of the Yellowstone lands into law in 1872. Forty-four years after that, President Woodrow Wilson created the National Park Service in 1916.[2]

Eight decades after the lodge's doors opened for the first time, we walked into its restaurant. I was surprised to see several pilots already sitting at a table waiting for their dinner. They, too, had driven to the lodge in one of the fuel trucks for a break from the starchy fire camp food. My date and I sat at a table near enough to listen and laugh at some of their flying stories. The night was a wonderful, surreal escape from the intense operations at the helibase and the surging fires nearby.

Only days later, on September 7, scores of firefighters would be called upon in a desperate fight against a firestorm to keep this historic monument from burning to the ground.

The day before that firestorm, I found myself stuck in the town of West Yellowstone on a mandatory day of R&R. Standing in the doorway of the local laundromat biting my thumbnail, I watched a wall of smoke and flame from the North Fork Fire backing toward town. There wasn't much wind, but if it increased or changed direction, the town would have to evacuate. I wondered what I would do if that were to happen. I had no car and no connections. *Would I have to hitchhike? Climb into a scared stranger's loaded truck?*

Maybe I could bum a ride to the nearby Hebgen Lake and go for a really long swim. . .

Local residents and tourists stood together in parking lots or on sidewalks, all eyes on the glowing hills. Bulldozers cleared a double-wide fireline around the town and helicopters flew back and forth with their buckets dumping water on the approaching line of fire.

Walking toward the town's tourist office, I stopped at an outdoor information station that described the government's plan of fire suppression. People milled about looking at the bulletin boards showing the fire's timeline and progression. Folding tables displayed tools and equipment used to construct fireline. I must have looked like a tourist in my shorts and tank-top because a heavy-set middle-aged government official wearing a clean, bright yellow fire shirt approached as I watched the fire easing toward us.

"Don't worry, ma'am," he smiled reassuringly, "Our crews of firefighters are top-notch!"

"Is that right?" I smiled.

But I did worry. I wasn't sure I should sleep that night. Despite the more than 10 million gallons of water helicopters had dropped on the Yellowstone fires, despite 1.4 million gallons of retardant the planes had dropped,[3] and despite the 665 miles of hand-cut fireline,[4] the fires were not slowing. In fact, after two months of enormous and aggressive attempts at fire suppression, some fires grew bigger every day. At this point, firefighters shared black humor amongst themselves with jokes like, "What's black on both sides and brown in the middle? A bulldozer line in Yellowstone!"[5]

Some bystanders covered their ears against the noise as a giant military C-130 air tanker flew low and slow over the town. It dropped a thousand gallons of red liquid retardant along the front line of flames.

Top-notch or not, we were losing this battle.

On September 7, as wind-fueled flames devoured mile after mile of forest in a fury headed straight for the Old Faithful Inn, I wondered at the coincidence of my mandatory days off in relative safety at my hotel in West Yellowstone. Officials closed the entire park for a day to all non-emergency personnel for the first time in history.

Hoping to save the lodge, firefighters rushed to install a sprinkler system on its massive cedar shake roof, while a dozen engine crews bravely stayed to spray foam and water on the exterior of the lodge and nearby cabins. The approaching black smoke darkened the sky.

This firestorm eclipsed the sun and created its own weather system. Roaring wind forced firefighters to stop work in the afternoon to evacuate in total darkness. Filmmakers shooting footage traveled with one of the last engine crews to flee. They captured the haunting scene in their documentary called *Yellowstone Aflame*.[6]

By some miracle, the heat and flames of the fire's front did not penetrate the protective layer of foam and water that covered the inn. Instead, the fire blew past it and into the forest beyond. The sprinkler system and the overall soaking with water and fire-retardant chemicals had saved the day ... and the iconic Old Faithful Inn. Saving it was a great triumph in a system of fires and firefighting that had seen few successes. And it signaled the apex of the fire.

September 8th marked the last of the raging, unpredictable fire behavior. Though few of us knew it, the end was finally near. On September 9th, the clouds rolled in. Temperatures dropped. Humidity rose. A few days later, on September 11, it snowed. The fire had finally met its match. Sadly, on October 11, when the Clover-Mist Fire was mostly out, a Wyoming firefighter, Edward L. Hutton, age 25, was struck and killed by a falling snag.

Only the miracle of nature could have stopped the fires of Yellowstone that year. Man could not. By mid-November, all the fires in Yellowstone were declared out.

Given the massive amount of acreage burned and the doomsday negative news reports, one might think the entire Yellowstone Park had been destroyed. To listen to some national news accounts, it was. But despite over a million acres of Yellowstone National Park being burned, that huge number represented only thirty-six percent of the park.[7] The burn's mosaic pattern left large pockets of green around the burned areas.

For all the intensity and volume of forest consumed by the fires, the majority of the vast wilderness of Yellowstone National Park was unscathed. Scientists would share the good news: surveys revealed that "less than one percent of soils were heated enough to burn belowground plant seeds and roots."[8] Those areas that did burn have grown back substantially, having benefited from the thinning and clearing of the dense forest and brush.

September is the best time to camp in Yellowstone. One awakens to the sound of the elk bugling and the ancient, haunting sounds of the buffalo mating calls. After the snow, firefighters took back control of the fire and many crews were sent home. Before it was my time to go, I stepped out of my tent each morning to see a sweet-scented layer of mist rising over wildlife feeding in the meadow between parked helicopters. For the first time, it was cold. Almost overnight, fall had arrived. I pulled my brush jacket out of my red bag and wore it over my sweatshirt and counted the days before I could leave for school.

Shuttling crews back to the helibase one day, I asked some of the weary-looking hotshots what conditions were like at their spike camps, feeling a sense of relief that I hadn't been a hotshot that summer. Thinking of my cozy tent and warm jacket, I knew that

they had packed only thin sleeping bags. From past experience, I knew how cold they could be at night. I asked them why they hadn't packed thicker sleeping bags.

"Believe it or not, it's not cold," one of them offered. "You just gotta' find a hotspot."

"Okay," I said, puzzled. "I'll take the bait…what's a hotspot?"

"Look for a spot on the forest floor where nothing grows—just a bare patch of dirt. That's where thermal heat rises from the underground volcano. If you lay down on a hotspot, it's like sleeping on an electric blanket. You'll have to turn over often to keep from getting too warm!"

I looked at their faces for hints of joking.

"You're full of… baloney."

"Swear to God! If you don't believe us, ask someone else!"

So I did. I asked at least three other parties and they all confirmed that there are indeed hotspots on the forest floor in Yellowstone National Park. Which might be the coolest thing ever.

One morning of my last week with the helitack crew, I met the superintendent of the Horseshoe Meadows Hotshots out of Central California. I didn't know it then, but Ben Charley was a living legend. Talk about Old Faithful. The year that I met him he was sixty-one. Only the slightest crick in a few of his arthritic fingers revealed his age. Good genes, love for the firefight, and serious dedication to his crew were the primary explanations for his ability to keep up with his twenty and thirty-year old counterparts.

In 1974, he began recruiting local Native Americans to work for the Forest Service. He himself was a member of the local Mono Indian tribe. In 1980, his crew was promoted to hotshot status and he led them for a total of fifteen years. He told crazy stories of fire experiences from all over the country, but Alaska was the last frontier his crew had yet to work. He was certain the following year they'd be called north. He assured me that "you haven't experienced

the full spectrum of wildland firefighting until you've fought fire in Alaska!"

"It's a whole different ballgame!" He said, smiling.

While we waited for his crew's shuttle, I listened rapt to his stories. Before I knew it, he was recruiting me to join his crew for the following year. It would be his final summer before retirement. It was also my plan to fight fire for one more summer. *How cool it would be to finish my fire summers with stories from wild Alaska!* Without thinking it through, I promised Ben that I'd apply to join his crew for our final fire season.

I had no idea the trouble that promise would bring.

Cover Girl
Chapter 13

September 1988. My application to transfer to the University of Oregon had been accepted. I registered for classes related to journalism and other liberal arts studies and moved to Eugene. Finding decent housing in Eugene near the campus of University of Oregon just days before school started was near impossible. The only rentable room left was in a quad, which is four studio apartments connected by a communal kitchen and shower. I would have to share this third-story quad with three guys I didn't know. It wasn't an ideal living arrangement: while frying myself an egg for breakfast, half-naked men from the adjoining rooms walked back and forth to the shower. I made a mental note to look for housing sooner for the next school year.

Shortly after moving in, I was reading in my room when I heard two of my neighbors enter the kitchen and start talking.

"Hey, a girl moved into the empty quad. She's been doing some of the dishes."

I put my book down to listen to their conversation through thin walls.

"Oh, yeah? Is she cute?"

I stopped breathing. I really wanted to hear if I was cute. There was the longest pause with the pop of a soda can opening. Maybe they were peering into the refrigerator trying to decide what kind of

sandwich to make. They weren't in a hurry. Finally, the runner from Red Bluff gave his answer.

"She's okay," he said.

Then I heard the rustle of what sounded like a bag of potato chips opening. After small talk about their schedules, they returned to their rooms and closed their doors. I breathed again and smiled. I was good with okay. If I put some effort into it, I might be more than 'okay.' That was good enough for me.

Because of my summer in Yellowstone, where I had to meet and interact with so many people, I had lost a lot of my shyness and became more at ease with people. This resulted in some life-long friendships that never would've happened if I hadn't initiated a conversation.

As I waited for my first class to begin, I was seated in the second row. As a transfer student, I noticed a different feel to the Eugene campus. Students here seemed to drink more coffee and were more vocal (maybe more caffeinated) about their opinions than students at Oregon State University. I doodled flowers on my yellow Pee-Chee while listening to nearby conversations. Two piqued my interest.

A thin, exotic-looking man in front of me spoke with great enthusiasm in a beautiful foreign accent to the person beside him. He smiled and laughed often as he spoke with perfect white teeth that stood out against his black skin. There was something magnetic about his manner and I liked him even before I knew him.

Meanwhile, a woman in the row behind me also talked with great energy and enthusiasm. I kept hearing words like, "fire," "hotshot," "blisters," and had to turn to look.

"Hey, are you a hotshot?" I asked.

"Yeah, out of La Grande."

"Wow! So am I. Let's talk after class."

Just then, one of the professors walked in to welcome us to our first day of class. She flicked her long black hair behind her, looked around at all of us, and among other things, announced that writing was like sweating blood. Looking back, I realize she was joking, but at the time, I wondered if I was in the wrong place again.

After class, I caught up with the man with the lilting voice and big smile.

"Excuse me, but… are you from Africa?" So politically incorrect.

"Yes, indeed," he said, "From the Maasai lands of Kenya. Where are you from?"

His smile was contagious. We shook hands.

"I'm from around here, but my favorite movie is *Out of Africa*."

Then the hotshot approached, and introductions went around again. They became friends that I still enjoy decades later.

At this point, my third year into college, I was ready to be done. No more sports, just get the classes and get out. However, my self-imposed solitary regiment meant that sometimes I missed the companionship and camaraderie of being on a team. In time, loneliness set in. One day in literature class, I struck up a conversation with the person sitting next to me. Laila was from Karachi, Pakistan. She might have been lonely too because after class she invited me to her apartment for tea.

Her room looked a lot different than mine. Ornate wool rugs covered the floor and rich tapestries hung on her walls. In the living room of her spacious apartment, our eyes both rested on a mounted antelope head with its horns spiraling toward the ceiling. She shared the apartment with her brother who loved to hunt.

When I complimented her on the rugs, she offered me one. I didn't think it was right to accept such a valuable gift when we barely knew each other, but she insisted. She said she was moving home soon and didn't want to carry them back with her. I joked

about how she sounded like royalty, and she admitted that at her home in Pakistan, people served her when she wanted something. Weary of the cold rain, at the moment, she wanted sunshine and at least a thirty-degree increase in temperature.

She shivered as she walked with me back to my bike. After witnessing the effects of drought and heat, I told her I didn't mind the rain as long as my bike had fenders. She laughed and said I was funny. After I straddled my bike, she handed me the rolled-up rug. I pedaled back to my apartment with the rug tucked under my arm. I pictured her wearing fire boots, standing in ashes with her soft, delicate hands and long, perfect fingernails trying to grasp and swing a Pulaski. *Who's funny now?*

Laila may have had servants in Pakistan, but in Eugene she cleaned house for two busy university professors who had three young boys. Before she left for Karachi, she offered me her job. Since money was tight, I was willing to try it.

Every Thursday, I pedaled up a steep hill to clean the two-story house. As the homeowners and I became friends, I made the mistake of mentioning that my mom baked the best pies. The wife immediately took me off cleaning duty for the rest of the day to bake a pie instead. I protested, assuring her that I did not know how to make my mom's flaky crusts, but she was adamant and helped me put on her apron.

When she left to run an errand, I called home. Mom said it wasn't a secret. Was there a Betty Crocker cookbook somewhere? While I checked all the cupboards and drawers, she said the water out of the tap needed to be cold. It's important, she said, to dribble the water into the flour mixture while stirring with a fork, handling the dough as little as possible.

The next hours stand out in my memory as the frustration level rose to a tearful crescendo as I tried to recreate my mother's masterpiece piecrusts. First the dough was too dry. It wouldn't roll

without crumbling apart. The next was too wet, the next too stiff, and then too sticky. I threw away batch after batch of dough. By the fifth attempt, I just settled with what I had. I left their house that evening with some small satisfaction knowing that their family came home to the delightful fragrance of an apple pie baking in the oven. Flaky crust or not, one can't improve on the aroma of baking apples, sugar, and cinnamon.

Cindy, my fellow hotshot, was dark-haired, dark-eyed with roughly the same build as me. People often asked if we were sisters when together. She was from the small timber and ranch town of Lakeview, Oregon. She also grew up riding horses and running on the cross-country team.

L to R: Hotshots. Cindy Israel and me *L to R: Ole-Ronkei and me*

When we moved into an apartment together the following year, we looked around the main room to think how we could decorate to make it look like a couple of firefighters lived there. We felt clever and crafty when we burned the edges of our posters one night while we listened to "Hotel California" from her Eagles record. I admired her self-discipline. She worked out hard every day and woke up while it was still dark to read her Bible. I'd see the light go on in her room and fall back to sleep for another hour.

I learned that my Kenyan friend, Morompi Ole-Ronkei, is the first-born son of a traditional Maasai Laibon, which is the spiritual, political and medicinal leader of his tribe. It's a position my friend would inherit. With a ready laugh and a mellow manner, he attracted people, especially other international students. He showed a genuine love for people and had more friends than anyone I knew. He could poke fun at Americans without insult.

Once we met for lunch at a café near campus and as the cups of coffee and glasses of water came, he wrapped his homemade scarf more securely around his skinny neck.

"Why is it that Americans need ice in their water in January?"

Good question. I replied that unlike him, most Americans have more than a zero percent body fat keeping them warm. When the waitress asked if he wanted soup or salad, he was emphatic that "Salad is for rabbits." He told me that in Kenya, they eat beef and drink a lot of milk. The Maasai are in the cattle business. He defied American dietary guidelines yet remained lean and thin. When he made Kenyan tea for his party guests, he boiled whole milk, not water, making it the richest tea I've ever tasted.

Once, after a long day of studying, he suggested that we go for a jog. I agreed, but at the last minute, grabbed my bike to ride beside him, instead. As he ran and talked, I could only breathe and pedal. I rode along at a good pace to keep up with him. Then we hit the hills. He would run to the top, then run in place while I caught up. That "jog" was a 20-mile loop. I watched him run effortlessly, mile after mile, while I pedaled, barely keeping up with him. I was no slouch on a bike; he was flat-out fast on a slow day.

"WHY…" I yelled as I pumped up a hill out of breath,"…ARE YOU NOT ON THE TRACK TEAM?"

"PRIORITIES!" He yelled back, flashing his bright smile.

He must've known that he could win races on the record holding UO track team, but his mission was to help his people. He

understood the need to sacrifice good things in order to achieve great things. His master's thesis involved comparing and contrasting the US government's land grab from Native Americans with the Kenyan government's treatment against the Maasai.

The story of how he began his journey to the US started when he was introduced to a medical doctor from the University of Southern California. For a month, Ole-Ronkei was asked to guide this heart specialist around his home in the Maasai Mara, one of the largest conservation and wilderness areas in Africa. The doctor was conducting preliminary research into the Maasai diet and lifestyle as there was a curious absence of heart disease among the tribe. As they became friends, the doctor recognized Ole-Ronkei's passion and potential, and assisted him in obtaining his student papers, which allowed him to attend college in the US.

Ole-Ronkei would say it was God who directed him to the doctor. Having a love for people and determination despite the challenges he faced, he was the version of a Christian that I wanted to be. In fact, it was while sitting next to him at a church in Eugene one Sunday that I stepped forward to be baptized. I hoped the gesture would inspire me to be more public about my faith.

We worked on a small project together that we dubbed "Operation Education," with the goal of encouraging annual sponsorship of Maasai girls to allow them to attend school. He would continue to spend the next decades pursuing opportunities for quality education for boys and girls alike.

The last thing I learned from him before I left for another fire crew was the Swahili words for goodbye which imply that separation is not forever: *"Kwaheri ya Kuonana…"*

I saw him again, decades later thanks to email. Dr. Morompi Ole-Ronkei has worked with a Kenyan university to start an outreach to the local prison. He has always believed in the power of education to break the cycle of crime and strengthen personal

resilience. He was also honored to receive the prestigious "Elder of the Burning Spear" award for his work as an advisor to the Kenyan president on a government task force for stronger national unity. They've been successful enough that government officials from the US are studying Kenyan ways to create unity in our own nation.

In the spring of 1989, I was standing in line at the grocery store, glancing through the magazine rack, my arms loaded with sundries. The May edition of *Sunset* caught my eye with the title, "Yellowstone Fires, A Year Later." And there I was. On the cover. Standing next to a geyser. Granted, the photographer had taken the photo from behind. I knew it was me, even if no one else did.

When it was finally my turn to check out, I dumped the groceries on the counter, walked back to the magazine rack and grabbed all five copies of *Sunset*. The checker looked at me with eyebrows up as I laughed and pointed at the picture.

"That's me!"

May 1989 Sunset Magazine

*L to R: Superintendent Ben Charley and Squad Boss Rod Carlton.
Horseshoe Meadows Hotshots, 1989*

White Snake
Chapter 14

JUNE 1989. After I finished the last spring exams at the University of Oregon, I boarded a plane bound for Fresno, California, and my new job with the Horseshoe Meadows Hotshots. Rod, my new squad boss, met me at the airport. I vaguely remembered him and his shaggy blonde hair from the previous summer at Yellowstone. On our way to the station, we stopped to buy groceries. The station was in the community of Pinehurst, about sixty miles east of Fresno, in the foothills of the Sierra Nevada Mountains. It bordered the Sequoia National Forest between the Sequoia National Park and Kings Canyon National Park. It was remote, which is why I had to buy a week's worth of groceries. Rod walked with me through the store, suggesting appropriate food items that travel well in a backpack. Half-way into my shopping spree, I felt him touching me.

I whirled around at him in shock and outrage. I was about to yell "Stop it!" when he turned to move further down the grocery aisle. As my new squad boss walked away, I noticed for the first time that he had shoved his Motorola walkie-talkie into his rear pants pocket. That radio had a long antenna that was fondling my backside, not him, as he stood next to me. When he looked back at me, there was nothing but surprise in his eyes.

"What's wrong?"

"I thought … Nothing! I'm just… not a big fan of yogurt!"

"Well, suit yourself. Hurry up. We need to get back to the station."

Four years into my work on fire crews, I continued to struggle to pick my way through the minefields a woman faces working in the male-dominated world of firefighting. Simple miscommunications and misunderstandings sometimes came with heavy costs. I was always wary of sending out the wrong vibe, or, like in this case, misconstruing simple mistakes. Though this was my third summer as a hotshot, and I did feel I was getting better at understanding the male-female dynamics in the firefighting world, there were still times where I felt unbalanced and without agency. Not all misunderstandings were as easily remedied as this one and I'm so glad we could laugh about it later.

Once the food was purchased, we continued our drive while Rod described the crew and living quarters. At the station, Rod introduced me to a crew comprised of Native Americans, African Americans, Latin Americans, and women. Women are a minority on most hotshot crews. But even if I were a man, I still might qualify as a minority.

I never knew my grandfathers, but my English grandmother told me that my grandfather was from Spain. That's where I got my olive skin tone. Later in life, Mom told me that my grandfather was actually from Puerto Rico. Me and J.Lo. I wondered if my grandmother was ashamed of her husband's origins. Why else would she tell people he was from Spain?

Mom and I had watched *Westside Story*. Even though I couldn't relate to feeling pretty, witty, or gay, I liked how they danced in the movie. As a kid, I was disappointed to learn I wasn't Native American. I had read about how they lived off and took care of the land. I used to pretend my Morgan horse was an Appaloosa and I a Nez Perce scout. In fifth grade, I brought my two Navajo nieces (by marriage) to school for "Show and Tell." I thought my class would

want to meet them. (Fortunately, my nieces knew that I meant well, but never let me forget it.)

There were four other women on the crew: Nancy, Sam, Pam, and I shared a mobile home they called the bunkhouse. Elena lived nearby. She was well-liked, no-nonsense, and had a good rapport with the men. Nancy was energetic and walked, talked, and swung her tool twice as fast as I did. Pam was tall, lean, and laid-back. Sam kept to herself. She was tough, not afraid to start a fight or finish it, and seemed to dislike me from the start. I didn't know why and gave her a wide berth.

When we got a call to a local fire, I climbed into my assigned crew carrier. They look like semi-trucks from the front, but when one climbs in the back, the interior looks more like the inside of a commercial airplane with a storage compartment above the seats for our packs and hard hats. The exterior is outfitted with storage compartments for all the chainsaws, fuel canisters, drip torches, hand tools, first aid kit, etc. Whitesnake's classic hits blared over the stereo and I sang with the lyrics "Here I Go Again…"

Others sang along, but overall, the Horseshoe Meadows Hotshots seemed older and more stoic or subdued than the Prineville Hotshots and the other crews I had met in Yellowstone.

Maybe the rugged landscape, the daily oppressive heat, and the intensity of the state's wildfires contributed to their quieter nature. In the Pacific Northwest, firefighters enjoy a reprieve at night when the temperature and wind drop and humidity levels rise, giving firefighters the upper hand. Not so in California. Especially when devilish Santa Ana winds blow away any trace of humidity, the hazards of crazy fire behavior sneak up at any time of day or night keeping crews constantly wary.

At higher elevations, the Sierra Nevada Range is steep, and the areas not peppered with black and white granite are covered in dense dry brush that stands waist high or higher. A combination of

scrub oak and manzanita that dull a chainsaw in five minutes. It's also extremely flammable. These elements might explain why the Horseshoe Meadows Crew was serious and reserved, and less likely to be boisterous.

Our first fire call was to a grass fire in the hills overlooking the Vandenberg Airforce Base (now Space Force Base) south of San Luis Obispo. Grass fires burn fast, but local engines had already doused the flame front, and the ocean's humidity had snuffed the majority of the fire the previous night. We arrived in time to knock out any remaining hotspots and cold trail. We did this by spreading out in a line along the edge of the black, already-burned area. We then walked through the black, searching and feeling for hotspots. I was used to working in vast expanses of forest and it was strange to look beyond the open, bare hills to the beautiful California coastline.

Days later, fireworks started a local fire on a steep hillside in the afternoon's triple-digit heat. Flames moved so fast through shimmering heat waves and tall brush that it was a race to douse it with water and carve a line around it before it jumped the highway and blasted up the hill away from us. A crewmember collapsed because he did not stop to drink water. A few of us got dehydrated and forced ourselves to gulp warm canteen water often or face the same fate.

All afternoon, I wiped sweat from my brow before it stung my eyes and tried to take deep breaths in the hot, smoky air with a growing sense of dread that this fire would get away and blow up. It was a huge relief to see engine crews arriving to drench the highest flames from the highway above us. Thanks to their help, we managed to catch the front and line the perimeter.

Just before dark, I climbed into our buggy with shaking limbs. Exhausted and dehydrated, I wondered about being in over my head. Wiping crusts of dirt and salt off my face with my wet bandana, I fantasized about cold watermelon wedges and jumping

in a lake. The climate was not friendly to firefighters. Watching a big, strong fireman collapse from exhaustion and dehydration was both alarming and disconcerting. *How would I be able to hold up?*

The previous three summers my home base was in Prineville where I had friends and was closer to home. Now I was far from home, friends, and comfort zones. I wasn't at all sure that coming to work here had been a good idea.

Days later we approached another small, local fire in the Sierra National Forest. We drove as close as we could to the fire and then started the long hike where I witnessed something I wouldn't have believed had I not seen it myself. Hiking single file through the sparse, knee-high grass, I looked ahead to see what I thought was a slender tree branch pop up, as if someone had stepped on the end of it.

One man yelled "SNAKE!" and jumped out of line. The guy in front of him turned with his tool to hold the snake down while the guy behind him took aim with his Pulaski and hacked off its head with one swing. With this snake-killing choreography, that rattler was dead in less than four seconds and without any fuss, like it was no big deal.

By the time I got there, another guy walked away with a big, ugly rattlesnake head on his shovel to bury it. The one who almost got bit used his pocketknife to cut two inches of rattles from the tail and put them in his fire shirt pocket. He picked up the snake's body and proceeded to tie the skinny tail end to his belt loop. We admired his trophy for half a minute before hiking again, him with the snake dangling off his leg.

When we took a dinner break hours later, I got curious.
"Why don't you just skin the snake and toss the rest?"
"You ever eat rattlesnake, Hamberger?"
I thought, rattlesnake-hamburger and laughed at my own joke.
"Can't say that I have."

"Well, you have something to look forward to."

"Yay."

He smiled at my sarcasm as he coiled the flaccid snake into his now empty Tupperware container and carefully loaded his prize into his pack.

We worked through the night lining and mopping up the small fire. Back at the station the following morning, we sharpened tools and filled canteens to be "fire ready" for the next one. Someone lit coals for a barbecue. I was hard at work on the tedious task of sharpening shovels when I smelled something cooking and approached. The meat roasting on the grill was white and tubular and it writhed as it cooked. The burnt-dust stink of sizzling snake made my mouth water the way it does when I'm about to vomit.

The men congregating around the chef were smiling and lighthearted. This barbecue might be a test for the newbie.

"Tastes like chicken!" They said, chuckling amongst themselves.

Ben Charley, our Super, approached to joke with them. Once the snake stopped moving, the guys came by with their pocketknives, speared a section, dipped it in barbecue sauce and went to town on it while they watched me watch them. I got out my pocketknife, cut the smallest section in half, applied salt and sauce liberally, and with much resignation, took a bite. I chewed and chewed the rubbery stuff and managed to swallow. Struggling to keep that snake from slithering back up my throat took every ounce of self-control I had. Once I was sure it was down, I gave my two cents.

"Chicken… tastes a lot different where I come from."

Judging from their reaction, I passed the test.

L to R: Horseshoe Meadows Hotshots Curtis Gibson and Chancey Bridges sharpening knives in Florida

Bad Bug
Chapter 15

Our bunkhouse had a small TV with one channel. I turned it on to watch the news one evening during my first week and stood mesmerized by what I saw happening on the other side of the world. In Beijing, masses of Chinese college students and civilians were peacefully protesting in Tiananmen Square against their government. The students were asking for an end to corruption, the abuse of power, and for the freedoms of democracy. Then, starting the night of June 3, their request was met with a massacre by military firing squads. On the television, there were various reports on the number of fatalities; I would later read that "No official death toll was ever released by the Chinese government, but human rights groups estimate it was in the hundreds, if not thousands" of unarmed college students and civilians, shot and killed by their own army.[1]

Days later, government tanks (the People's Liberation Army) rolled into the square to face off with more unarmed protesters. Tanks. Against flesh and blood. One man stepped out of the crowd and into the street.[2] He stood alone, blocking a line of army tanks while the world held its breath. Curiously, he had a grocery bag in each hand. Was he on his way home to feed his family?

I couldn't say whether I was looking at courage or stupidity. If only we could know what went through his mind as he left the relative safety of the crowd to take a bold stand in defiance of tyranny. Tense seconds ticked by. The tanks halted and did not shoot. Finally, fellow protesters broke the standoff by escorting "Tank Man" away. He melted into the crowd, unscathed.

I wanted to meet the *driver* of that tank. I wanted to know what kept him from pressing the kill switch. Was he going against orders when he stopped? Was he punished or applauded for putting on the brakes? Was there a raging debate inside the tank or was he silently waiting with a finger on the trigger and sweat trickling down his temple? Both Tank Man and the driver showed me how an individual's character can affect the whole world. Later that summer, my character would affect the crew, but it wasn't for being wise or courageous.

Not long into the fire season, we got a strange assignment: not to fires in California but, instead, we boarded a government plane bound for Miami, Florida. Once there, we were driven a short distance east to the Everglades National Park. A day later, we stood on a sand road, dripping sweat, watching a helicopter land in an endless sea of sawgrass.

Since I had helicopter training and a valid red card allowing me to do a hover hookup, the crew boss beckoned me forward. Talking to the pilot made me miss my previous helitack job. Effortless flying over groundpounders could hardly be called work. Once the hookup was done, I reluctantly rejoined my crew, dreading the prospect of hard physical labor in 90-degree heat and high humidity.

Across the flat horizon was a dried up, burning swamp. I was at a loss as to how we would fight this fire. It was a dry marsh—sawgrass sedge that grows six feet high with tough stocks at the base. We had arrived without our usual tools: no chainsaws, no shovels,

no pulaskis. Those would be useless here. Instead, they handed each of us a tool they called a "flapper," which looked like a semi-truck's mud flap attached to a long wooden handle. We were to beat the flames burning the stocks of sawgrass with these flappers, hopefully without stepping on a cottonmouth. We had been told to watch out for snakes, which made us all jumpy.

Everyone's shirts were soaked with sweat in the first half hour. Sawgrass has sharp, serrated edges and scratched my arms where I had rolled up the sleeves of my fire shirt. Tempers flared as the futility of the assignment registered. This 'wetland' was below sea level and would be underwater again as soon as the big rains came, which should be soon. Without any structures to protect, we burned the sawgrass in a wide line around hardwood hammocks (small islands of trees) to protect them from the wildfire. Park officials said it was the region's worst fire season in a decade and did not want the fire to cross the park's boundaries for another Yellowstone-like fire that would threaten homes and towns if they didn't make efforts to slow it.[3]

Watching sawgrass burn in the Everglades National Park, Florida

What I didn't know at the time was that the cracked mud we walked on was actually peat. Peat is spongy plant matter rich in nutrients that sustains the swamp's biodiversity as the first link on

the Everglades' food chain. When peat is bone dry, it burns like fuel. In fact, in countries where peat is common, it was once used as fuel. In drought conditions, fires burn hotter because the fuel is drier. If a hot fire burns huge areas of peat to barren bedrock, the delicate balance of the food chain can be destroyed. When the Everglades are not in a season of drought, the flames will barely reach the top layer of peat. Instead, they burn through the sawgrass above the peat and go out without human interference. This cycle is natural and necessary.

Just like in our forests, fire keeps the Everglades "clean" by providing new growth and keeps invasive species, such as cattails, at bay. Young, tender sawgrass shoots that emerge after a fire are a favorite food for many of the park's inhabitants. It was our job to control and direct the fire as a way to protect this ecosystem.[4]

It was also an unrelenting exercise in self-control to force ourselves to keep working through high temperatures and humidity, regardless of our growing heat rashes from excessive sweating under our packs —a bonding experience we could've done without. On the bright side, I saw my first fireflies wink and let their little lights shine. We never did step on a snake or cross paths with an alligator. The rains came on our fifth day and finished the work. We were relieved to board an air-conditioned government plane to fly from sea level back to the forests of the West.

We were dispatched from one fire to the next by the National Interagency Coordination Center (NICC) located adjacent to the Boise Airport in Idaho. (In 1993, the name was changed to the National Interagency Fire Center, NIFC.) The 55-acre campus includes numerous wildland fire management stations. From there, dispatchers monitor the location and status of every fire in the nation. For any given fire, they know what resources are available (incident management teams, smokejumpers, hand crews, helicopters, helitack crews, lead and retardant planes, engine crews,

bulldozers, fire camp operators, etc.) and what resources already have been committed. NIFC also knows the exact arrival and departure dates of each resource at each fire throughout 700 million acres of federal public land. The amount of logistics they monitor and record is staggering.[5]

Days later, we were sent to a fire in King's Canyon National Park. As we started our daily descent into the canyon, my knees suddenly went rubbery and the ground started to spin. I had to stop, which stopped the entire crew. Rod walked back to my end of the line to see what the problem was. I was bent over, my hands on my knees, breathing hard, waiting for the dizzy spell to pass.

Rod took one look at me and my green face, shiny with cold sweat, and knew instantly what it was. A stomach bug was making the rounds through the crew. Two of our guys had stayed in camp with it the day before. There I was, at the mouth of a burning canyon, in the middle of nowhere with the stomach flu. *Help me, Jesus!*

Rod conferred with the other bosses and came back to me while the rest of the crew moved on. I was relieved of duty for the day and ordered to sleep and hydrate. Without objection, I followed him back up the trail panting and shaking from the smallest effort. I had to spit a lot and tried unsuccessfully not to vomit. By the time I staggered to the top, he had built a fort out of brush and branches like I had made as kid. He cheerfully pointed out that at least I would have shade. He then said he was sorry but it was the best he could do and he'd check on me as often as he could.

I was neither gracious nor grateful for his efforts. I heaved again and with great effort, crawled into my brush bungalow and pulled my space blanket from my pack. It was hot, but I was cold and had a sudden splitting headache. I made a foolish effort to take two aspirins for the headache, and barely made it out of my hut before everything came back up with a wrenching heave.

For several hours, I laid in anguish. Even with earplugs, the roar of huge airtankers loaded with retardant flying low and the helicopters, with their bucket drops, buzzing back and forth above me was too loud. In the middle of a war zone, my body fought the virus. I heard other crews moving by and was relieved for the small amount of privacy my little fort afforded.

True to his word, Rod hiked to the top of the canyon at noon to make sure I was still alive. I was dozing and did not want to be disturbed.

"Hamberger! How much water have you drank?"

"I can't even swallow my own spit!" I growled with my arm over my eyes.

"Well, I'm not leaving until you sit up and drink an entire canteen of water."

He waited a full minute for me to respond before he tapped my boots with his toe.

"Okay, okay!" I sat up, dizzy and annoyed.

I drank half a canteen before it all came back up. He made me drink the other half while he stood there. This time it stayed down, though my eyes watered with the effort. Then he made me set the timer on my watch and ordered me to drink half a canteen every half hour.

"When I come back, there better be at least two empty canteens here."

I smiled at this. We both knew I could pour the water out and he'd never know. We both knew I wouldn't.

"Go away," I sighed as I covered my eyes with my wet bandana.

It was a small comfort to have him sit beside me, but I knew he couldn't stay. As long and hard as his hike in and out of the canyon was, I wondered if he would be this attentive to a guy on the crew. At the time, I was too sick to appreciate his character and concern.

That afternoon ticked by in my lonely fort as I drifted in and out. Rod did return a few hours later that afternoon and I glared at him while choking down more warm, slimy canteen water. He rewarded me with a bottle of Gatorade, demanding that I drink the whole thing while he waited. While I swallowed, he told me what was happening in the canyon.

After drinking, I laid back down and closed my eyes, exhausted. As wretched as I felt, I didn't care what was happening with the fire, but listening to him took my mind off my misery. If there was too long of a pause in his speech, I whispered, "What else?" to keep him talking. It must've put me to sleep because I didn't hear him leave.

Miraculously, by the time the crew walked out of the canyon at sunset, the pounding headache and nausea were gone. Who knew warm canteen water and Gatorade were the keys to bouncing back? Rod knew. Now that I could think straight, I was touched by his concern. I was also glad to see my crew's weary faces at sunset as I crawled out of my fort, shouldered my pack, and fell in line for the walk back to the bus.

The other memorable thing about that fire was my introduction to the barrel cactus. We must've been on the back side of King's Canyon, closer to the desert terrain of Owens Valley and Death Valley National Park, because we occasionally came across them. In that part of California, a big barrel cactus was about the size and shape of a basketball. When fire swept past them, they could be a source of some excitement.

Parts of Kings Canyon are extremely steep. On average, it's a mile deep and deeper than Arizona's Grand Canyon.[6] As we dug line along the fire's edge, we added many water bars to prevent soil erosion. (These are little ditches to slow and direct water diagonally across our line when the winter snow and spring thaw came.) While building fireline, water bars, and cooling hotspots inside our line, we watched for any wayward barrel cactus.

When hot ashes and embers collected around its stem, the base would eventually burn through. With nothing rooting it to the ground, it would suddenly start to roll down the steep slope gaining momentum as it bounced along like a ball of fire, sparks flying, and a trail of little fires in its wake. At night, these burning orbs were spectacular. If I heard a warning shout, I was quick to make sure I was not in the path of the flaming meteor. Getting hit by a burning cactus would be unpleasant. Sometimes those barrel cacti didn't stop until they reached the riverbank far below. If we saw a barrel cactus inside our line and there was heat in the ashes, we'd dig a cup trench on its downhill side to prevent it from rolling and starting more fires. They definitely inspired us to stay alert on those days when the main fire was out and we were finishing our work mopping up.

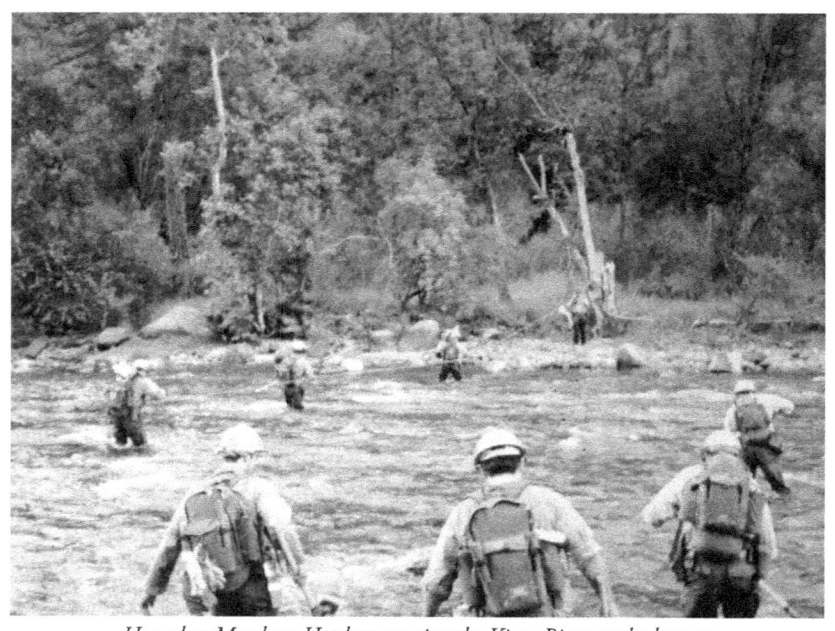

Horseshoe Meadows Hotshots crossing the Kings River at the bottom of mile-deep Kings Canyon, California

Killin' Time
Chapter 16

With nothing else to do in our spare time, I learned what it meant to go "froggin." One evening in July, five of us walked to the pond at the station after dark toward the crescendo of a croaking chorus. Sitting in the grass behind the cattails, armed with six-packs of beer, buckets, fishnets, and flashlights, we waited until the sky was dark. Then, we shined the flashlight along the shore until a set of eyes emerged just above the water's murky surface. SPLAT! Our net slapped the water as someone attempted to scoop the frog out of the mire and into the bucket. Those frogs must've had a sixth sense because we missed them as often as we caught them.

It wasn't what I would call sport, but between scoops, we'd click off the flashlight and when my eyes adjusted to the dark again, I leaned back on the bank and listened to the quiet conversation and laughed at the jokes. I inhaled the fresh, sweet air devoid of smoke and watched the sky's stellar display. After an intense week on the fireline, it was fine entertainment.

The day after one such adventure, I learned that frog legs twitch a lot while frying. Somehow one of the legs twitched itself onto the kitchen floor causing a scream or two and a lot of laughing in our kitchen. As I looked at my plate, I didn't understand the appeal. To me, they tasted like the stagnant waters from which they came. All that summer, the radio played the Nitty Gritty Dirt Band's hit song "Fishin' in the Dark" and to this day, I think of catching frogs.

In between our rare nights sitting on the banks of the pond hunting frogs, we were putting out fires. We worked more than one fire in the Santa Catalina Mountains northeast of Tucson, Arizona, both in the Coronado National Forest and the Saguaro National Park. We were in hilly country, covered with brush, saguaro cactus, and small pine and oak trees. One day, dark thunderheads rolled in and covered the blue sky. Within minutes, we were in the midst of a full-blown thunder storm. It was my first experience with a desert storm, and we were totally exposed. At the time, nothing terrified me more than the boom and crack of thunder directly overhead. The sound waves vibrated through my bones. Searing bolts of lightning struck close enough for us to smell the tang of ozone and feel the hair rise on the backs of our necks.

With no nearby structure to provide shelter, the crew hurried to a cluster of young pine, the only significant vegetation on the open hillside and huddled under their spindly branches. Within minutes, the storm's deluge had drenched us. Ironically, in those minutes of downpour, it became a race to light a fire before every bit of fuel was too wet to burn. Someone resorted to lighting a flare and putting it in the hastily constructed fire ring under the wet branches. Once lit, out came cans of beans and weenies and packages of instant coffee. Someone raised a canteen to toast:

"Here's to not being struck by lightning!"

We took turns standing with our backs to the fire to dry our t-shirts, as we marveled at the beauty of the storm clouds gliding past us and the fresh, sweet smell of summer rain. Nature was doing in an hour what it would have taken us days to accomplish. Now, all we had to do was get out of the way and watch the flames shrink until they sputtered out altogether. Fourteen separate fires in the Coronado National Forest had burned 4,300 acres before the rains came.[1]

Me and crewmember Luther Earl Larkin Sr. viewing petroglyphs

We often traveled through wild spaces that didn't see much traffic. Once we stumbled upon petroglyphs somewhere in the Southwest. It gave me pause to imagine people and their horses hunting and gathering there centuries before us. What would they think of us? Our fast food, fast cars and our cities?

Another fire took us back to California. With big fires in this state, the government used what we called "convict crews" or "con crews." Today, they call them inmate crews. These crews were prison inmates who had earned work eligibility for good behavior. They could choose to join a fire crew with other inmates.

Back then, they wore bright orange jumpsuits to alert other firefighters of their status. Working with inmate crews seemed like a win-win situation for both the state, which was grateful for cheap labor, and for the men stuck in prison, who were desperate to get outside and work at something bigger than their own problems. After nine months of sitting in confining classrooms, I had made the same choice as the prison inmates.

Whenever we worked with all-male con crews, our superintendent warned us to "be heads up"; we were to stay away from them and not to go anywhere alone. On one occasion, while we were working the night shift, we had a short section of line to construct

and the rest of the time we were to hold it while another crew conducted a back burn. We were warned that some distance behind us a con crew was also holding the line.

Around midnight, the back burn began. Our orders were to spread out along the gently sloped fireline to watch for sparks that might cross into the dry brush. I was at the end of the line; my holding area happened to have a horseshoe-shaped rock outcropping with a ten-foot drop to the fire below.

The person in front of me in line was not far away, maybe 20 feet, but the topography was unusual so that I couldn't see her above me. Every ten minutes, we shouted out to each other. From the edge of the outcropping, I watched the fire below.

The backburn was going well. I relaxed. It was a calm night with only the slightest breeze coaxing the fire in exactly the right direction. After standing guard for what felt like an hour, I sat down at the edge of the rock and let my feet dangle off the cliff, pleased with my vantage point. I got out some trail mix and my Walkman radio/cassette player with little portable speakers, hoping the music would help me stay awake. Singing to a country song on the radio, I didn't hear his approach until he was right behind me.

The con crew was supposed to be way behind us, but there he was—ten feet away—in his big orange suit and me with an instant adrenaline rush.

My eyes were locked on him while bending to pick up my pulaski. I stood back up, but was at a loss as to what to do next.

He spoke slowly, in a low, gravelly voice, as if he had at some point been choked.

"Nice music. Who's singin'?"

The moment felt surreal as I listened to the country-western singer drawl lonely lyrics.

"This is Clint Black. He sure can sing, can't he?" I spoke loudly, hoping to attract attention from my nearest crewmate. He nodded slowly.

"So can you."

We stared at each other. He was motionless and solid, like a wall. I knelt down, shut off the radio, and stood back up, trying to think of small talk.

"Aren't you supposed to be with your crew?" Again, speaking loudly while praying that someone would come.

He took a deep breath and stepped toward the ledge to look out over the fire below us. As he stepped forward, I stepped to the side, wondering if I could make a run for it. Just then, Rod walked into view. He saw me all wide-eyed and rigid and then he saw *him*. He immediately moved between us.

"Hey! Get back to your crew right now or I'll radio for an escort," Rod demanded.

Jumpsuit snorted and smirked as he looked at Rod. He turned and slowly disappeared into the darkness.

For a solid minute, I watched the darkness, trying to calm my pounding heart. Rod just stood next to me, at first saying nothing. Then he turned and radioed our boss. I collected my Walkman, letting my heart rate slow, and sent a silent prayer of thanks.

Rod turned to look at me and I shook my head.

"I'm not gonna' stay here."

"No," he said. "You're not. You okay?"

"Five minutes ago, I was trying to decide whether I'd rather fall off a cliff into the fire, or fight an inmate!"

"And?" He asked.

In the dim light of the still-burning fire, I could see him looking at me expectantly.

"And what?" I said.

"What'd you decide?"

I turned on my headlamp to shine it directly into his smiling eyes.

"Not funny. Why don't we all carry radios? I could've used one to call for help."

"Good question …. C'mon, let's move up the line. We're still at least an hour from daylight. You've probably seen enough boogey men for one night."

The tension in my shoulder muscles and gut eased with relief. As we hiked together up the line, I blurted my gratitude.

"Thank you, Rod. Your timing was impeccable."

"Impeccable, huh? Alrighty then."

Once again, Rod had helped me out of a bad situation. For that, I was grateful.

I worked on many of the same fires where inmate crews were employed. Most were polite and hardworking. They are an asset to states that offer inmate crews and we appreciated their help and willingness to do whatever task necessary. Often their gratitude for the opportunity to work in the forest makes them outstanding firefighters.

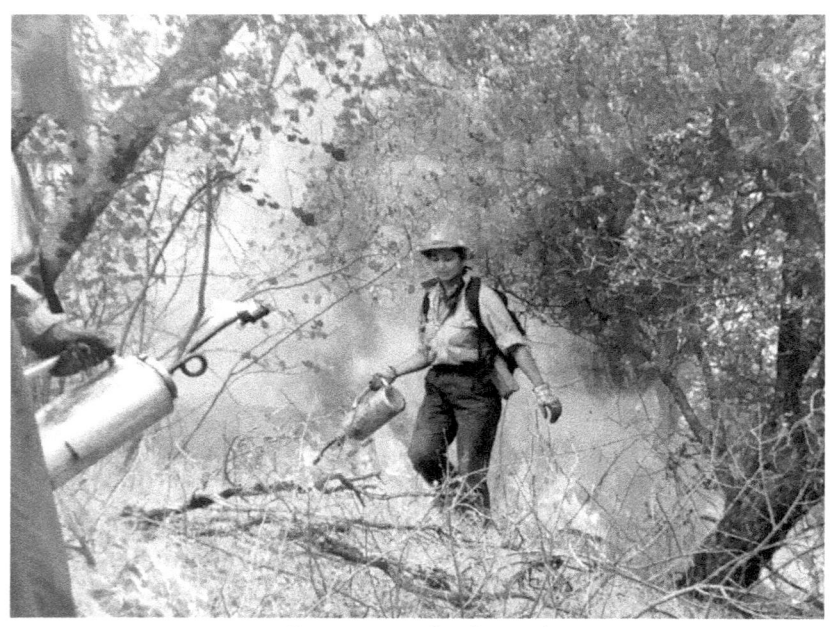

Burning out with a drip torch

The Burn
Chapter 17

On the radio, Willie Nelson sang of getting on the road again. The song resonated. The summer had been a blur of chasing fires and flying or driving from one state to the next. From Florida, we had been dispatched almost 2,000 miles westward to Albuquerque, New Mexico, and then were bussed to the Gila National Forest outside of Silver City. Next it was almost 1,000 miles back to our station in CA. From our base, we then hit fires near Tucson, AZ, then north to a fire outside of Globe, Arizona; and another 700 miles north to a fire near Utah's Vernal City. After that, we drove 500 miles to a fire in Idaho, then 400 miles to Lovelock, Nevada, and another 500 through the stunning granite peaks and cliffs of Yosemite National Park, to our station. That summer, when we weren't on a fire, we were traveling to one.

Either country music, blues, or rock played depending on the driver and the radio reception. When we heard fire classics like "Ring of Fire," we all fell in to singing with Johnny Cash, which made the miles and the hours pass less slowly.

One of my favorite drives was along the Arizona-Utah border through Monument Valley. I had never seen Navajo country. Scenic at any time of day, we passed through in the dusky light of early evening when the rusty reds, pinks and golden desert colors

shimmered with heat waves and glowed on the Alhambra Rock. This high desert's grand expanse is a sacred space, but we stopped only long enough to take photos of the massive red sandstone buttes before rolling on.

We arrived at a fire staging area which had been set up at a fairground. A number of crews were waiting for specific fire assignments and/or transportation to fire camps. As we were one of the last to arrive, the grassy field and sidewalk were crowded with hotshot crews from about every state in the West. It felt like a Who's Who red carpet affair for hotshots. Everywhere, groups of mostly men stood in their black leather fire boots, standard green Nomex pants, and t-shirts sporting their crew colors and logos. Adding to the red, white, blue, and black, we stepped off the bus wearing our bright orange t-shirts. Other crews watched, probably ranking us based on our appearance. I was uncomfortable with being on display, but maybe we all were and that's why we were in such a hurry to get our stuff unloaded and get to our assigned area.

I had been sleeping when the bus stopped. In the rush to get up and out, I rolled up my pant legs but didn't bother to lace my long bootlaces all the way up or roll my pant legs back down. I quickly tied the laces at the ankle and hurried off the bus. It was a mistake I'll never repeat.

I threw my daypack on and someone thrust two hefty red packs at me that I slung over each shoulder (these packs are filled with personal stuff like extra clothes and a sleeping bag). Burdened by three packs, I had to grip each shoulder strap so they wouldn't slip. With all our gear in tow, we strutted single-file down the runway of crews.

I made it almost to the end when the big loop of my leather laces caught on the hook of the other boot in mid-stride. Down I went, hard. I couldn't even brace myself. I landed with an "Ooof!" A full-on face-plant knocked the wind out of me. The person behind me was also loaded down with gear and tripped over my prostrate body,

crashing down on top of me. Before I knew it, we had a three-person pile-up. There was a lot of cussing and yelling of my name, which may have puzzled onlookers who thought our crew had an affinity for Jesus and fast food.

I was mortified. My knee was not happy about it either. They should put warnings on bootlace wrappers:

WARNING: Don't be lazy with your laces or you'll fall on your faces!

Everyone knows that coffee may be hot, but not everyone knows what happens if you're in a hurry and don't lace your boots properly!

My face felt hot as I was pulled off the ground none too gently. I wiped the grainy bits of concrete off my chin. There was no way I was going to retie my laces in front of everyone while my crew left me. I unrolled my pantlegs, gathered my packs and limped like a bow-legged cowboy to our camp site.

As I was putting Band-aids on my elbows, Rod approached from behind and put his hand on my shoulder in a comforting gesture as he leaned in to look at the damage.

"That was quite a show you put on back there. You okay?"

"Mmm-hmm." I didn't trust myself to talk.

"Well, don't sweat the small stuff!"

I angled away from him and kept my eyes on my bleeding elbow, relieved that it was getting dark. In the moment, it was hard to concede that falling on my face in front of everyone was "small stuff."

If I wasn't working on the fireline, I was trying to sleep. If I tried to read a book, it usually ended up lying on my sleeping face. I was bone tired and spent from physical and mental exhaustion. A postcard I wrote to my parents from Gallup, New Mexico, told them of the toll the relentless heat and the fires of the Southwest had taken on my body. Because of the heat, I was constantly wary of dehydration. The terrain and altitude of the high desert depleted me and pushed me to my reserves.

That postcard should have been a warning to me: it mentioned Rod more often than it should have. I had begun to look forward to seeing him stride toward the back of the line to check up on us ground-pounders. He and I smiled and joked with each other a little too much. When the crew sat to eat, I would sit by him, if I could. If he asked for a volunteer, I would usually offer. Sometimes I found myself asking basic fire questions just to stall him from leaving.

"So, hey, Rod, where's our safety zone?"

Shameless! You know exactly where the safety zone is! Even though I inwardly rolled my eyes at myself and avoided eye contact with the other women who knew I was flirting, I couldn't seem to help myself.

Rod was a completely capable firefighter and boss. I admired his confidence in the woods and around fire. There was a sense of self-sufficiency about him that reminded me of the hero of the movie, *The Man from Snowy River*. In the eighth grade, I watched that movie over and over and even learned how to play the theme song on the piano, while imagining that I was Jessica, the object of his affection. Mr. Snowy River knew who he was, what he wanted, and where he belonged.

Rod had a great sense of humor. And he thought I was funny, which was a nice change from being the invisible little sister type, which was how I thought others saw me ... or didn't see me. I walked among my crew with more confidence, knowing that Rod was looking out for me. After the flu episode and the experience with the inmate, he felt like a friend. As a newbie to this crew, I was grateful for friends. But sometimes there's a fine line between friend and more-than-friend. Having an amorous relationship with a boss would put me in danger of breaking the unwritten cardinal rule for women on a fire crew: you don't mess around with fellow crewmembers, *especially* not with a boss. I saw it happen on occasion, but didn't think it would ever happen to me. I was the good Christian girl who knew better.

In September, we were at a fire in the Plumas National Forest northwest of Reno, Nevada. Because of the higher elevations, it got cold at night. After climbing into my sleeping bag, I struggled to stay warm. Most of the other fires we had worked were located in the heat of the Southwest, where even our thin sleeping bags were too warm. Not so in Plumas National Forest. By the second night at fire camp, we would shiver into our sweatshirts and stand with our backs to the smudge pots to absorb the heat. I was the last one standing at the smudge pot dreading another miserable, sleepless night of shivering, when Rod walked by and saw me.

"Why're you still up?" He asked with concern.

"I'm freezing. This is the only place where it's warm," I said, while he stood there absently rubbing his hand across the stubble on his chin.

"Why don't you bring your sleeping bag into my tent and you can sleep against me?"

He spoke matter-of-factly, as if he were discussing fire behavior. As if sharing a tent with him was no big deal, the practical thing to do. I didn't react, but inwardly, my eyebrows shot up at the suggestion.

"Uh… thanks, but I'll manage.

"Suit yourself, but you'll be warmer and you'll sleep."

Walking to my tent, I felt weird, and wondered what his intentions were. Was he just being super-practical? Or was there more to it? I trusted him.

That night I shivered in my thin sleeping bag, feeling my body heat dissipate as the temperature dropped to nearly forty degrees. Another night of not sleeping translated to my being a zombie on the fireline, a walking accident waiting to happen. I had tolerated a lot of miseries as a hotshot, but I HATED being cold. *What was it he said? Suit yourself? Did I want to die of hypothermia in the mountains above Reno?*

No!

The Burn

It suited me to be warm!

My indecision should have been a warning to me. The bottom line is that it should have been absolutely out of the question. Because Rod was married.

I remember the day I was cautioned by another crewmember. We were home from a fire and had started the morning with a long PT session that ended with a three-mile run. The last mile was uphill and I struggled not to stop and walk. A fellow crewmember slowed his pace to match mine. We jogged together awhile without talking before he finally spoke.

"You know he's married, right?"

I stopped, placed my hands defiantly on my hips, and hedged.

"I knew he had kids…" I said. "Why doesn't he wear a ring?"

We jogged on in silence for some distance, before my crewmate spoke again.

"The more important question is what are you gonna' do about it?"

With that, he picked up his pace and was gone, leaving me to walk back to the station in a foul mood with a gamut of emotions racing through my head. I had been flirting in blissful denial: I liked my boss; he liked me; and no one else seemed to notice or care. At least, that's what I'd been telling my twenty-one-year-old self.

On that night, when Rod offered to share his tent, I should've pulled the sleeping bag over my head and toughed it out. Or I might've exercised assertiveness and approached the crew boss at dinner to ask where I could find an extra sleeping bag. But I didn't think of it at dinner. Instead, after what felt like hours of chilly deliberation, I got up, gathered my sleeping bag, tip-toed to Rod's tent, and unzipped the flap.

"What the…?" He checked his watch.

"Jesus, Hamberger!"

"Let's not bring *Him* into this… anyways, we're *just* sleeping."

I nestled in beside him and slept warm and well for the rest of that fire. Our clothes stayed on for those few nights, but I knew I was sleeping on thin ice … and playing with fire. Back at our fire station, I added cold weather apparel to my pack, and wondered if I could trust myself to back off and act appropriately. I had been trespassing on sacred ground. What was happening between me and Rod went beyond friendship… and in God's eyes, and everyone else's, it was wrong.

How does one suddenly turn off one's feelings for another? I could quit and return to Oregon. Distance and time apart would return it to a friendship. But if I quit the crew, I would risk not getting hired for the next summer. I might need the job next year. So much for the job I enjoyed. Also, I had begun to realize that one of my strengths was being part of a team. Working as a hotshot, I had learned the importance of sharing the workload, of communication, of holding up my end of the responsibilities. I was proud of being a valued member of the crew. I was also proud of my hard work that gave me a financial independence. Graduating from college debt free on my own dime was my immediate goal. I chose to focus on that, but it still wasn't easy.

It helped that I received a letter from Paul asking about my summer. Paul had been a constant, if long distance presence in my life for six years. The only boyfriend I had ever had, I had only seen him once since the officer's ball in Pensacola, Florida two years before. The timing of the arrival of his letter was an interesting coincidence. Was God talking to me?

Since Paul shared my faith; he would understand my dilemma with Rod. In a decision I would almost immediately regret, I decided that Paul would shoot straight on what I should do. So I put it all in a letter … and mailed it. I don't know what I was thinking.

In hindsight, that letter was a cry for help and I rarely asked for help. His scathing letter in response did my heart good as it grabbed

me and gave me a good shake. With no equivocation, he strongly suggested that I change my mind and my behavior around my boss:

"What were you thinking?! The --- ing guy's married! Need I say more??!"

Paul was right, of course. Nevertheless, his scorn and anger stung. But later, on page two of the letter, he softened and waxed poetic with a playful pun as he concluded:

"Quench the fire that burns *my* soul!"

Figuring out my relationship with Paul was a never-ending challenge. As nebulous and periodic as our relationship was, he was important to me. I wondered if we would ever have a chance to return to the closeness and togetherness we shared in Mexico. Maybe. I hoped so. I looked forward to that day.

Back at the station, there was talk of live music and a dance at the nearby grange hall. The other crew women asked if I was going. Absolutely! I loved to dance. In the midst of this intense summer, the cheap thrills of a grange-hall dance were something on which we could all agree.

When we arrived, the hall was crowded and loud with people having a good time. When the band played the Doobie Brothers' "Listen to the Music," someone took me by the hand pulling me to the dance floor and I didn't stop dancing … until halfway into the evening when a fight broke out. Hearing a scuffle over the music, I turned to see Sam punch Pam. When Pam saw me, she grabbed my arm and shoved me out the door.

"What was that all about?" I turned to look at her.

"You." Pam answered, wiping blood from her lip.

"Me?"

"Sam was gunning for you… said she was gonna' do some serious damage to your face."

Shocked, I immediately realized what she meant. My stomach churned and my face felt hot as we strode in silence across the gravel

parking lot, toward the bunkhouse. My "friendship" with Rod *was* affecting the others. Sam was local; she would see the unhappy effects of my stupidity on his family long after I was gone. When I started to see my behavior in this light, I began to wish Sam had hit me, not Pam. If I were her, I might've come out swinging, too.

Pam entered the bunkhouse, but I lingered outside and sat on the steps with only the chirp of a cricket to break the silence. I'd never been in a fist fight before and wasn't about to start now. I wasn't angry with Sam. More like embarrassed. Ashamed. And then there was Pam. Knowing Pam had defended me when I was in the wrong was a new experience for me, one that required some thought, a lot of humility, and gratitude. When I finally entered the house, Pam was sitting in her room greasing her boots. I leaned against her bedroom door frame.

"So. You stepped in and blocked her from punching me?" I asked.

"Yep."

"Why?"

She stopped polishing her boots to look at me.

"I thought we were friends. That's what friends do."

I looked at the floor. "Pam, you know I'm not…"

"Yes." She continued the work on her boots.

I'd been wrong about Pam. I'd assumed that because she was a lesbian it somehow ruled us out as friends who would take a punch for each other. Feeling foolish for the second time that night, a long awkward moment passed.

"I'm sorry. I misjudged you while you were looking out for me."

She brushed more conditioner into her boots with steady strokes.

"Sometimes I can be so…" I shook my head and looked down at the floor, searching for the right word.

"Obtuse?" She offered.

"Well, that's putting it kindly."

We both smiled. Her short, boyish haircut accented the angles of her face.

"Thank you, by the way, for intervening and sparing my face."

"You're welcome. For the record, Sam doesn't like me either. She was swinging at me as much as she was going after you. Once she sobers, she'll be civil again."

I settled into the other chair in her room and asked about her home. Pam was soft-spoken as she told me about growing up the youngest in her family with three older brothers and a sister. She, too, was a rower on the Western Washington University Crew Team while she studied for a degree in industrial recreation.

"You're telling me that you left Seattle and a career managing a corporate fitness program to join this crew?" I was shocked.

"Life is short. I wanted out of the city... and the rain." She shrugged.

As she talked, she applied more leather conditioner, which would make her boots softer and more flexible. Band-Aids covered her bare feet where they'd been rubbed raw. My feet were almost as bad and I brought my boots in and sat down to join her, even though my efforts were in vain. My boots were still too big and no amount of conditioning could fix that.

As we sat softening our boots, she pointed out a problem that can creep into the dynamics of any group when one is favored and receives special treatment. Pam informed me some of the crew thought I was that person receiving special treatment. I vehemently denied this allegation. But I wasn't sure. After we turned in for the night, I laid in bed, defensively scanning our recent fire history for proof that I did not receive special treatment. That's when I remembered the lunch box.

We had started our night shift at the Balch Fire a few hours earlier, when I noticed I was feeling a bit off. I had a headache and my shoulders were tight and burning. A couple of ibuprofens and some black coffee would help, not that I had either of those things.

We were all breathing heavily from hiking to the top of a monster hill. We listened as the boss instructed us to punch in a section of line to tie in with the crew above and below us and then install a hose line so we could blackline it later in the night. Piles of rolled hose waited to be laid and connected along the line before we could start the burn.

Thirstier than usual, I swallowed the last of the water in my first canteen as I listened. Blood pounded in my head and it was taking forever for my heart rate to slow. I was wondering if there was any Gatorade in my pack when I heard Rod ask for a volunteer. He needed someone to hike back to the bottom of the steep hill to pick up our midnight meals and carry them back up to the crew. No one offered. I saw him looking to choose someone.

Not me. Not me. Please don't pick me. I tried to make myself shorter and leaned in to hide behind the guy in front of me. Like when my math teacher was choosing someone to do a long division problem on the chalkboard.

"Hamberger! You're up!"

I cussed under my breath. Someone gave me a slap on the shoulder in sympathy. Slamming the empty canteen back into its holster, I tightened the straps on my pack. It was going to be one of *those* nights. Usually, I could hike down a trail like a mountain goat, but using a headlamp in the dark confused my depth perception. There were big boulders and water bars to step over, and slippery spots of shale to slide on, making the trek more arduous and slower than it would be in daylight, but hiking down the huge hill was the easy part. Getting back up with meals for the 20-person crew was what had me worried.

At the bottom, it was noisy and busy with hotshots, local hand crews, and engine crews coming and going. A heavy blanket of dust and diesel exhaust shrouded the fresh mountain air as big fire trucks idled, bumper-to-bumper along the gravel road. I searched through truck headlights and the engines' red parking lights having

no idea where to find our lunches. Humoring myself, I smiled to imagine approaching a busy fire official studying his map to say something silly.

Umm, 'scuse me. I don't really care about this massive fire suppression operation. Can you just tell me where my lunch is?

While standing in the midst of all the activity wondering where to look, a voice called.

"Horseshoe Meadows!"

He must've spotted my orange hard hat with a horseshoe emblem. I turned to see a man approaching with a large cardboard box in his arms.

"Here's your lunches."

He thrust the box into my arms and walked away. There I stood, with the big box that I could barely see over. Without handles, there was no easy way to carry this awkward burden back up the humungous hill. Weighed down with what seemed an impossible burden, I had a sudden urge to cry, just for a second, before replacing it with grim determination.

Pull it together!

Calling on the sisterhood of strong women from around the world, I remembered a photo in *National Geographic* of a woman in Africa carrying a heavy load on the top of her head. I hoisted the box onto my head and adjusted its position. Once it was nicely balanced on my hard hat, I took some tentative steps. This might be do-able.

Hoping that nobody bumped into me, I started the steep climb for the second time that night. Men passed me carrying heavy rolls of hose under each arm. I could hear them coming up behind me. They were breathing hard; I sounded like a spent racehorse in comparison. It was a wonder that I could hear anything above my own loud breathing. Some of the men passing must have felt sorry for me, because they said things like, "You're almost there!" even

though we both knew I wasn't. I barely eked out a "Thanks!" or "You too!"

The dirt on the trail had been churned to a fine powder from all the foot traffic. The darkness concealed the dust I sucked into my lungs with each breath, but I could taste it. With burning hamstrings, I tried to encourage myself with the mantra, *Slow and steady*. But I was not even halfway.

When running on the high school cross-country team, it had seemed like every practice had a hill to run. Coach Bushong subscribed to the idea: *"that which doesn't break you makes you stronger."* I wasn't a fan of Nietzsche, but if I allowed myself to dwell on the pain for even an instant, I would stop. So, I sang motivating songs in my head like Matthew Wilder's, "Break My Stride," and kept moving. One step at a time.

Halfway up, I started to talk to Jesus, asking for an ounce of supernatural strength and energy. Different Bible verses came to mind. There on that mountainside, near midnight, with twenty lunches weighing heavy on my head, I recited Isaiah 40:31:

Those (exhale)
who wait (inhale)
on the Lord (exhale)
Shall renew
their strength; (step over the water bar)
They shall mount up (don't trip on that root)
with wings (beware the loose boulder) like eagles,
They shall run
And not be weary
They shall walk
And not faint.

Imagining how it would feel to fly with wings of an eagle to the top of this mountain, I felt a lightness of being. This state of

reverie lasted until I inhaled a gnat that hit the back of my throat. I coughed, which threatened to upturn my precarious package.

I dared to look up. There was still a third of the mountain to go. Guessing how many steps it would take to crest the ridge, I began to count. In Spanish. Anything to keep my mind off the pain. When that got boring, I guessed at the contents of the lunch sacks. *Most likely ham sandwiches, but with packets of real butter? Or would it be that white glop they called margarine? No offense to the ones who worked day and night just to keep us fed, but there's certain things that don't belong in a firefighter's sack lunch. Like packets of mayo! Don't wanna' be sick out here. Stick with the mustard. Fruit? Who'd put a banana in a firefighter's lunch? Some kind of sick joke! My bet's an apple. Apples give us Vitamin C, potassium, magnesium, and the fiber we'll need for the Wonder-bread-with-rainbow-meat sandwiches. Chocolate? Lord, let there be chocolate. M&Ms melt in your mouth, not in your hands. Dr. Pepper is perfectly pristine poured over pulverized ice. Preferably when I'm done panting… perhaps tomorrow…*

I could no longer ignore the pain in my neck. My grimace got tighter. Just a few more steps. I tried to hike faster, but the box had to come down. Finally, after a 30-minute climb, I reached the top. I staggered to the far side of the staging area, knelt to my knees, and tipped my head forward. Catching the box in my hands, I set it on a stack of hose.

Taking off my pack, I untucked my sweaty t-shirt to revel in a calm, floating sensation. I sat for a minute to catch my breath and rub my neck. Enjoying my runner's high, I noticed my headache was gone. I also noticed that the hose line was locked and loaded. From the orange glow of firelight, I could see a cluster of my crewmates not far away and walked over to join them.

They were intent on something. The guy in the center of the group was holding what looked like a white plastic pistol with a wide barrel. They called it a "Very" pistol, a flare gun invented by Edward Wilson Very, a US naval officer. It was used in both world

wars to send signals. This flare gun has been adopted by wildland firefighters to ignite fires in heavy fuels and steep terrain.[1]

Crewmembers watched as the guy in the center loaded the single-shot flare gun, aimed high, and fired. With a loud BANG, an explosion of red light arced up into the black void, illuminating the brush below it. It dropped into the brush and WHOOSH! There was fire. It was the easiest way to light a line of fire in a steep section of terrain thick with brush that stood between the fireline and the wildfire.

It was the coolest thing, and everyone wanted a turn shooting. There was almost a party atmosphere while we shot the flares and watched the fires that sprang up on impact just where we wanted them. It was one of those rare moments when everything seemed to cooperate: Light winds were blowing in the right direction, we had a wide fireline, and plenty of water to douse any errant sparks.

"Hey, let me try. I want to shoot it," I said.

"Nope. Better leave this job to the men."

My eyebrows shot up in surprise and dismay at such language. *What?!*

My retort was swift: "Ah, okay. Good luck finding your lunches I carried all the way up this blasted hill!"

With a growing awareness of prejudice, I turned to walk away in disgust when one of them grabbed my arm.

"Get over here. You get one shot! Aim it to the left about ten feet from the smallest fire."

I hit it dead on. A great deal of satisfaction can be found in the simple act of pulling the trigger and watching that flare explode into a burst of flames. For a while, we stood watching a line of fire form, listening to the hiss and whistle of burning scrub oak. Sometimes we'd see what we called "fire devils." Whirling eddies of air combined with combustible gases look like little fire tornadoes with a haunting howl. Mesmerized by the eerie visual effects, I was comforted by the fact that there was water behind us. We watched

The Burn

Horseshoe Meadows Hotshots: L to R: Nancy Ayala, me, Chancey Bridges, Elena Rios, Eugene Osborne, and James Workman in 1989

with satisfaction as the fire progressed in a tidy line up the hill toward our line.

"Wouldn't it be great if firefighting were this easy all the time?" I asked.

"Yeah, but we'd all be out of a job," said the nearest crewmate.

"Hey, so where are those lunches, Hamberger? We're starving!"

In my mind, that hill hike to fetch the lunches was an instance of not being favored and of working as hard as everyone else. I also remembered being one of three women that Ben Charley (our Super) chose to be the fire starters when our crew's assignment was to ignite a burnout operation. When the boss handed each of us a drip torch, it felt like an honor. To me, burning out is important, almost sacred work. It's not difficult, but the end result clears the land of excess fuel and it stops the wildfire. Problems sometimes arise if the wind picks up and changes direction, but this time the two fires met and ran out of fuel.

It felt like we walked miles along that hillside, so intent was our concentration. When we finally tied in to a fireline, we walked back to the start point. The fire moved nicely up the hill toward

the ridge line, just like it was supposed to, not too hot and not too fast. The big pine and fir trees would survive to protect the hillside from winter mudslides. By the next summer, the hillside would be carpeted with green grass and wildflowers. It felt good to watch the controlled fire that we had started do what it was supposed to do. It was a job well done.

The most exciting thing that happened toward the end of the season occurred the day we were working on a remote ridgeline. That afternoon, the fire started to blow up below us and retardant drops were ordered. The reddish-pink liquid slurry is designed to coat the ground, trees and brush to slow the spread of fire. It works well... when it lands on the fire.

"Hey, guys, they've ordered a retardant drop. Move off the line and get ready for a show," our squad boss ordered.

We moved twenty yards away from the fireline, into position to watch the giant air tankers spray the mountainside below. I quickly dug in my pack, searching for my small camera, remembering that I was on my last roll of film. I blew as much dust and grit from the lens as I could before I heard the rumble of the approaching plane. This was going to be a rare photo opportunity and I focused on finding the perfect angle when I heard panicked yelling.

"DUCK AND COVER!"

"DUCK AND COVER, NOW!"

A deafening roar drowned out all other sounds as I looked to the treetops to see the air tanker flying right toward us. With a glance, I could see the pilot was off course. All we had time to do was drop to our knees and cover the back of our necks. I was shoving the camera down the front of my fire shirt when I felt the slime spray my pack and hard hat. I heard cussing before the red rain stopped.

As soon as it had stopped, I pulled out my camera and started snapping photos. Crouched five feet behind Pam, I had only been

lightly sprayed, but she had been closer to the main drop-zone and had a gallon of goo dripping off her hard hat. We both laughed.

One of the guys had taken off his pack to adjust his shirt and didn't have time to put it back on. The entire back of his fire shirt was coated in slime. Both he and Pam looked like they had taken a shower in Pepto-Bismol.

We laughed again when his fire shirt dried; it was so stiff, it literally stood by itself. Our laughter was mostly relief, as we knew that people could've been hurt. We'd heard stories of slurry drops dislodging giant boulders, crushing cars, creating rockslides, breaking tree branches, and even knocking down entire trees. The pilots did eventually drench the fire's hotspots and our fireline held. All in all, it was a good day and a good ending to a challenging summer.

In the dreary, cold and rainy months back in Eugene, I would find myself smiling as I remembered that sometimes slime happens.

Horseshoe Meadows Hotshots Pam Hoffman and John Workman drenched in fire retardant

Cathedral of Seville, Spain. Photo by Fernando Domínguez Cerejido

Spain
Chapter 18

Entering my last year of college, I looked at the colorful poster advertising a semester to study in Seville, Spain. Enduring four years of high school Spanish and more years in college, I was now in 400 level classes. Though it took hours, I could write basic essays in Spanish. A friend had returned from her semester in Spain and talked at length about her experience. Our Spanish professor also urged our class to go, insisting "If you can afford it, you should go!" Thanks to long days on the fireline, I could afford it, and I wanted to go.

With my Latin blood, I assumed I had ancestors from Spain because Latin America's first immigrants came mostly from Spain or Africa. Maybe I'd feel some kinship with the Spaniards I'd meet. Once I had paid the $1,500 deposit, the next challenge was to maintain the B or better grade in the professor's required class. If we didn't make the grade, we couldn't go and would lose our deposit. Counting down the days to departure, I was looking forward to my future surroundings: sunshine and red geraniums on ancient, cobbled streets … when Paul called.

He wanted to see me. Tired of letters, he said he'd buy me a plane ticket to Hawaii. I could stay as long as I wanted. His invitation to Oahu was both thrilling and frustrating. Part of me wanted to say, *"How 'bout tomorrow?"* His letters described swimming in the

surf with sea turtles. I daydreamed of drifting on a catamaran with him through turquoise waters or reclining in a hammock under the shade of palm trees waving in a gentle breeze. My reality in Eugene was cold, grey, and wet.

But the timing couldn't be worse.

I held the phone to my ear, quiet, as I considered the full impact of his offer. Just say the word, he said, and he'd send the ticket. Now I faced another choice: Spain and the unknown, or Hawaii and Paul? I couldn't do both. And I was afraid that if I accepted Paul's offer, I'd never leave paradise to finish school.

"Hello?"

"Yeah, I'm here."

I sighed, as I searched for words.

"Why now, when I'm eight months from graduating? I've already paid the deposit for Spain. I have to be in class every day or I won't make the grade. I'll lose my spot … I can't come."

I knew I was the odd duck to decline his offer. And it wasn't just about Spain; our relationship was complicated, and his invitation to Hawaii involved a subterranean commitment that I was too scared or not ready to make. I hid my insecurities behind the trip to Spain.

I told him I'd love to visit when I returned from Spain and graduated. *What's another eight months after waiting six years?* I suggested he come visit me in Spain. I even had the audacity to tell him to be patient, which was met with a stony silence.

When our conversation ended that night, I had a headache and felt a deep weariness. Soon I had a raging sore throat. The next morning it was still sore. And the morning after that. Days later, I went to the doctor who gave me the bad news.

"You've got mono."

"Mononucleosis? As in the kissing disease? I'm not kissing anyone!"

I wanted to cry.

"Have you been sharing water bottles? Been more stressed than usual in the last few months?"

Now I had a headache again and rubbed my forehead.

"That sounds about right."

"Well, mono's a virus that requires rest—like three to six months to fully recover."

"My flight leaves for Madrid in three months."

The doctor shook his head as he scribbled quick notes in the chart.

"What about traveling to California next week to my brother's wedding?"

"No. You're sick. The only place you'll be going is to bed."

I smiled at the impossible simplicity, wiped my eyes, and slid off the exam table thinking, *We'll see about that.*

When my parents stopped at my apartment on their way to my brother's wedding, I was lying asleep under the kitchen table. Sun shined through the window onto the floor in a rare sun break. I was under the table because that's where the sunbeam was—my body craved warmth and light. At this point, I had been sick for a month. I had warned them that I probably couldn't go to the wedding.

When they arrived, I was wearing grimy sweats, hadn't showered in days, and when I swallowed, something like razor blades still cut my throat. I had hardly eaten. When they walked in, they looked alarmed.

"I'm still sick," I croaked as I crawled out from under the table.

"We see that."

"The doc said I wouldn't be able to go to Spain… or the wedding."

"I'm sure your brother will understand."

Mom said this as she turned on a light, cranked up the heat, and filled the teakettle. Then she rummaged through kitchen cabinets,

finally procuring a bottle of Tylenol. Meanwhile, Dad looked for a football game on our three-channel TV.

"I'm not so sure. They postponed their wedding date from the summer at my request, just so I could come."

On the verge of tears, I sat at the table wrapped in a blanket trying to swallow the bitter pills. Before long, my mom set a plate of poached eggs on toast in front of me, along with a cup of peppermint tea. Suddenly, I was ravenous. She sat at the kitchen table and wrapped her hands around her own mug of tea while I ate.

"Ma, did you see the movie *Moonstruck* with Cher?" I asked.

"Yeah. That was a good one." She smiled.

"You remind me of Olivia Dukakis in that movie... she was strong and steady. So are you... you're a good mom."

She patted my hand and I sipped the tea. That's how we said, "I love you."

Illness never comes at a convenient time. My parents left, as did my sunbeam. I crawled into bed and slipped into a fevered oblivion. I'd have to miss my brother's wedding, but I had to go to Spain. I had to. I was not going to be felled by stupid mono. The trip had been paid for by toil and tears. I was going to Spain, even if it killed me. I took vitamins and dressed to attend my classes, but remained in bed whenever possible. Over the Thanksgiving holiday, I stayed on the couch and watched movies when I wasn't sleeping. I returned to school for the last few weeks before the Christmas holiday. My recovery was slow, but I was determined to finish school.

Somehow, even as sick as I was, I made it through my last fall semester of college. I managed a B minus minus in that Spanish class. Moving out of the apartment, it barely registered that I was done with school in Eugene. I would attend my last spring semester in Seville, Spain. Christmas break at my parents' house was a blur of convalescing. Consuming copious quantities of chicken soup, I also drank glass after glass of watered-down orange juice. And for three

weeks, I slept.

The sleep and OJ seemed to do the trick. By early January, I was beginning to feel better; the fever ended and my sore throat disappeared. I had made up my mind: I was going to Spain. One afternoon, a few days before it was time to board the plane, Mom took me shopping, something we rarely did together. Her favorite store was Goodwill, but that day we drove to the big mall. She bought me a large Samsonite suitcase, the latest in luggage, with two wheels and a retracting pull strap. Presenting it to me as an early college graduation gift, she smiled and gave me her blessing.

"May you go far in life."

The night before I left for Spain, I was still packing when my dad came to my bedroom door and watched. It was awkward. To cover the silence, I pointed to things in my suitcase as I read aloud my packing list. Finally, he asked if he could pray for me. This was a first. We sat on my bed, eyes closed, heads bowed, and he called upon our Father in heaven to provide for my health, give me discernment, and protect me while I was a stranger in a strange land. It was a beautiful prayer. I sensed the comforting presence of the Holy Spirit in my little bedroom. I even shed a few tears after he left. I was a bit perplexed though, as to why he thought my semester in Spain needed to be prayed over more than my summers of fire.

My classmates and I arrived in Madrid in the morning after twenty-four hours of flying in and out of multiple airports and across the Atlantic. Outside the terminal, we stood blinking in the late January sunshine. The city bus delivered us to our hostel, where we left our luggage and went to stroll through one of the city's many parks. The park bustled with people, street musicians, food stands, doves, old men playing chess, and horse drawn carriages that were parked along sidewalks strewn with peanut shells. All around me, I felt a joy for life.

For the first time, I heard the Gipsy Kings, a Spanish group whose music was playing over a loudspeaker. Watching what I would learn was a typical Saturday morning in Madrid and listening to the Gipsy Kings' classic songs, like "Bamboleo," I was instantly happy. The song title was close enough to the Spanish word for firefighter, *bombero*, that it felt like a cosmic welcome to Spain. It's impossible to hear that kind of music and not feel joy.

Once in Seville, we were given our housing arrangements. Our Spanish professor had warned us that she'd be choosing our roommates and not to plan to room with our closest class friends. I didn't have any close friends in the class, but like the others, I was anxious to know my roommate.

Since God has a way of always stretching me, I guessed that mine would be Jeanette, the classmate I never talked to and didn't know a thing about, because we were both quiet. I smiled when, sure enough, our teacher announced that Jeanette and I would be staying together. Searching for her in the group, I glimpsed her small frame standing toward the back, looking down at her papers. I walked over and gave her a sideways hug and took a deep breath to overcome my shyness.

"Hello, roomie. Looks like we're gonna be buds for the next six months. Shall we check out our new digs?"

She smiled shyly and agreed. We flagged a taxi and made hilarious attempts to read a map and give the driver the address to our *casa nueva*. We laughed so hard the driver finally took our paper to read the address for himself while we sat in the back as new friends.

We arrived at a small white house, which abutted the sidewalk like all the other small white houses connected to each other on the street. When the taxi pulled up to the curb, a short, stocky woman who looked to be in her seventies greeted us with a thick Southern-

Spain accent. Her name was Angelita. I set to work introducing myself.

"*Buenos tardes, me llamo Katie.*"

"Karo?" She frowned. It sounded like she said Carol, or Carl.

"No. Katie."

"Ka-doe."

I decided she might do better with the long form.

"Kate, *como* Katerina."

I said it with a flourish, the way I imagine it's said in Italy. She smiled and nodded her head.

"Ah! Carolina, si! (thi)"

Then she turned to Jeanette.

"Zha-ni." For the next six months we were Yanni and Caro-lina.

She turned and beckoned us into her small, whitewashed house that smelled faintly of fried fish. A widow, she rented a room in the back which had two small beds, two dressers, and a small lamp and table between the beds. We walked through a tiny tiled outdoor courtyard where several songbirds chirped inside a bird cage. Both her kitchen and her bathroom were adjacent to the courtyard and each was the size of a large restroom stall in the States. She advised us to take quick showers because the only hot water was solar heated from the black tank on the roof. As it was January, we would be lucky if we got lukewarm water.

The courtyard had a narrow stucco stairway built into the wall that led to a flat roof. From the roof, I could look across other flat roofs to see a portion of the Spanish beer factory, Cruz Campo. I would spend hours every day on this roof with a notebook, a Spanish-English dictionary, and my textbooks.

There was no easing into this semester. Teachers at the Institute of International Studies also taught at the local university and spoke no English in their lectures. Worse, they spoke a dialect of Spanish that I struggled with from the first day. As the story goes, there was

once a king of Spain who had a lisp. In deference to his majesty, the common folk began to speak with the same lisp. All Ss and Ds were spoke with a soft *th* sound, and they dropped their R's. It took me forever to understand and pronounce the accent.

I was up and dressed early the first morning of school to walk to class, but struggled to open the wrought-iron inner door. I twisted, turned, and jerked every knob and latch trying to open it. Angelita's room was right next to the metal door, where I was making a racket that echoed across the tile floors and up the stucco walls.

"*La-pe-tha-e-thaa-the-aw-tha!*" Our housemother yelled from her bedroom. It sounded like one long word. I stood there trying to translate while she repeated herself several times. Then it came to me.

"*La puerta esta cerrada!*" The door is locked.

I needed to unlock the door. Not helpful. She came out in her curlers and bathrobe and glared at me like I was a brick short of a load. She twisted this and turned that and the door eventually opened. I thanked her and apologized for the early hour but she waved me off.

Yanni liked to sleep in, so I learned the bus route and schedule on my own. A bus ride in Seville was different from the quiet, spacious, half-empty buses that we ride in Oregon. It's standing room only on the way to the city center and an overload for one's olfactory senses. Most Sevillians had limited hot water reserves in the winter and did not shower every day. More like once a week. Instead, the men on the bus, wearing pressed suits and ties, shaved, then splashed themselves every morning with aftershave.

Every aftershave on the market was represented on that bus. The result was potent; it was spicy and nice, but sometimes it made my head spin. The ride home in the afternoon was another story. I imagined myself shouting that they all smelled worse than a crew of firefighters, but to be fair, mental work smells worse than physical

work and forest fire smoke covers a multitude of smells. I took to walking the forty-five-minute route back from school. It was a good way to burn off the fresh bread calories.

The bread. Oh, the bread. Near our school, I'd stop each morning at what they called a bar, but was more like a café. I'd order orange juice and toast, and my mouth would water as the server cut Valencia oranges and fed them into an industrial juicer, then sliced a small loaf of bread, still warm from the oven to toast. This slice of heaven established a daily routine. I became friends with the servers who were there all day every day. Sometimes they'd even help with my homework.

It was a lot colder in Seville than I expected in January and February. No one had central heating because Spain is very warm the rest of the year. Angelita had a small electric heater that she turned on under the dining table when we ate. Her tablecloth was more like a thick blanket that covered our laps so the lower halves of our bodies were toasty warm. After lunch, we often sat with the *señora* for an extra hour and tried not to doze while watching Spanish soap operas. We couldn't understand them, but it was the warmest place in the house. Sometimes while sitting there, I'd force my eyes open only to find the other two watching with their eyes closed.

"You're seriously going to bed wearing your jacket?" Jeanette laughed from her bed, later that night.

"Yep. You have no idea how much I don't like being cold."

She rolled her eyes, maybe thinking I was over-the-top about it, but after a few minutes, she put her jacket on, too.

Not far from the famous Tower of Gold (*Torre del Oro*), an exquisite watchtower that had been built in the 13th century, was a place where classmates would play pool and have a drink. It was here that I met Rosie, a local college student at the university. She knew enough English that we could communicate and we became

friends. Riding on the back of her Vespa scooter, I saw the old city up close. We circled the great water fountains in the middle of the roundabouts, rode past the palm tree-lined university, and along the great Guadalquivir River, the very river that Christopher Columbus sailed up to deliver gold to the Spanish crown. It was a surreal thought: here I was, almost 500 years later, in 1990, riding into the sunset along that same river.

Scooter rides with Rosie were one of the highlights of my days in Seville. Our classes were difficult; the professors lectured on Spanish literature, history, architecture, and current events. The first three months, I felt like I understood every third word. Concentrating on what they said, I sometimes caught myself staring intensely at their lips. Sometimes they talked louder, in an effort to help me understand. If their volume of discourse was any indication of my lack of understanding, I was in trouble. My brain was exhausted by lunchtime every day and I still had to read assignments from Spanish textbooks. Tattered and dog-eared, my dictionary began to look the way I felt. It wasn't long before all the reading and writing and struggling to understand took its toll.

Homesick and lonely, I couldn't just pick up a phone to call home. Placing an international call cost too much; letters took weeks to arrive. I realized, too, that I missed being with God publicly, like going to church. More accurately, I missed being with other people who wanted to be with God.

As a girl, I'd wake up early on Sunday mornings to get ready for church while the rest of the house slept. I'd pedal my bike to the community church simply because I wanted to. Light streamed in through the colored glass, while I sat listening to the music and the lyrics praising God in harmonies that rose beyond the ceiling. Church services brought a sense of peace. I believed in the God the pastor preached about, and I believed in the Jesus the Bible

describes. For me, church, in the form of a group of believers, was where love and beauty came together.

I saw a myriad of Catholic churches in Seville and visited the city's most spectacular church, the Cathedral of Seville, several times. The first time was with my Spanish Architecture class. It's known as the *Catedral de Santa Maria de la Sede*. It's the largest Gothic cathedral in the world. The builders began construction in 1401. (For historical context, I thought of the elementary school rhyme: *In 1492 Columbus sailed the ocean blue*.) This church predated Columbus by almost 100 years and was designed to demonstrate the wealth of the city.

From start to finish, builders completed the architectural wonder in 127 years. It was financed by the gold and other natural resources taken from the New World. Spanish monarchs appreciated Columbus's contributions so much that they built him a royal tomb inside.

I was awe-struck by the gold, silver, marble, and ornate designs and carvings that all pointed to a master Creator. See Psalm 8:1 *"How majestic is your name in all the earth"* and *"The earth is my footstool"* from Isaiah 66:1. Those verses came to mind, which was probably the goal of the architect.

The cathedral's ceiling is 132 feet high.[1] The average American stands almost six feet tall. It would take 24 people stacked one on top of the other to reach the ceiling. I felt an instant reminder of the greatness of God (and my smallness in comparison). A person could sit for hours staring at the stained-glass windows. Each window is an intricate colored-glass mosaic showing a Bible character in action. There's David, an ordinary shepherd boy being anointed as the future king of Israel. Over there is Paul, a killer of Christians, being blinded by the light and his conversion in the middle of the road. And there's Jesus, as he rises from the dead. The famous floor to ceiling altarpiece features forty-five exquisitely carved scenes from

the life of Jesus, all plated in gold. These intricate carvings shined through the heavy pall of incense in the quiet gloom of candlelight.

The cathedral was stunning on every level, but it was empty. I longed for a community of believers. I was lonely living in this country of foreign customs and language. I enjoyed Jeanette's company, but she spent most of her free time exploring the city with her best friend from class. I often prayed, asking God to help me through the loneliness and to find more friends. After a particularly long, lonely night, I was inspired to do some investigating.

At Seville's Office of Tourism, I asked the woman at the counter if there were any non-denominational churches in the city, like a community church. She pulled an old binder out from under the counter and blew the dust off its cover. She flipped through pages, found what she was looking for, and wrote down an address. We went to a big map spread out on the counter next to us and found the address of the church. She marked it with her finger. Then I gave her my address. In a city roughly the size of Portland, there was one church that fit my description: It was a ten-minute walk from where I lived.

Sunday finally came. On my walk to the church, I stopped at a *pasteleria* to choose a churro from a large assortment of mouth-watering pastries and ordered an espresso. I found an unoccupied table outside and joined others who sat and read the front page of *El Mundo*, the Sunday edition of the newspaper. Sunday morning leisure time… one of the joys of life.

When I got to the church, the pastor was greeting people at the door. He was tall, his dark hair greying at the temples, and his accent was less pronounced; I understood him. He greeted me warmly and may have thought I was a local, which happened a lot. If I didn't wear typical American attire, the t-shirt, jeans, and Nike running shoes, I looked like I belonged there.

The crowded church was bright and noisy and I sat toward the back, shocked to see so many American students. I had never seen any of them before; I learned that they studied at the University of Seville. A blonde American woman sat at an electric keyboard and sang harmony when the music started. The blonde woman later introduced herself. Rachel was from Wisconsin. She led a mid-week Bible study for American college students and invited me to join them.

At her apartment later that week, I was surprised, again, to find a large group of students, from almost every state in the US, gathered to study the Bible. Because the pastor of that church was willing to welcome homesick Americans, and because Rachel was willing to share her apartment and reach out to students, I now had a dozen new friends. We met at Rachel's every week. Often on the weekends we met at different restaurants for *tapas* (appetizers of Spanish cuisine, like delicious fried baby squid known as *chopitos*). Exploring the city and great food with new friends minimized my bouts of loneliness, while I made the most of the time I had left in Spain.

With the coming of Spring, the fragrance of orange and lemon blossoms wafted everywhere and the days grew warmer. I took off my jacket and finally began to understand the Spanish of Seville. My study abroad was turning into a great adventure.

Village of El Rocío in Andalucia, Spain. Photo by Rafale Tovar, via Flicker

Gypsy Girl
Chapter 19

While studying on the roof one day, Angelita shouted for me: I had a phone call. Running down the stairs, I hurried to pick up.

"Hello, Hello?" I said breathlessly through the static.

"Kate, what took you so long? It costs twenty dollars a minute, ya know."

"Oh. Dad. Hi. Is everything OK?" I asked, bracing myself for bad news.

"Yeah, all is well here. Everything OK there?"

"Yep. Things are good. I have to study… a lot. The semester's almost over."

"Well, take care of yourself. I gotta go. Bye, now."

And with that, he hung up.

I stood there holding the phone, considering the significance of the call. It may have been the first ever call from my dad. *Did he miss me? Was he worried about me?* There wasn't a name for it back then, but now I know my dad struggled with social anxiety. Phone calls were hard for him. His brief connection was heart-warming and seemed to assure the *señora* that I was not an orphan. During my six-month stay in Spain, his was one of only two phone calls I received.

Letters were our lifeline home. Because of the expense of overseas calls, I and the other students mostly relied on the mail

for a touch from family. Mail was handed out before our first class, which motivated most of us to arrive on time every morning. We all hoped to receive a letter and that connection with home.

The letter writers in my world must have been suffering from writer's fatigue. Day after day, I waited for a letter and pretended it was fine when I didn't get one. The day Jeanette got a package, we oohed and awed. We all wanted her to open it right then and share whatever it was, but she preferred to enjoy the guessing game we made up about what was inside.

"I bet it's a package of cotton briefs, some toothpicks, and dental floss!" said Peter, who was met with dirty looks.

"Maybe it's a book on Spanish wildlife and a good pair of readers from your grandma," joked another.

The guessing game continued through the day. The idea of a care package was new to me, and I couldn't wait to see what she got. Back at our little house that evening, I sat on my bed across from hers and enjoyed watching her open it. She pulled out a big bag of M&M's that were coated in pastel colors for Easter. Almond M&M's. My mouth watered. Jeanette poured a generous amount into my cupped hands.

"Wow! I didn't even know these existed! They're the best M&Ms ever."

"Where have you been?" Jeanette laughed.

I laughed, too, and sat back to enjoy the candy, while listening as she read her letter aloud. We mentally traveled to her home in Washington, as she told me more about her loving family. I will forever associate almond M&Ms with Jeanette and Spain and the *Semana Santa* holiday.

Semana Santa, the Holy Week of Easter, is Spain's biggest holiday. The streets are packed with parades where elaborate religious icons plated in gold and silver are carried on the shoulders of men dressed in hooded robes. My reactions to my first sight of

these men were shock and horror: they reminded me of members of the Ku Klux Klan, except the gowns they wore were black. One warm evening during *Semana Santa*, a group of us walked down a crowded street past a bar, where a man wearing a robe with his hood off stood leaning against the entrance, drinking a beer. His sweaty hair was plastered against his red face. I asked him about the black robe and masked hood.

"These are an expression of the Bible verse '… *All have sinned, and all fall short of the glory of God.*' (Rom.3:23) The robes unite us. None of us measure up to God's standard."

The Spaniard then saluted us with his bottle of beer.

"Amen!" We responded.

And the Bible says we're all equally forgiven, if we ask, (1 John 1:9) I wanted to add. It was a relief to learn that the appearance of evil and inequality I associated with those hooded robes turned out to be quite the opposite.

Studying on the white-washed roof in my swimsuit resulted in a dark tan. Walking past a construction site on my way home every day, construction workers shamelessly leered at me, flashing their gold teeth. They made obscene gestures and derogatory comments. Among other things, they called me a gypsy.

"*Ay, Gitana!*"

"*Ven aqui, Gitana!*" One of them shouted from the unfinished roof.

As obnoxious as they were, they weren't as scary as running into a prison inmate alone in a forest at midnight. Gypsy or not, I walked with confidence, like an American hotshot, or, like a loved child of God. I could look those men in the eye. Their words and gestures were ugly, but I wasn't going to change my walking route just to avoid them… at least, not most days.

My favorite Bible verse is Psalm 84:5, *"Blessed are those whose strength is in you, whose hearts are set on pilgrimage"*. Living in Spain, working on fire crews, and attending universities required grit and a determination to stay with it, when it would be much easier to return to my comfort zone. I've always felt certain that God would give me the strength and provision I needed. As I've traveled and depended on God's help to overcome big challenges, my faith has grown. When there was no other option, I was forced to rely on God's provision, which creates an experience-based faith.

One afternoon at school, Peter, who was from a farming family in Pendleton, Oregon, announced he was going to take the train to Madrid that weekend to see an art exhibit at the Prado, one of Europe's finest art museums. Did any of us want to go? Several girls said they were interested, but on Friday night, only Peter, Manuel, and I boarded the train.

Looking back at our trip, I am struck by the power of Spanish art. I was particularly moved by the mosaic work. The intricate designs made of small colored tiles, arranged to create masterpieces, were stunning. They also used mosaics of wood—marquetry. I found myself transfixed by a table that had once stood in the king's palace: the entire top was inlaid with different types of wood that had been painstakingly cut into shapes and then meticulously arranged in floral and geometric forms. I recognized different types of wood grain—oak, pine, cherry, walnut, teak, mahogany, birch, and fir, but there were many more, and all were sanded and polished to a brilliant sheen.

It was a delight to be visually reminded of how creative our art can be. I was equally amazed by the beauty of the architecture of the Cathedral of Seville as I was by the beauty and artistry of the mosaic work. However, the Spanish art that most stood out to me—more than the paintings of Picasso or Salvador Dali, and his melting clocks—was the work of Goya. Many of his paintings

are incredibly disturbing. He was drawn to depict social upheavals and turmoil. He created unforgettable images of the dark side of humanity. A few weeks later, I had a close encounter with it.

"Four o'clock!" the bus driver yelled out, as he pointed down the deserted road. "Don't be late!" Just before he had dropped me off on the sand road in the remote village of El Rocio, the driver explained that the bird refuge was a mile beyond the village, and I would know I was halfway there when I came to an intersection of another sand road. The important thing to remember, he said, was that I must return to that intersection by 4 p.m.. That was when the bus would pick me up for the return trip back to Seville. There would be no other buses and nowhere to go if I missed it.

Watching as the bus pulled away, I shouldered my backpack and started down the narrow road which cut through an endless stretch of thigh-high sea grass. I was at the southernmost tip of Spain, where the last bit of Europe juts into the Strait of Gibraltar. The great expanse of grass reminded me of the Everglades. It looked like the end of the earth.

I was on assignment for my Current Issues class, headed for a bird refuge to interview the manager about the heated national controversy over whether or not to build beach resorts on protected marsh lands. While riding in the empty bus all the way to the end of the line, I had begun to question my decision to take this trip alone. Besides being safer traveling with a friend, it's more fun. But none of my classmates wanted to come. They were all busy with their own reports, which were due the following week.

I had walked along the road for ten minutes when I heard a noise like distant thunder behind me. I turned to see a beautiful white Andalusian stallion cantering toward me through the grass. His rider was an old man who sat effortlessly in the saddle. He greeted

me with missing front teeth, which made his words hard to understand. I guessed that he was asking me where I was going and I pointed down the road and told him. He motioned to me to get on the horse behind him. Bemused and unsure of the right thing to do, I stood there for a moment. In general, one doesn't climb behind a total stranger onto the back of a stallion as if it's no big deal. But the horse turned a kind eye toward me and waited patiently as the old man held his hand out and gave me a stirrup. I smiled at the surreal tone this trip was taking, and climbed on behind him.

As the stallion pranced along, the old man told a story, periodically pointing toward the bird refuge and the sea grass. I didn't understand most of what he was saying. He kept talking in his low, quiet voice. With hindsight, I suspect he was trying to warn me, but I completely missed it. He stopped his horse at the intersection of the sand roads and said the refuge was just a little way further. When I dismounted, he tipped his ivy cap and turned his horse to canter back toward the village.

"*Adios Señorita!*"

There were no tourists at the refuge and the place looked deserted. Once I found the manager, he was happy to see me. He answered my questions about resort construction within the bird refuge with enthusiasm, railing against greedy corporate exploitation. After the interview, I toured the park with its waterways filled with every form of fowl one could imagine.

By the time I left, I was convinced that building resorts nearby would displace the resting area that birds had been using for centuries. Thousands of birds landed on these grasslands and waterways to recover from their long flight from Africa in the spring. These same birds returned in the fall, on their way back to Africa and many birds remained there for the winter.

On my way back to the village, from out of nowhere, a big dog appeared, nosing through the grass along the path. I scanned the

horizon on each side of the dirt road, wondering from where in the world the German Shepherd had come. I saw nothing but grass. The dog didn't seem particularly interested in me, but I welcomed its company.

"Hey, big dog," I said, as it went about its business. The dog seemed to ignore me.

We continued toward the bus stop when I heard a man yell. Surprised, I turned to look and off to my left, a tall, dark, lanky man was striding toward me through the grass, with malice in his eyes. He had long, black greasy hair, ragged clothes, and rotten teeth. Far behind him, in the distance, I spotted a ramshackle shed with a faint line of smoke inking out. I had not noticed it before. The man yelled again and pointed with wild, angry gestures to the dog that was off to my right. I shrugged and shook my head to indicate it wasn't my dog. I turned and began to walk faster, but he was getting closer. In seconds he was only a few yards away, yelling at me in a language I didn't recognize. Alone with a man who seemed out of his mind, I prepared to run. My heart began to race. *Jesus!*

Suddenly, the German Shepherd came up beside me, trotting between me and the man. This made the man angrier and he started toward me. I was just about to run when the dog stopped and turned toward the man. He growled, his lips curling over big teeth. His hackles were up. He had sensed the threat. For a long minute, the dog and I stared at the man as he stared at the dog. Slowly, never taking his eyes off the dog, the man backed away, all while muttering and spitting. Eventually, he turned around and walked back in the direction he had come.

The encounter was over. The dog went back to exploring in the grass. I reached the intersection. The bus came.

Still trembling, I climbed in and breathed a sigh of relief. I looked out the window to say a silent thank you to my champion, but the dog was gone.

Did that really just happen?

I scanned the horizon, but there was no sign of the dog. It had vanished as quickly as it had appeared.

The semester was almost over when I finally dreamed in Spanish and awoke in a good mood. (They say when you dream in another language, you're finally getting it.) That day at school, I was invited to a party. Seville was so hot in May that most businesses closed every afternoon around two o'clock and reopened at six in the evening, when the shadows were long and the heat tolerable. The bar where we gathered was packed and the waiters re-filled drinks with sweat streaking down their temples.

Jeanette and I listened to the stories of our classmates' field trips with their host families and the lavish meals that were cooked for them. It sounded like we got the short end of the stick with our host and her meager meals, but at least we hadn't gained 15 pounds which required a new wardrobe, like several of the others had.

The sun set. The temperature and volume rose in the bar, which had no air-conditioning. The place was packed. People kept coming. We moved our party to a table outside while other patrons congregated in the street. Loud, happy music played from surrounding speakers. The sense of celebration was contagious, and I turned to Peter, who happened to be the closest classmate to me, and shouted in his ear.

"Is tonight special or is it this crowded every time you come?"

"Definitely a different vibe tonight …maybe 'cause you're here." Peter winked at me.

He told me earlier that he had a girlfriend waiting for him at home, so I chalked his comment up to the festive mood everyone was in and the *vino fino* he was drinking.

The Gipsy King's song "Vamos a Bailar" came on and everyone cheered. We danced shoulder to shoulder in the street, under the

stars. Goodbye mono, adios hard work, loneliness, prejudice, and fear... I shook it all off and danced, aware it was a once in a lifetime kind of night.

Losing track of time, it was after midnight before I decided it was time to head home. I had missed the last bus back to our house. Hailing a taxi the way I remembered Audrey Hepburn had in one of her movies, I felt cool and cosmopolitan. Sitting in the cab's backseat after hours of dancing to loud music, the silence felt tomb-like. I asked the driver to turn up the radio. They played classic rock and a lot of American pop on Spanish radio. I expected to hear yet another Phil Collins song.

Instead, a song came on that I recognized from the first piano chord. My brothers were always listening to Supertramp and I started to sing to "Take the Long Way Home" in tune with the radio. The driver smiled into his rearview mirror and turned up the volume, nodding to the rhythm. But toward the end of the song, it struck me how sad it was and stopped singing. According to the lyrics, we need catastrophes in order to grow.

When the semester ended, everyone made plans to do their last traveling before they returned to the States. Once again, Peter invited his classmates to travel with him, this time to the southernmost coast of Portugal, a region called the Algarve. Several thought it seemed like the perfect way to end the semester. After many goodbyes, I headed for the train station, bound for the Algarve. I expected to see other classmates waiting, but Peter stood alone on the platform waiting to board.

"Is it just the two of us?" I asked.

"Yeah, I'm glad you showed up. Touring is not as fun by yourself." Peter smiled.

The train was prompt and before long we were sitting across from each other on bench seats, delighted to discover that the

windows opened. We took turns leaning our heads out on a curve to see the whole length of the train ahead and behind us. We joked about the train actually being a time machine because the scenery became more pastoral with farmers plowing terraced fields with the help of an ox, while donkeys stood harnessed to loaded carts. With no air-conditioning, we left the window open, played cards, and ate sunflower seeds, our bare feet propped on our backpacks.

We arrived in Lagos, Portugal, after dark and were met by locals who invited us to stay the night in the room they had for rent in their homes. One well-dressed older man, wearing a nice vest over his white collared, button-down shirt rolled up at the sleeves, pointed at us and raised two fingers. He looked kind so I nodded in agreement: Yes, we needed two rooms. He motioned for us to follow. As tired as we were, we hoped it was a decent place, because neither of us wanted to wander around a strange city at night looking for somewhere else to stay. We walked ancient cobblestone streets that wound up and up until we thought he was playing a joke on us. *Stephen King would have a heyday with this scenario!*

Finally, we stopped in front of a narrow door. We could see by the light of the moon that it was a white-washed stucco house. Once inside, his wife took her apron off and they proudly showed us their room with a double bed. Alarmed, Peter and I looked at each other. It would have to do. We each paid fifteen dollars and sprawled on our bouncy bed. It squeaked with each bounce, which was good for a laugh. Spreading the local map across the bed, we decided which beach to visit and which city bus to catch and called it a night.

We opened the white curtains the next morning to a panoramic ocean view with dazzling blue-sky and white-washed homes below. Vivid color splashes of bougainvillea vines spread magenta across white walls, as terra cotta pots of scarlet red geraniums flourished beneath them in the hot sun. A fresh sea breeze filtered the sound of gulls following the fishing boats in the distance.

We had arrived before the crowds of summer, and the mostly empty beaches were pristine. We hiked down a steep path to a secluded cove where warm emerald water lapped at my feet. We spent the entire day swimming and lounging on the beach. The reality of a day spent at the beach was just as beautiful and rejuvenating as what I had imagined the previous summer, except that the handsome man beside me was not Paul. I sat quietly and watched waves undulate along the rock cliffs. Peter was also lost in thought and there wasn't a need to talk.

That day on the beach stands out as one of the most relaxing, memorable days ever.

"May you have an exciting life." My mom once told me those words were part of a Chinese curse. I later read that the actual translation was "May you live in interesting times." When she told me this, it struck me as odd, because Americans seem to pursue excitement as a good and fun thing. But there's such a thing as too much excitement. Maybe each person is born with a quota of how much excitement he or she can enjoy, and beyond that amount, they become intolerant or resistant to it. Or, maybe the more excitement one experiences, the more he or she craves to balance it with quiet calm. Whatever the case, those few peaceful days in Portugal felt like a soothing pause between two of the most exciting seasons of my life.

Me with my camera. Photo by Dave Hunter

Misfit
Chapter 20

JUNE 1990. "Shouldn't you be graduating about now?" Mom asked.

"Yeah, I thought so, too, but I haven't heard anything."

"Well, maybe you should call someone!"

It was early June and the return from Spain to my parent's house found me restless. It seemed like I should be graduating, but I hadn't received any information about a time or place. I thought I'd feel smarter and more confident when I graduated. It was disappointing to realize that wasn't the case. Nor was I ready for a career. My mind drifted to one of my more challenging classes at the University of Oregon.

Every day in *Writing for News Media*, we were given a speed test: five minutes to compile a list of facts and create a clever lead sentence that captured the reader from the first word. Watching the seconds tick by on the big wall clock, I felt stress bunching the muscles in my shoulders as my classmates clacked away on their keyboards. Something about hearing *Ready, Set, Go!* in front of a computer left me paralyzed as I waited in vain for brilliant leads. When they came, my leads were mediocre at best. Listening as classmates read theirs aloud, I wondered (once again) if I had chosen the wrong

subject of study. I'd been working toward a degree from the School of Journalism, but I didn't think fast and there's hardly time in the world of clocks and deadlines to take time to ponder things while looking out the window.

Added to my slowness was the fact that almost every technical thing I had learned was obsolete by the time I graduated. We sat at huge computers with little green screens, blinking yellow cursors, and floppy disks. I had read in the school newspaper that within a year, the school was doing a total overhaul of their newsrooms. Besides hating deadlines and ever-changing technology, I didn't trust myself to be a productive addition to any quality press agency. Over the years, I had written scores of letters to friends and family. Those pages were usually the culmination of thought and processing while I worked the pulaski on the fireline. They all said I could write, but they were my friends. *How would I sell myself to a prospective employer if I had no confidence in my ability as a writer?*

Shaking myself out of my anxious reflections on school, I wondered instead if maybe I had misunderstood the graduation requirements. Maybe I wasn't graduating. Maybe that's why I was reluctant to call the school and find out if I was supposed to graduate. A whisper of fear poked at me that somehow I had fallen short on credits. My advisor had not been great at guiding me through the process. Weary of schoolwork, I didn't think I could bear it if I were told I wasn't done. After adding up my credits again, my confidence returned: it sure seemed like I was done. Despite my tendency toward conflict avoidance, I finally called the school.

After a short conversation, I quietly hung up the phone and brushed tears from my face before my parents noticed. Yes, I was qualified to graduate. But the ceremony was that evening. Somehow, I had missed all of the messages and reminders.

I didn't have a cap and gown and I had missed rehearsal. As a result, my name was not on the list of graduates attending the ceremonies. I was going to miss my own graduation.

I was the youngest in my family, but the first of six kids to graduate from college with a bachelor's degree, and I wouldn't get to celebrate it.

When I told Mom, she just stood there shaking her head.

"How is it that you didn't know?"

"Three different addresses in the last six months might've had something to do with it! I've been home for almost a week so why are you just now asking? I didn't think it mattered to you."

"Of course, it matters!" She rolled her eyes.

"Well, you have an odd way of showing it!"

I stormed out of the house to go for a run and have a good cry. Just this once, I wished I had the type of mom who would've called the school while I was abroad to order the cap and gown for me. Feeling sorry for myself, I borrowed her car and drove to Eugene the next day to visit Cindy.

Even my few close friends were difficult to lean on now. Ole-Ronkei had returned to Kenya, Laila had returned to Pakistan, and Cindy had joined a group of cyclists and was enjoying a new social circle. Everything about the city of Eugene seemed foreign now that I was finished. I needed to move on and to do that, I needed a job.

Sitting in my parent's kitchen at breakfast a day later, my dad entered and acknowledged the fact that I had graduated from college.

"So, you're all done with school, eh?"

"Yep. All done." I continued to read the Want Ads.

"You know, I would've paid for your schooling if you had gone to a Christian college."

I froze. Then raised my eyes to stare at him while recovering from the sucker punch.

"You're telling me this now?"

"No, I told you this years ago." He continued to pour his coffee.

"I don't recall... seems like something I'd remember."

Scanning my memory for any conversations with my dad about college, nothing came to mind. I graduated from college debt free on my own dime. Completely exasperated, I stood up and quietly left the room, needing to go on another run.

Years later, we revisited that conversation. He said when I was 17, he'd given me a pamphlet about the Oral Roberts University, a conservative Christian college in Oklahoma. Besides all the rules, the curfew, and the dress code, I didn't like how far away it was. I vaguely remember dismissing it as not somewhere I wanted to go and then forgetting about it. I realized later that my dad took the dismissal personally, but his comment at the breakfast table felt mean-spirited. I couldn't think of a reasonable explanation.

My dad was from the era when men wore ties and slacks to work and respectable women wore skirts. He'd watch Lawrence Welk and his troupe of old-fashioned singers and dancers on TV every Saturday night. He had never said anything, but I guessed that in his eyes being a firefighter didn't fit his image of a lady. He may have been ashamed of what I did to support myself, but I'll never know because we didn't talk about it.

It helped me to remember that God created me to be strong and capable. My dad's version of a godly woman differed from the one I read about in the Bible. I love how it describes believing women as being *"clothed in strength and dignity."* (Prov. 31:25) Even so, I prayed for direction ... and a job.

The next afternoon, Ted, an assistant crew boss from the Alpine Hotshots called with a job offer. I had sent in an application for another firefighting position before I left for Spain. While in Seville, I did daily workouts at a gym in case I was called.

"Katie, wanna' fight some fire with the Alpine Hotshots?"

I had met Ted at a fire the previous summer, but I'd never heard of the Alpine Hotshots. I didn't know what state they worked from, but it seemed like answered prayer.

"Yes! Just tell me when and where."

"How soon can you get to Las Vegas?"

Las Vegas?

(They were temporarily stationed in Las Vegas, Nevada.)

Hanging up the phone, I danced a jig right there in the kitchen, my adrenaline already pumping. Mom walked in with a load of laundry in her arms.

"Ma, I'm flying to Vegas! It's time to make some moo-lah!"

"So. You learned to gamble in Spain?"

"No! I just joined a hotshot crew. Time to pull my fire boots off the shelf!"

I hurried back to my room, but glanced back to see her shaking her head. She liked that the work gave me freedom to do things like study in Spain, but we didn't discuss the job's dangers.

From under my bed, I pulled out the big suitcase I had just unpacked. Packing was easy since I mostly wore government-issued Nomex all summer. My hands shook at the prospect of jumping back into the unknown, but I focused on the car I needed to buy and the choices that come with having money in the bank.

Once on the plane, I thought about my dad's apparent indifference to my departure. Maybe he wished he were going to Las Vegas. He was a careful gambler. He had suffered as a boy in the Great Depression. As an adult, in his free time, when he wasn't fishing, he spent hours poring over racing forms, filling small notebooks with pages of numbered columns as he searched for the elusive winning algorithm.

When I was younger and the horse races came to town, I would sometimes sit with him as he tried to pick the winning horse. He'd put two-dollar bets on my choices, but I rarely won, mostly picking

pretty over fast. Later in life, I've tried to look past pretty and placing bets doesn't tempt me. I'd worked too hard to gamble losing.

Pulling out my new CD player, I inserted my favorite Gipsy Kings CD, and played "Volare" I would fly and I would sing, just as the song said, and be grateful to have this job.

At the time, the Alpine Hotshots normally operated out of Springdale, Utah, located just outside of Zion National Park. Our temporary work was in a forested area north of Las Vegas, so we stayed in the old Thunderbird Hotel, near "The Strip." In the parking lot, Ted introduced me to my new crew. As I looked from one man to the next, my face grew hot. I hadn't thought to ask … I had just assumed there were women on the team. With mounting anxiety, I turned to face Ted.

"Where are the other women?" I asked in a lowered voice.

"You're it!"

"What? Four months living with these guys without any other women? You could've warned me!"

"Would it have made a difference?" He looked a little confused at my surprise.

"It might've," I conceded.

I thought back to our phone conversation. *Did he tell me I would be the only woman and I just somehow missed it? Why would they hire only one?*

"Well, look on the bright side. You get your own hotel room," Ted said, smiling as he held out my room key.

I looked at him while considering catching a flight back to Portland. There had always been at least a few women on my hotshot crews. Doubts assailed me. *Was I strong enough? Will I fit in?*

Since most fire crews are fully staffed by spring, my being hired in June was unusual. I was lucky to be a replacement. And I *did*

want the job. So, one day at a time, I decided. I took the key, and rolled my suitcase down the outdoor corridor to my room.

Previously, I had gotten along with some crewmembers better than others, but I always felt comfortable with them. I hoped to feel the same about the Alpine men.

That first week, the crew settled into a routine of extreme physical training, followed by more hard work. Each day after breakfast, we walked past diehard gamblers still sitting at their slot machines in the dark, air-conditioned restaurant. Stepping into the bright sunlight and heat of the mid-morning summer desert was a shock to the system.

After jogging through heat waves to a nearby city park, we circled up in the grass for strengthening exercises. This crew enjoyed push-ups and sit-ups. My workouts in Spain and at home were not nearly as challenging. Alpine training translated into maximum soreness. I had to be careful not to eat too much breakfast or I'd lose it.

After what felt like hours of PT every day, we drove up the highway to work on a tree thinning project. The crew was ready and waiting to snuff out any lightning-sparked fires, but I was thankful for this chance to catch up with their level of fitness. We worked at thinning brush and overcrowded tree stands. The crew took turns: half the crew used chainsaws to cut while the other half swamped. And then we switched.

A swamper collects cut brush, tree limbs, and small trees from the sawyers and throws them into piles for burning in the fall or early spring. I enjoyed this work. When we were finished, we had transformed a scraggily, overgrown section of forest into a park-like setting. Besides being pleasing to the eye, the increase of sunlight reaching the forest floor encouraged grass to grow. This made the deer and elk happy and also decreased fuels. If a fire burned through the area, it wouldn't burn as hot, saving the bigger trees and fertile

topsoil. Thinned forests that experience periodic controlled burns are healthier and fires are easier to contain.

Halfway into our workday on that first day, I was handed a chainsaw. I strapped on the chaps and started to cut while my partners waited to swamp. My arms were already shaky from the morning's push-ups. That, and concentrating to keep proper angles on the cuts, had me dripping sweat. I was slow. A half-hour into it, my swampers were bored and impatient. I knew if I tried to go faster, I'd get sloppy. An accident with a chainsaw is not worth the risk. With a resigned sigh, I shut off the saw and turned to the two guys working with me.

"I feel like I'm wasting time cutting at this pace," I said. "I'll keep cutting if you want, but I'm good at swamping. You're both good at cutting. If you don't mind, I'd rather keep swamping."

They didn't mind. I set the saw down and returned the chaps. One of them revved the saw and got busy, cutting in double-time to make up for my slow work. Apparently, waiting for me had given him a second wind. Or maybe he wanted to prove the point that they were better sawyers.

As I got to know my fellow crewmembers, I took photos of them like a reporter would. I was curious to know who these men were, where they were from, and how they ended up on this crew. Surprisingly, they represented almost twenty different states and were either college graduates, or had at least some college or military experience.

Only one person on this Utah crew was actually from Utah. He was our newbie, an 18-year-old named Gene, who the crew dubbed Opie for his innocent looks and manner. While we worked, he shared about his upbringing in the Latter-Day Saints, crediting his faith with giving him a clarity and optimism about his future. His clarity and optimism were not unlike my own.

Another hotshot with religion was a tall, dark, and very thin man we called Bones. While a Christian, he sometimes spoke in a way that got him into arguments. His faith seemed severe; members of the crew recalled a time when a rock song was playing on the radio and Bones told everyone listening that they would go to hell for listening to such rubbish.

I took to heart the Bible passage that says to believers that it's none of our business to judge how people who don't believe live. (1Cor. 5:12) I had learned the hard way that inevitably if I spoke about my beliefs, I would turn around and do or say something so un-Christlike as to give Jesus a bad name, just like the lyrics from DC Talk's song "What If I Stumble." I mostly kept quiet about believing in Jesus.

During that first long, sweat-filled week, the cumulative fatigue factor was great. I wasn't used to working in desert heat or higher elevations. Out of breath all day long, I had just enough energy after work to pull off my boots and fall prostrate onto the hotel bed. At the end of the last day of the week, I quietly congratulated myself as we drove back toward the city. My sense of celebration was cut short, however, when our rig made a sharp turn off the highway onto a gravel road and slowed to a stop. The driver yelled, "Indian Run!" A few of the guys let out whoops in mock happiness. Others groaned and cussed. I stood, stiff and sore from the morning's PT and afternoon chainsaw work, remembering that no matter how physically fit I was or wasn't, I despised Indian Runs.

Pulling off my boots in exchange for running shoes, which we all carried with us, I stepped outside and looked down the gravel road marked by sage-covered rolling hills stretching endlessly into the horizon. We got in line, single file, while my heart beat double time. The leader had a red rubber ball in his hands and when we started to run, he threw the ball up and over his head backwards to the guy behind him. That guy had to catch it while we ran, and

then he too threw it up and over his head behind him, and on down the line it went. We never stopped running.

When the ball reached the back of the line, that person had to sprint to the front with the ball in his hands to start the process all over again, as the new leader. If someone dropped the ball, the whole line had to stop and drop for push-ups before we continued the run. Those with sadistic tendencies purposely threw the ball in such a way as to make it almost impossible to catch. Sometimes they'd purposely knock the ball out of the arms of the person sprinting to the front. As I watched the ball bounce over everyone's heads toward me at the back of the line, I prayed that the person in front of me would be kind and the run would be short.

As I caught the ball and began my "sprint" toward the front, I giggled through the pain. Like a cartoon character running in place, I was breathing hard and my legs were moving, but I was not advancing up the line. The boss was probably thinking, "*Uh-oh, this is her sprint?*"

If the crew had not accepted me, they could've easily caused me to quit from that run. I was close to the end of my endurance. But all the balls thrown my way were catchable and when we did those push-ups in the gravel, no one seemed to notice when my wobbly arms only bent an inch. Score one for the crew.

On the drive back to the hotel, I got curious and turned to the guys sitting behind me.

"So, what's that run have to do with Indians?"

One of the guys smiled, while the other rolled his eyes and shook his head.

"No idea. Maybe you should go ask the boss."

"No! Don't encourage her. The boss may decide we need to run it again for educational purposes!" They laughed.

"So, Hamberger, you got a boyfriend somewhere?"

At that point, I wasn't sure if I did. It had been almost two years since I last saw Paul and the letters had stopped, but maybe that was from all the address changes — both his and mine. A hotshot's nomadic lifestyle was hard on relationships and so was life in the military. Regardless, I didn't like the way the guy was looking at me.

"I do. He's a Navy pilot."

"Yeah? Then what are you doing out here?"

"Saving for a car, paying bills... same as you."

I never did learn why that team building exercise was called an Indian Run, but I didn't think I'd like the answer if I heard it. Passed along from summer to summer it might be time to give the run a new name. I turned back around in my seat feeling lonely. There in a crew buggy full of hot, sweaty men on a dusty gravel road outside of Vegas, I wondered where Paul was.

The bus returned to the paved highway and began its descent from the mountains. From my window seat, I could see the sprawl of the desert city. When I had flown in, hundreds of private swimming pools, lush green lawns, and golf courses had shimmered in the heat waves below. They all sucked massive quantities of water from Lake Mead and the Colorado River, as if there were an endless supply. It was wasteful and shortsighted. *What happens if Las Vegas runs out of water?*

Throughout my travels across the West, I saw more and more examples of unbridled extravagance using up our precious natural resources. When a region experiences a sustained drought, bad fire seasons are never far behind. All those luxuries take a toll on the water supply. Our hubris extends to building houses in the forests and then wondering why when they burn ...

On a more positive note, I had survived my first week as an Alpine Hotshot. I accepted an invitation to walk with some of the guys to see The Strip. I was beginning to enjoy the character of this motley crew. And, I hadn't ever been to Las Vegas. Everywhere

there were neon lights, traffic, and crowded sidewalks. The whole city vibrated with a kind of jangling energy. At the entrance of a casino, a woman wearing thick make-up, a tight, low-cut shirt, and a pink mini skirt approached us with a tray full of free beer.

"Oh my god! Have I died and gone to heaven?" One of the guys exclaimed. "Somebody pinch me!"

His crewmates were happy to oblige. I looked at the pretty woman with her tray of free drinks and she looked at me. For a minute, I considered what it would be like to trade places with her for a day. I would not like her job and doubted she would like mine. We entered the dark casino to the sound of a hundred slot machines ringing out their hollow euphoria. As the moving sidewalks propelled us ever deeper into the casino's dark abyss, I didn't understand the allure. It wasn't what I imagined when I thought of heaven.

I walked beside Dean, who was a college English major and professional river rafting guide when he wasn't a sawyer. Hailing from South Carolina, he was handsome and spoke with a subtle southern accent. He had a fun way of expressing himself. If he agreed with you, he might say, *"I concur wholeheartedly."*

After our day off, the first fire call came. It was a five-acre spot fire at Red Rock Canyon, just west of Las Vegas. As fires go, it was easy; we had it lined and mostly out by the end of the first day. The second day we went into mop-up mode with our gloves off, cold-trailing and spreading any remaining heat to cool. Everything had to be cold to the touch before we left.

In the afternoon during this final process, we got another fire call. It was near Payson, Arizona, roughly 400 miles southeast of us. It had the potential of being a big fire with ample overtime and hazard pay.

We were about to learn just how big this fire could get in a day.

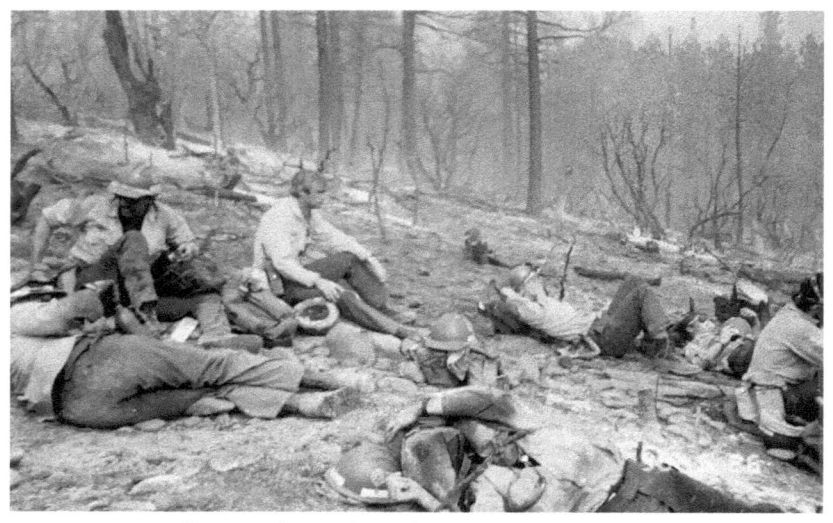

*Alpine Hotshots at the Dude Fire, near Payson, Arizona
(Top left, Squad boss Dave Hunter. Far right, I'm holding my hard hat)*

Bad Moon
Chapter 21

There were four Davids on this crew. By the end of the day, I saw each of them as a hero. All worked beyond the call of duty to fight a Goliath. After checking out of the hotel, we drove all night. The last to join the crew, I got the last seat available in the crew carrier, with almost no leg room and hot air blowing from a broken A/C unit.

Sleep was impossible in the stifling heat, and I was on the verge of being car sick. Finally, in the wee hours of the morning, I volunteered to ride shotgun. The privilege comes with the responsibility of keeping the driver awake. If I couldn't sleep, at least I could stretch my legs and roll down the window. One of the Daves, a sawyer on the crew, drove the second shift. I wondered how he did it, drive at night and then cut all day. At one point, he caught me dozing and smacked my shoulder.

"If you're gonna sleep, get out of that seat!"

Sitting up straight, I watched by the light of the moon how the landscape changed from desert to forest as we gained altitude on the Arizona highway.

We were enroute to the Tonto National Forest, about a hundred miles northeast of Phoenix and ten miles northeast of the small town of Payson. On June 26, 1990, the weather forecast blared over the radio: temperatures were expected to reach a record-breaking 122

degrees in Phoenix.[1] That kind of heat grounded the commercial jet planes at Sky Harbor Airport. It's the kind of heat that kills people. We were traveling toward extreme fire weather.

In a drowsy struggle to stay awake, I rolled down the window, tapped my toes to the rhythm, and sang with the radio John Fogerty's "Bad Moon Rising" by Creedence Clearwater Revival, oblivious to the ominous lyrics.

At dawn, we drove through the Bonita Creek subdivision, a community of about sixty homes and vacation cabins belonging to people who valued the forest setting and kept big trees standing near their houses for the aesthetics. It was our job to try to protect these homes. We were one of the first hotshot crews to arrive and unloaded on a gravel road on the edge of a slope into the canyon. Local crews had already begun constructing fireline. We stretched stiff muscles and downed granola bars and quick-energy snacks while listening as our boss detailed our day's task. Sluggish and sleep-deprived, I hoped we'd have a short, easy day.

The assignment was to improve and complete the fireline and tie in with the Prescott Hotshots above us. Once the line was complete, both the crew above us and then our crew would burn out our section. In order for this plan to work, we had to hustle to finish the burn before the heat and afternoon winds.

By noon, our line was ready and we waited for the burn. Our safety zone was up the fireline, an area known as "the black," where a burnout operation had already occurred. The safest place to go in a wildfire is the black area that has already burned and cooled, where there is nothing left to burn.

We were spread out down the canyon side watching for sparks from the burn operation above us. I joked with Gene, who was just above me on the line. It was hard not to laugh at the funny things he said and did. As the hour passed, I noticed squirrely breezes blowing first from one direction, then another as smoke and clouds

covered the sun. What we couldn't see through the smoke were the thunderheads collecting overhead. Wind gusts fanned flames in all four directions. Ash fell like snow. Training in fire behavior warned us of these potentially dangerous signs—falling ash, high temperatures, low humidity, and shifting winds. Especially the shifting winds. I became restless and uneasy.

With no radio, I didn't know what was going on below us. Around 2 p.m., the wind, the smoke, and my unease increased. I kept looking down toward the bottom of the canyon where a smoky orange glow became more and more obvious. The size of the ash flakes increased; I could now hear the crackle of burning wood. I suggested to Gene that we move up the fireline toward the others. I wasn't ready to admit getting scared, but knew this was a situation that shouted *Watch Out!*

A minute later, as we made our way upslope, Dave Hunter, our squad boss, ran up behind us breathing heavily. He said, "Go, Go, GO!" as he pushed on my pack, propelling me up the slope. Through his radio chatter, I heard an urgent voice yell something like, "All crews to the safety zone!" and then "Get out of there *now*!"

As we hurried up the steep canyon and caught up with the rest of our crew, several firefighters jogged past us toward the fire with grim looks on their faces.

Are they crazy? Why were they running toward the fire?

It felt like a bad dream: every muscle strained to run, but I couldn't actually move. Smoke went from noticeable to extremely thick in seconds. I took in as much oxygen as my lungs could hold. The acrid air burned my throat. While hiking single file up the slope, it got dark as smoke blocked the sun. Hearing the roar of the fire, I turned around to see a raging inferno. It sounded like a jet engine at takeoff. That's when Dave yelled over the roar. I could barely hear him.

"DON'T. LOOK. BEHIND. YOU!"

A wall of angry red flames devoured the tops of tall ponderosas below us. The giant flames raced upslope. They looked to be headed right for us. I was terrified. This was a firestorm. There was no outrunning it. My thoughts turned inward as I moved and breathed for what I thought might be my last minutes alive. *I'll never experience being a wife and mother? I won't get to say goodbye to my mom. I have so much more life to live.*

Horrifying thoughts of burning to death had me wondering how long I'd suffer unimaginable pain before I died. This led to thoughts of God. Only God could stop this unstoppable force, or at least change its course. Fervently praying, I bartered until I realized I had nothing God needed. Then I got honest about how small I was and what I needed: One who can move mountains and stop storms with one word.

I needed God.

Coughing from the smoke, I somehow kept up with the giant strides of the men in front of me. Wondering how much longer I could continue, I looked ahead with indescribable relief. Before us was the relative safety of the smoking black area that had burned out earlier. As we stood doubled-over, gasping for breath, coughing and spitting, the boss's radio came alive. A medevac had been ordered. The command came to clear the area for a helispot *ASAP!*

In the next minute, chainsaws from our crew and then several other crews whined to life as sawyers cut swathes of hot, charred stumps and smoking branches, while the rest of us pulled debris out of the clearing with a speed and efficiency borne of adrenaline.

Looking back toward the fire, I saw our boss and the men who had run toward the fire emerge from the smoke. Their faces showed exhaustion and determination. They carried a backboard between them. On it lay a burned firefighter. A 212-helicopter touched down in a tornado of ash and flame on one of the fastest-built helispots

ever created, just long enough to load an unconscious firefighter. Then it was gone.

Heroes, whether they do so consciously or not, follow the Golden Rule: treat others the way you want to be treated. I believe that's why those brave men were determined to rescue that firefighter, even when they knew they might not make it out themselves. Several hotshot crew bosses had hiked toward the blaze to make sure no one was left at the bottom of the canyon. That's when they discovered the firefighter who had literally walked through fire to escape.

The Perryville crew below us had been divided when the fire jumped their line. Surrounded by fire, they had deployed fire shelters all firefighters carry on the outside of their packs. The shelters were made of a thin layer of fiberglass laminated to aluminum foil to reflect radiant heat and trap breathable air inside. The current model (from 2002) has added a thin layer of woven silica to the layers of fiberglass and foil. The foil reflects radiant heat and the silica cloth slows the transfer of heat to the inside of the shelter and offers better protection from direct flame contact.[2]

The average forest fire burns at around 1600 degrees Fahrenheit. Some have been measured at up to 2400 degrees. The human body can survive up to 250-degree heat for a short time.[3] To use a fire shelter, one has to open the triangular material and lay on the ground with it covering the body, tucked under the hands and feet holding it down against the wind that fire creates. One of the firefighters who deployed was unable to take the intensity of the heat. He stood and started walking through the fire, with the shelter wrapped around his body.

The crew bosses spotted him emerging from the flames and radioed for EMTs to come with a burn blanket. The man's hard hat had come off. His hair, his pack, and his clothes were smoking; his face and neck were badly burned. When he collapsed, the medics inserted an IV for fluids and together hefted his large frame onto

the backboard. The burned firefighter was not yet unconscious and lay in agony, facing the flames, certain they weren't going to make it out. These firefighters struggled to carry his weight up the canyon, to bring him to safety. They knew that until they walked into the safety zone, they were not safe. [4]

Once the medevac helicopter had left and the fire had burned past us, we were left to sit in warm ashes and desolate silence. Wincing through a throbbing headache and burning eyes, I looked at the men around me, their faces streaked with sweat and tears. Their expressions reflected a sober realization that we had escaped a firestorm.

Because of the fierce courage and determination of his fellow firefighters, the man who walked through fire did not die. Six men from the Alpine crew received certificates of merit for their actions on that fire. The US Department of the Interior presented the entire crew with an "Exemplary Act" certificate that likely still hangs on the wall of their office today. In that blackened clearing, we waited for hours in a fog of exhaustion and dread, every drop of adrenaline spent. The radios went silent.

Huddled in groups, crews listened to the fire's rampage as it engulfed one home after another in the subdivision. Gene sat with his head bowed, quietly weeping. In the distance, propane tanks exploded like bombs in a war zone. The unbearable sound I tried to block with my hands over my ears was the barking and desperate whining of a dog trapped in its yard, condemned to burn to death. The sound of the worst way to die echoed through the canyon.

It was almost dark by the time we were able to walk back through the ashes to our rigs and drive to fire camp. Most of the crew grabbed their sleeping bags, threw them between sage brush, and were asleep when they hit the ground, but not me. I wanted to change out of my reeking t-shirt. I walked a short distance before unrolling my sleeping bag.

While the moon was low on the horizon, it was dark. I sat on my sleeping bag, struggling to get the ash-crusted laces of my boots untied, when my nose started to run. I kept wiping, but by the time I got my boots off, my nose was running so bad I put one of my sweaty wool socks up to my face. Switching on my headlamp, I saw blood covering the backs of my hands and my bandana. There were smears of blood on my yellow sleeping bag. I had a gusher of a nosebleed. It ran down my arm and dripped off my elbow. I cried a feeble "Help!" and then retched as a gush of blood and mucus flowed down the back of my throat.

It's hard to cry with a bloody nose. Shoving my feet into my running shoes, I trudged down the gravel road to the camp's first aid station with my head back, pinching my nose. The people manning the first aid tent were asleep and I stood there for a minute not wanting to wake them. I walked to the portable sinks to wash the blood off my hands and noticed Travis from our crew reading the camp bulletin board.

When he saw me holding my nose, he found a chair and woke a nurse. He told me that six firefighters below us on the line died that day: Five men from the Perryville Inmate Crew and one woman. The inmate firefighters included Joseph Chacon, Alex Contreras, James Denney, James Ellis, and Curtis Springfield. Sandra Bachman, their supervisor, was 43.[5] She had a son waiting for her return. This had been her first experience with a forest fire.

The nurse told me to sit in a reclining lawn chair and wait for the bleeding to stop. When Travis walked back to camp and the nurse turned to write in her notebook, I felt alone enough to let tears slide from my closed eyes while the day's events and the tragic result replayed in my mind.

The next morning, our crew boss walked to where I lay sleeping and nudged me awake with the toe of his boot, concern etched his face. Dried blood stained my yellow sleeping bag. Bloody socks

and bandana littered the ground around me. I squinted up at him, grimacing at the bright light and hoarsely mumbled something about a bloody nose.

"You alright, Kate?"

"Yeah. I'll manage."

I sat up, wincing at my pounding headache and groaned.

"I need some aspirin."

"Yeah, there's a bottle of it being passed around the crew right now."

He asked if I was up to working. I considered what else I'd do. The idea of sitting at fire camp reliving the previous day was out of the question. I'd rather work. Hopefully I wouldn't get another bloody nose, but the nurse at the first aid tent said it might come back.

Weak and shaky, I moved stiffly to my usual place at the back of the crew line-up for the walk to the camp kitchen for breakfast. My hair stank of acrid smoke. We all coughed and spat like lifetime smokers. Emotion threatened to spill over when I allowed myself to consider different outcomes of yesterday's blowup. As we sat to eat, the crew's table talk gave me a new, comforting sense of acceptance and belonging. Maybe we shared a gratitude for the simple pleasures of safety, good food, and good company.

We had an easy assignment that day, but before we left camp our crew met with trauma counselors. I have only the vaguest memory of this "debriefing," where we sat in a semi-circle and counselors encouraged us to talk about what happened. A crewmate described it later as uncomfortable. According to him, nobody wanted to talk about it and we couldn't wait to get out of there and back to work holding a nearby dozer line.

The Dude Fire went from 1,800 acres to 3,000 acres in an hour; overnight it went from 5,000 to 15,000 acres. By the time the fire

died, it had burned more than 24,000 acres. Besides killing six people, it destroyed 63 homes and structures. It forced over 1,100 local residents to evacuate. It took ten days to control using 61 fire crews, 33 engines, 14 helicopters, 12 dozers, and 10 air tankers.[6] One of the historic cabins that burned to ashes belonged to the late Zane Grey, author of fourteen western novels that he wrote in nine years in the quiet of a forest that no longer existed.

The ZigZag Hotshots Superintendent, Paul Gleason, who was at the fire, vowed to improve firefighter safety measures. He developed the LCES system (Lookouts, Communication, Escape Routes, Safety Zones) as a minimum safety standard.[7]

"In a 1991 paper on the system, Gleason wrote: 'The afternoon of June 26, 1990, as I knelt beside a dead Perryville (inmate) firefighter, I made a promise to the best of my ability to help end the needless fatalities, and alleviate the near misses, by focusing on training and operations pertinent to these goals'."[8] Gleason's LCES system is still a vital component of firefighting today.

The nurse was right about my bloody nose starting again. As I stood watching for sparks along the dozer line, it returned with a vengeance. Back at fire camp, I got a ride into town to the local hospital. By the time I arrived, my nose had stopped bleeding and the doctor was reluctant to cauterize the capillary. Instead, he gave me a squeeze bottle of saline solution to squirt up my nose every fifteen minutes. Apparently, the intensely dry air and heat was the culprit.

As I walked out of the hospital, a heaviness settled in my bones. A nearby phone booth made me think of my mom. Sliding the folding door shut, I made a collect call. When my mom answered, I choked-up. Suddenly I missed her so much and wanted to hug her in the worst way. I could only say hi before silently weeping. I hung up the phone and slid to the floor hugging my knees. Tears from

fear and sadness for the ones who couldn't make this call rolled down my face and I thanked God for my life.

Eventually, I stood and called my mom again. She had seen the news on TV about the fire in Arizona. Breaking our unspoken code of silence about firefighting, she asked if I was there. I didn't want to lie, but also didn't want her to worry. I told her that we were just holding a dozer line away from the fire's front and that I was working with a really great team of *people*, not wanting her to know that I was the only woman. When we ended the call, I knew this needed to be my last summer as a hotshot.

Jayne Belnap working with the Alpine Hotshots in Alaska, 1990

Black Clouds & Brown Bears
Chapter 22

Alpine Hotshot Crew's station was a shabby converted motel in Parowan, a dusty little town an hour's drive north of St. George, Utah. We worked often at Zion National Park. For me, venturing into Zion was a case of love at first sight. Winding our way through the towering walls of burgundy rock which seemed to shimmer through the heat below a turquoise sky, the canyons seemed surreally beautiful. A plaque at the visitor's center said the Hebrew word 'Zion' means "place that God loves."

A monsoon's flash flood had dumped a pile of sand and debris across one of the park's hiking trails. After the Dude Fire, a group of us cleared it for tourists. This provided a welcome respite after the previous fire experience and we enjoyed talking to visitors from all over the world while we got to know each other better.

The heat and humidity of the drenched desert had the men stripping off their sweat-soaked t-shirts, revealing six-packs and well-defined pectorals. When I sent a girlfriend a photo of my working environment, she wrote back asking how I could focus on work in such conditions. I replied that it's just one of the hardships of the job. I was raised in a house with older brothers who washed their cars without wearing a shirt. They had athletic physiques so I was used to it, but it wasn't the same.

When the next fire call came, I was more surprised and less excited than anyone. We were bound for a part of the country where

no one wants to take off his shirt: we were flying to Fairbanks, Alaska. The previous summer, the prospect of working in Alaska had sounded exciting, but this year more experience had me considering potential problems.

Legend and lies blur in stories of Alaskan firefighting. Tales of grizzly bear attacks, and even more tales of mosquitoes flying so thick the air is black had me chewing my thumbnail. I'd heard if you didn't wear a mosquito net over your head, you'd go crazy trying to keep them out of every orifice on your face. No, I wasn't excited about this assignment at all. It's cold up there. I had developed enough assertiveness to consider how to stay warm without sharing anyone's tent, *but still...*

Determined not to set foot on northern soil without a warmer sleeping bag and other necessary supplies, I asked to borrow Ted's truck to drive to St. George. Pushing the cassette tape into the truck's player, I listened as Linda Ronstadt soothed my fears with her melodies. Ted was forever playing or singing from her album *Canciones de Mi Padre*. Absently singing to "Blue Bayou," I trusted that God would provide what I needed and drove to an army surplus store. I hoped to find necessities for wilderness work: a mosquito net, bear spray, and the warmest sleeping bag ever made. Returning successful from my treasure hunt, I handed Ted his truck keys and remembered the banners stretched across Main Street.

"Can you believe they're performing Shakespeare in the park tonight?" I laughed.

"What's wrong with Shakespeare?"

"Nothing! Shakespeare's the best! It's just... we're in Utah. I'd expect something more like *Calamity Jane* not *Troilus and Cressida*!"

"Well, you wanna go?"

"You mean, together? Like a date?"

"Or, like two Shakespeare fans."

Considering the previous summer's predicament with a boss, I was careful to guard my heart. There was a lot to like about Ted,

but I was more discerning after learning a hard lesson. Later that evening, we sat in the grass at the park sipping Kahlua n' Creams. Grateful for the distraction from worry about the days to come, I read to him from the program.

"It says here that an author and literary scholar by the name of Joyce Carol Oates calls this play 'the most vexing and ambiguous of Shakespeare's plays.'"

"We all have things in our lives that are vexing and ambiguous," he laughed.

"Cheers and amen to that."

We clinked our plastic cups together and sat back to enjoy the play, enjoying the contrast between culture and wilderness.

The next day, we boarded a chartered plane bound for the far north. This fire was as close to the Arctic Circle as I'd ever get, near a town called Tok, about 200 miles southeast of Fairbanks. When we unloaded our gear at fire camp, I wondered at the super abundance of old chainsaws we had packed.

"Why so many? And why did you bring the junkers?" I asked Jude, a lead sawyer.

"Oh, you'll see. We're not in Kansas anymore!"

The trek to the fireline the next day started with a bus ride to the Tok River. We unloaded at the water's edge and climbed into shallow-bottomed riverboats that carried us upstream. The country we entered looked wilder with each passing mile. No more houses with smoking chimneys, no telephone poles, no power lines and no roads. The hills were heavily wooded with small trees. Their growing season this far north is only a few months every year as permafrost stunts the trees' growth.

Several hunters sat at a campfire on the shore where we unloaded. They had cooked what I remember as a kettle of moose stew, but Gene insists it was slabs of salmon. *Maybe we passed their camp twice?* Whatever it was, my mouth watered. They offered us some, but we couldn't stop.

We hiked inland for what felt like a mile, before we reached the back edge of the fire. What I saw looked to be an impossible situation. We stood on a foot of thick moss, fallen spruce needles and dried grass. Everywhere, red glowing embers snuggled against fuels that would keep a fire smoldering forever. Below this layer of dry moss and duff was not dirt, but permafrost—dirt that's frozen solid. Only snow could quench this fire. The best we could do was prevent the fire's growth by putting a line around it. Then I wondered, *how does one construct fireline without dirt?* The answer was easy and almost fun.

First, we cleared our fireline of trees and brush. That didn't take long because of our excellent sawyers and the small-sized trees and bushes. Then, two sawyers, with the junker chainsaws and worn chains, cut a line through the moss near the edge of the smoldering fire. The cut lines ran parallel, about eighteen inches apart. Using the hoe side of a pulaski, someone cut the underside of the moss. The rest of us took turns rolling up the mossy, sod-like carpet, which we then pulled to the far side of the line. The finished product looked like a narrow permafrost sidewalk through the middle of the forest. At the time, I didn't stop to think how many decades it would take for nature to erase our fireline's footprint.

Once settled into the work, I noticed more details about our surroundings. The terrain wasn't the way I had imagined it. As steep and mountainous as the geography is in the lower western states, I figured it would somehow be even steeper and more rugged in Alaska. That may be the case in other areas, but it was a pleasant surprise to find it relatively flat where we worked. I was in a good mood when I told the guy next to me I was "going to look for arrowheads," code for *I have to pee*, and walked into the woods.

No arrowheads were found, but I discovered that my body had decided (against my will) it would be *that* time of the month. *Super bad timing!* I carried supplies in a pocket of my pack. What I didn't want anyone to know about was my fear of bears.

It started when I was young and watched a scary movie trailer about Bigfoot. My fear of Bigfoot expanded to include bears. As a kid living in Prineville, my family used to dine at the Grizzly Bear Pizza Parlor. While we ate, I stared at the big bear head hanging on the wall above us. It was just a black bear, but I imagined the hungry beast killing its prey with its long claws and strong jaw full of sharp teeth.

My fear hadn't been an issue until now. Now I was bleeding where Grizzlies hunt. Those stories I'd heard about bear attacks on women came to mind. Looking over my shoulder, my pulse pounded in my ears. It was not an open forest. A lot of small trees, brush, and fallen logs filled the space between the more mature trees. If there were a bear near me, I wouldn't see it until it was too late. *Would I hear it? Do they crash through the brush, giving their prey time to panic, or are they quiet and stealthy like a mountain lion?*

Looking back toward the fireline, I made a mental map of the fastest route back with the fewest logs to jump. I imagined a grizzly attack ranks right up there with fire as the worst way to die…*good grief, get a grip!* I hustled back to the line and hoped no one noticed I was crowding the guy ahead of me.

I was so distracted by the possible presence of bears that it took a while to notice an actual absence: there weren't the "black clouds" of mosquitos I was told to expect. I didn't even notice until I was scrounging in my pack during a break looking for trail mix and had to pull out the cumbersome mosquito netting.

"What the heck is that?"

Some of the guys had taken an interest in my pack's spilled contents.

"Hello! It's mosquito netting." (*Duh!*)

Before long, I was modeling the wear-under-your-hard-hat netting to a greatly amused group. I had to admit it did seem funny when there weren't any mosquitos.

"Hey, Hamberger, mosquitos don't like smoke. In case you haven't noticed, it's pretty smoky out here."

"Laugh all you want, but if they ever do show up, you'll be begging me for this!"

I shoved the netting back in my pack, careful not to let them see my can of bear spray. (*Like a can of aerosol spray is going to stop a 1,000-pound bear from attacking. And even if it did, it's not like I could say to the charging bear, "Hang on! Let me get the spray from my pack!"*) It did occur to me that having a spray holster on the outside of my pack would be wise.

The other thing mosquitos don't like is wind. It was a windy afternoon. I looked up at the swaying treetops. They weren't the only ones swaying; my body stood motionless, yet I rose and fell with the tree roots that rose and fell. I had never seen anything like it. Alarmed, I watched as the forest floor moved as if it were cooking at a slow boil. I stood next to a black spruce, which has a shallow root system that fans out on top of the permafrost, but under the moss. When the wind blows the tops of the spruce in one direction, the roots from the opposite side of the tree are pulled up under the moss. Perched over those roots, I bobbed like a sapling, while the earthy-sweet scent of compost filled the air. This was the sort of surprise — of the beauty and the mysteries of nature—that I would miss when my fire days were over.

"Hey, Hamberger, guess what time it is," asked Gene. He was like the sweet, younger brother I never had. I tried to humor him, but the sun's usually telling position was perplexing.

"I have no idea. Seven o'clock?" I yawned and rubbed my eyes. Our crew trekked toward our pick-up point. The muted cadence of forty boots stepping on submissive ground dulled my senses.

"Try 9 o'clock! We left fire camp at seven this morning. We've been working for fourteen hours." Alaska in the summer was in a state of perpetual twilight.

Though the sun had set, we walked through hazy light down the fireline we had created earlier in the day toward the river and the flat-bottomed boats for our cruise back to the bus. We still had an hour of travel before arriving at fire camp for a late dinner. As we pulled into camp, the boss announced that a shuttle bus was driving to the local high school, and if anyone wanted a shower, they should be ready to board the shuttle. The men snorted and smirked. Not one of them wanted to shower: they all wanted the extra hour of sleep. I would have preferred to sleep, too, but needed to shower on account of those bears.

Usually not a fast eater, I wolfed down lukewarm spaghetti to catch the shuttle. I was tired and frustrated that I had to use precious sleep time to ride to a school to shower, wait for everyone to finish, and ride back to camp. Greatly vexed, I stomped back to our sleeping area to grab my gear. Ted noticed and asked if anything was wrong. I shook my head and rolled my eyes.

"Want to talk about it?"

"No."

I didn't want the crew to think I was prissy because I wanted a shower. But they also didn't need to know why I felt a shower was necessary. I'd feel ridiculous trying to explain. Other women on crews made the mistake of sharing that information and didn't hear the end of it in crude jokes. This was a great time to have another woman on the crew.

Luckily another woman did join our crew on a temporary assignment, just before departing for Fairbanks. Jayne had worked for government agencies like the National Park Service for a long time in various capacities, and loved firefighting. She joined a fire crew whenever she could. Older and easy-going, she wore a smile and big glasses held together with tape. Those few days she and I partnered to cold-trail or mop-up, I found her to be smart, friendly, and opinionated. I loved that she wasn't insecure or competitive. I remember wanting to be like her and wished she would stay on the

crew for the rest of the season. It was good to talk with her about things I wouldn't discuss with the men. Yet another thing I'd lose when I left firefighting was the uncommon camaraderie with other fire women.

Only a few people boarded the shuttle for the high school. In the quiet bus, I sat and considered the fact that according to a TV documentary I had watched about bears, their sense of smell is 2,000 times better than a dog's, which, on average, is 100 times better than man's. *How did scientists even calculate those statistics?* Bears could smell food from twenty miles away. Looking back, instead of nightly showers, I might've been better off keeping that can of bear spray handy and work standing directly in the smoke.

There might be jokes about smoked Hamberger, but I could live with that. (Literally.)

After a few days in a land where the sun never sets, we learned to fall asleep even though it wasn't dark. Feeling more energy, a few guys went so far as to show off their survival skills and built elaborate sleep shelters. One was ex-military and a smarty. He carried a section of black tarp and twine in his pack. Cutting a few tree limbs, he fashioned a tent-like roof on a balancing lever. When dew collected on the tarp, it would tilt from the weight until all the dew water rolled off to the sides, keeping him and his sleeping bag dry.

Gene, the ultimate boy scout, built a lean-to using thick moss from the forest floor as his roof. The next morning, he emerged from his shelter with swollen, sleepy eyes. Concerned, we asked if he had slept well in his fancy shelter. He shook his head no. Much of the sod had collapsed through his roof, partially covering him. The sod that didn't fall had beetles, spiders and centipedes

Gene Garate with his sod shelter in Alaska

dropping from the moss onto his sleeping bag all night. He acted out what that looked like and it kept us laughing for a long time.

On our last day on the fire, we waited for a helicopter shuttle back to camp. Relieved, I was glad to be returning to the lower forty-eight where I'd no longer need to be hypervigilant. Disciplined crew that Alpine was, everyone sharpened their tools as we waited. Looking down the line of weary, hardworking men with their heads bent to the task, it was a moment in time I didn't want to forget. I took a photo that later became a favorite.

As we prepared for the helicopter shuttle, I offered to help tape our tools. Handing the helitack guy a tool bundle, he looked at my work and smiled.

"You've done this before."

"A few times."

When we landed, I climbed out and looked up at the helitack guy who was holding the door open. It was Scott, my crewmate from the Prineville Helitack Crew! I hadn't seen him since Yellowstone two summers prior. It was good to see a friend with history and I gave him a hug and insisted on a photo.

I couldn't get over running into him in the middle of the vast Alaskan wilderness. He couldn't get over seeing me with a rough-looking hotshot crew out of Utah. He kept shaking his head as he smiled. We didn't have much time

Scott Perse and I near Tok, Alaska, 1990

to visit. As I said goodbye, he put his palm on my cheek and told me to take care. There was genuine affection in his eyes and the feeling was mutual. *Is it normal to suddenly miss someone you haven't even thought of in years?* I choked up watching him fly away.

"Well, at least now we know she's not a lesbian," I overheard one on the crew saying.

To lend to the apparent mystery, I turned to reply, "You know nothing!" Maybe for the first time, I didn't care what they thought of me. Smiling faintly, I marched past him to the bus, suddenly homesick for the familiar. I was learning that friends become more precious as time passes.

We worked on the Tok fire for over a week and I never saw one of those legendary black clouds of mosquitos or a grizzly bear, but I could finally say I'd fought fire in the Alaskan wilderness.

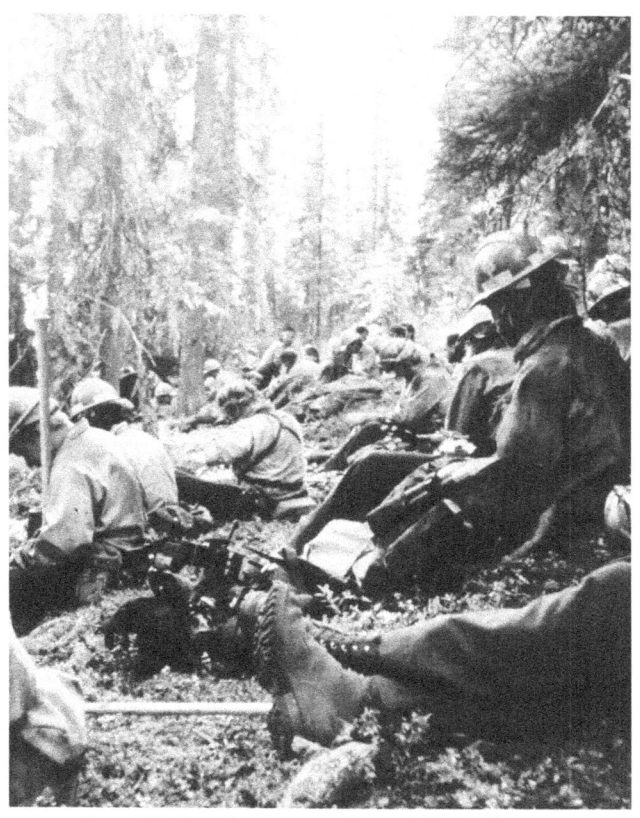
Alpine Hotshots sharpening tools near Tok, Alaska

*Standing with the Wyoming engine crew:
L to R: Patrick Hayden and Steve Dobby*

Chapter 23

"Hello. Welcome to the crew, Nathan," I said, as I smiled and shook his hand.

Nathan had joined the Alpine hotshots the day after the blowup at the Dude Fire in Arizona. He was tall, had blue eyes, and a confident, ready smile.

"Nate. Call me Nate. It sounds more manly," he said, with a nasally East Coast accent. There was a smile in his eyes.

"Where're you from, Nate?"

"New York. How 'bout yourself?"

The morning's fire assignment meeting halted our conversation. At the time, I would not have guessed that he would eventually become my best friend on the crew—because for the next few weeks, we hardly talked. July's fires had us constantly on the move. Shortly after our return from Alaska, we worked on fires in Idaho before rolling to a stop near a brush fire in northern Utah, near the Colorado border.

Now we were in or near the Ashley National Forest where there's mixed terrain and fuels. At sunset, we were digging line around a small lightning fire. Nearby, a spot fire took off and three of us went to put it out. Due to unusual evening wind gusts, our fire made a run toward a grove of aspen trees. We quickly dug line and shoveled dirt with all our energy focused on the flames. It soon grew dark.

This little fire was stubborn. Despite the increase in humidity and decrease in temperature, the breeze pushed the fire to the trees. Tired, out of breath, and wondering if we were ever going to stop it, I kept throwing shovelfuls of dirt at the flames. Meanwhile, the other two guys pounded out line to flank it on either side.

Suddenly, I felt water spraying the flames from behind me. Flooded with relief, I kept working as two guys carrying their engine's water hose began to put water where it was most needed. Within an hour, the five of us had lined the spot.

We continued to work all night, stirring, digging, and spraying. We talked and laughed with this two-man engine crew that had come out of nowhere. One of the guys, Patrick, worked with me, soaking hotspots, while I used my pulaski to stir the coals into the mud. Then we both chopped and stirred to conserve his engine's water. He and I spread embers and doused firebrands. His partner, Steve, took the hose and worked with the two on the other side of the spot. Sometime around midnight, Patrick traded beef jerky for my trail mix and we leaned against his engine facing the burn, mesmerized by little blue flames and the glow of embers.

One learns a lot about the character of a person by working at his or her side all night. It's unusual to find lazybones on a fire crew. I paid attention to whether a new person did the same amount of work I did—if he or she was willing to put in the time and work. Like, if the hose line became too short and one of us had to hike back to the rig at 3 a.m. for three more rolls of hose, did that person find an excuse not to go?

Patrick was no lazybones. In fact, when I struggled to move a heavy fallen tree branch away from the fire, he dropped the hose to help me move it. He also helped to improve the fireline when he could've continued spraying water. I noticed when a person worked beyond the call of duty. That kind of man looks out for the people

around him. Was he the responsible firstborn child in his family? Did he grow up caring for younger siblings?

Dawn came as we mopped up. For the first time, the light was good enough to see with whom I was speaking. I forgot what I was saying in mid-sentence. He had kind eyes and I liked how he laughed. He was easygoing with a sense of humor. I was always drawn to this combination. It reminded me of Paul, but Paul was impossibly far away.

"Sorry… What was I saying?" I asked.

"You were discussing the pros and cons of working on a shot crew." He said it with a wry smile.

"Right."

Our spot fire was completely out and the other guys were walking toward us.

"How 'bout I finish that fascinating discussion another time?"

"How 'bout we go find some coffee?"

I smiled. We were in the middle of a forest, far from any cozy cafe. I imagined sitting at a warm booth with a cup of steaming coffee between my cold hands. I could almost smell the perfect mix of sweet and savory with crispy bacon and thin pancakes drenched in maple syrup. A bit of heaven.

As my crew prepared to depart from the fire, a wave of fatigue hit and I climbed into the rig without saying goodbye to the Wyoming engine crew. Too often good men and women came and went in my life and I was too tired or busy to think about whether I'd ever see them again.

Our next destination was the nearby Uintah and Ouray Indian Reservation in Northeast Utah; we didn't even have to leave the state. We were sent there because of predictions of dry lightning. Dry lightning meant big fires on our horizon, but in the meantime, we waited. By day, we sat around the fire station; by night, we stayed

at a small motel, where I sat in my room all by myself. All too frequently, my mind drifted back to memories of Paul.

I've heard men are better at compartmentalizing, but I also subconsciously prioritized and focused on what was right in front of me. For all I knew, Paul could be with someone else. I mused about this one day while thumbing through a newspaper. There were rumors of war coming to Kuwait.

I imagined Paul flying to the Persian Gulf with anti-aircraft missiles aimed at his plane. *Would he go there? Would the enemy fire at him?* In previous years, his letters and occasional brief visits had made all the difference for me. Though infrequent, his letters had always conveyed that he was rooting for me, cheering me on, no matter how far away he was. They helped me to endure difficult times. *Did my letters help him the way his helped me?*

Maybe supporting each other was what kept the sporadic letters coming and going. We were both busy being a part of something bigger than ourselves and we were like-minded, or at least we had been, with similar approaches to life and God. As I thought about him, I wondered, *Should I try to call? How would I reach him?* I sat staring at the phone. I could call his parents. Their number had been etched in my memory since I was fifteen. They might know a number to call. *What would I say?* I thought about the time we spent together in Mexico until I felt tears on my face. If our relationship was over, it had ended without so much as a goodbye or any kind of closure.

I didn't call that night.

I called the next night.

His dad answered and said I'd just missed Paul. After a brief visit with his parents, he had left for the airport a few hours before I called.

I couldn't believe it. If only I'd picked up the phone and called instead of just staring at it.

"Is there a phone number I could give him to reach you?" his dad asked.

"No. Not until summer is over. Just… please tell him that I'm glad he's okay and that I'm praying for his safety…and that I'd like to see him again someday."

What does a crew do when standing by? They play Hacky Sack. Some people, like me, are terrible at Hacky Sack. Every time that little beanbag came sailing toward me, I'd get so excited, I'd kick it to the next county. Someone would have to run across the parking lot and fetch it out from under a parked car while the rest of us stood scratching our noses in awkward silence.

I preferred to read, listen to the radio, talk, or write letters. I was writing a letter when the engine crew assigned to join us on our next fire approached. With delight, I saw that it was Patrick and Steve driving up the gravel road in their BLM engine. Watching from the cab of our truck, I smiled as Patrick casually scanned the vicinity until he found me and smiled back. It wasn't long before he strolled over.

"Care to join me?" I asked.

"I'd love to…" He looked over at the pages I'd written, strewn across the dashboard.

"You write essays in your free time?"

"No. That would make me a nerd. These are letters." I laughed at my nerdiness.

He picked up a page and held it up to the sunlight.

"You've got the best penmanship I've ever seen! It's like art."

"Thank you." I smiled. "Someone once told me I wrote like Thomas Jefferson…that was a stretch. Some days it's good, other days it's terrible."

He was quiet while I gathered the pages and tucked them into a notebook.

"Perhaps I could receive such a letter one day." He looked at me long and steady.

"Perhaps you could, if I had your address."

Wasting no time, he pulled a mini notebook and pen from his fire shirt pocket and wrote his address and phone number. Patrick also had pretty penmanship. We passed the time getting to know each other. He was born and raised with sunshine on his shoulders in Colorado and listened to John Denver on occasion.

The next afternoon a spot fire was sighted. It was only a two-person job. Maybe because of my helitack experience, I was chosen to accompany my squad boss, Dave, to take the helicopter to the fire. We'd be stuck out there all night. Usually, I'd jump at the chance for extra pay and adventure, but for once I wanted to stay and pursue this new friendship with Patrick. I struggled with the idea that choosing to spend more time with Patrick over hazard pay and adventure was a sign of weakness.

To be a hotshot, I had to be strong emotionally. I thought, (wrongly) that being vulnerable was the same as being weak. Often the job required me to ignore emotions so I could deal with the matter at hand. A certain amount of that is healthy self-control. But I've learned there's a difference between self-control and denial. When I operated in a state of denial, I wasn't honest or clear about how I felt. What I didn't understand back then was that taking the time and energy to think through and be clear about my emotions, needs, and desires is actually being kind—both to myself and others. It allows for truthful conversations that will improve good relationships and possibly end bad ones. The best I could do in the moment, though, was give Patrick a quick hug. I even thought to ask someone to take a photo of the Wyoming engine crew in case it was the last time I would ever see them… and it was.

On the flight to the spot fire, the pilot pointed out a herd of big horn sheep and later, a herd of antelope. Before the helicopter

descended, a blackened spot about the size of a backyard showed where lightning had struck an old juniper and was burning the surrounding sage brush. Dave and I had the area lined by sunset. It was completely out by dark. We built a warming fire, got out our space blankets, and gathered enough wood to burn through the night.

To pass the time, I shared the entire plot of *Out of Africa* with the poor man because he had not seen the movie. Then we sat across the fire from each other in companionable silence. I was struck by the vast number of stars. They felt so close. I got the same feeling whenever I slept on a top bunk and the ceiling is only a few feet from my face. A poem I read suggested that the night sky was like a heavy black cloth with tiny holes in the fabric that allowed the light from the other side to escape. Science tells us it's not the case, but when one is under such a big night sky, it feels like anything is possible. I thought of *Psalm 19:1-4:*

> *The heavens declare the glory of God;*
> *the skies proclaim the work of his hands.*
> *Day after day they pour forth speech;*
> *night after night they reveal knowledge.*
> *They have no speech, they use no words;*
> *no sound is heard from them.*
> *Yet their voice goes out into all the earth,*
> *their words to the ends of the world.*

The sky that night also reminded me of when I sat in the beauty of the Seville cathedral and looked up at the ceiling, half a football field above me. The wonders and the immensity of our beautiful planet reminded me how small and fragile we are. Waking in the night, I thought for a moment I'd lost my hearing. I was surrounded by absolute silence. That night, I vowed to remember how I slept be-

side a small campfire across from Dave, my kind and quiet squad boss, in a wilderness far removed from all traces of man. Transfixed by the stillness and moved by an almost sacred feeling, a sense of peace washed over me.

After our work in the Uintah and Ouray Indian Reservation, a stretch of time passed where we worked locally, mostly in Zion National Park. With no fires, our assignment was to eradicate salt-cedar tamarisk, an invasive species of brush, that grew along the Virgin River. It was hot, tedious work, but laboring in this beautiful place was worth it. After a long day, we'd return to headquarters where Polly, our crew cook, had dinner waiting.

Squad Boss Dave Hunter at our spot fire in Utah

Polly was also from Oregon, and when at our station, we had the luxury of enjoying her excellent cooking. I didn't think about it at the time, but to have a hotshot crew live in such a remote location and share meals as often as we did was unusual. It lent a greater sense of family to the crew.

Sometimes I'd hang out with Polly after work, enjoying conversation with another woman. I complained once about wearing Nomex everyday of every summer and she rummaged through her suitcase and threw me a pale blue tank top with pleats and silver metal buttons down the front with a ruffle along the bottom.

"Well! This is decidedly feminine," I said, laughing as I held it up.

"Try it on."

It fit perfectly.

"That was one of my favorites, but you can have it."

"Dare I wear it? Put my hair up and add make-up? Maybe some silver hoop earrings?"

I didn't actually have silver hoop earrings and my make-up consisted of a bottle of sunscreen with foundation in it and a pale coral lipstick, also with sunscreen. The radio was on in Polly's room, and while I sang with Billie Ocean about how the tough get going, Butch, our crew foreman, approached Polly's open door, hoping for a haircut. She set up a chair outside and oiled her electric clippers. I watched while she cut his hair and he grumbled about not wanting an audience. This drew the attention of others who offered helpful suggestions as to how to make Butch look more butch. There was a lot of laughter and she gave two more haircuts before dark.

Dave Zuares gets a haircut from Polly RC Walker

One evening later that week, there was a knock on my door. Nate stood in the doorway with a soda in each hand. Shrugging as if to apologize for the lack of choice from the vending machine, he asked if he could come in. I stood in the doorway deciding. Nate struck me as a charming, fun-loving flirt who might have multiple girlfriends. Thinking he was a ladies' man was a hasty judgment, but to the degree that I enjoyed his presence on the crew, I suspected he would challenge my beliefs and mindset.

Zion

He was a year younger than me, but emanated a confidence that made him seem older.

He was fun to work with and it was entertaining to listen to him banter with others, especially when he argued with one of the Davids about the nature of God. Listening to them was like watching a tennis match. Nate had a way with words, but what David lacked in eloquence he made up for in zeal.

I worked in an environment that many women would envy, surrounded by intelligent, handsome men in beautiful places. I also knew that after summer, Nate would go back to his world in New York, and I'd return to mine in Oregon. That's just how it was.

"You can come in, but just to be clear, I'm *not* going to sleep with you," I blurted.

A slow smile spread across his face.

"Ok!"

He stepped past me into my little room and sat in the only chair, tilting it back against the wall and cracked open his soda. I left the door open, walked the three steps to the narrow bed against the wall, and sat to open my Coke.

"Cheers." I said.

"To abstinence," he said with a wink.

"You mock me, but I'm all about keeping things simple."

"Right."

Long pause.

"Well, besides the obvious reasons, I plan to wait for marriage."

There. I said it while looking down at my soda. It was unbearably awkward. I felt a conviction that waiting for marriage honored God. Before I slept with someone, I wanted to know that *"...I am my beloved's and my beloved is mine."* (Song of Songs 6:3) I was pretty sure that Nate would never be mine.

He took a long swig from his soda, then reached for his back pocket and pulled out a deck of cards.

"So… in that case, how 'bout we play Crazy Eights?"

It was the first of many card games we played together in the evenings. Sometimes instead of playing cards, he'd ask what I was reading. We could talk for hours about books we had both read. He was easy to talk to and I leaned on his comforting presence. But an old familiar voice would shout in my head. *Not mine!* As I struggled to remain true to my convictions.

As the nightly visits continued, that warning voice in my head went from a shout to a whisper. I struggled not to give in. Each night I breathlessly ushered his six-foot-something frame out the door before we crossed any lines. As my willpower waned, my prayers sounded like, *Lord! Send us to a fire, quick!*

And the Lord answered … we were sent to Georgia. Which is *not* what I had in mind. The Shorts Fire in the Okefenokee National Wildlife Refuge was flat, hot, humid, and filled with bugs, alligators, and snakes. We drove past miles and miles of mostly the same species of pine that were all about the same age, making the forest look suspiciously like a tree farm. One of our first assignments was awful: to preserve an old wooden bridge that was some sort of historical landmark.

This bridge area was overgrown with scrub brush and the occasional poison oak bush sprinkled in the mix. I was extra cautious pulling the brush the sawyers cut. But I wasn't careful enough.

Within hours, the oils from the plant rubbed up against the exposed skin between the top of my leather gloves and my rolled-up shirt sleeves. When those itchy spots emerged, they screamed to be scratched. If I couldn't resist—and I couldn't—the rash would spread, blister, and ooze, which would cause it to itch even more. The best relief came from soap and ice-cold water, but that was hard to find on the line. On a tip from our EMT, I found myself rubbing antiperspirant over my forearms. He said it would close my pores so if I did come into contact with more poison oak oil, it wouldn't

spread as far or as fast. I was desperate enough to try it. Smelling flower-fresh, I now attracted bees.

Poison oak, though, was not the only worry. Next to bears, snakes were the most terrifying thing on my scary wildlife list, and we were working in and around a shallow, stagnant, stinking, slimy, murky, mosquito-infested creek bed. It was only a matter of time before an angry cottonmouth surfaced.

The muggy afternoon hours dragged by, when I suddenly heard a lot of hoots and hollers. When I turned to look, I could see a gathering of men forming a circle, all of them focused on what was in the center. Though I wasn't sure I wanted to see whatever it was, my curiosity won out and I leaned in.

Two snakes were fighting; one was an injured rattlesnake, whose writhing body was as thick around as my wrist; the other was a cottonmouth, who appeared to be winning. The cottonmouth rose like a cobra, coiled on its dull black body. Its big, wide-open white mouth contrasted against the darkness of its body.

As I watched, four of our eco-friendly hotshots decided to relocate the snakes before they killed each other. Two men held shovels gently but firmly behind the heads of the snakes while two other men reached down and grasped the snakes' necks behind the shovels. They held these snakes, rendered momentarily harmless, as if they were pets. Ted turned to me with the cottonmouth in his hands to give me a good look.

"Want to pet him?" He laughed at my horrified expression.

"Are you crazy? You're crazy! Get that thing away from me!" I said, as I backed up, my eyes glued to its gaping cotton-ball mouth. As much as I loved nature and being in it, the hypocrite in me had no use for venomous snakes.

"K-Kill it!" I stammered, dead serious.

"Nah, this guy's got as much right to be here as we do... more, in fact. We're gonna' take a walk up the stream. I'll release him to a long and fruitful life."

The two snake handlers walked in opposite directions to release their catch far away from us. The rest of the workday, it took great self-discipline to even place a toe where there might be snakes. If I had been slow to avoid poison oak, I was twice as slow to avoid cottonmouths, carefully double-checking every stick on the ground. That day our crew unearthed *five* furious cottonmouths. Somehow, no one was bitten.

Conditions got worse, especially for the men. Georgia's heat was intensified by the humidity. Local fire officials claimed that the humidity levels while we were there were lower than usual, which created fires that were more difficult to contain. Coming from the desert, we were not convinced of this "low" humidity. Trying to work in this climate gave most of the men a nasty bout of heat rash. They said it felt like a million hot pinpricks wherever their body held the most heat and sweat. At the end of the workday, the guys were desperate for relief from the rash. Our EMT got out a can of corn starch that passed from man to man. Before long, half the crew had peeled off their sweaty t-shirts to throw handfuls of corn starch under their arms, around their belt line, and over their shoulders where the straps of their packs rubbed.

Naturally, insects and all manners of creepy crawlers love this type of climate. In fact, the locals showed us how they taped their pant legs tightly to their boots with strapping tape every morning. They said it kept chiggers from crawling up their pants to burrow under their skin, feasting and laying eggs. The local lore, which held that those tiny red chiggers lay eggs under the skin, is not true, but chigger larvae do bite, and it does itch and blister. Taping pant legs was a good idea.

We were directed to our sleeping area upon arriving at the enormous fire camp that served hundreds of firefighters and personnel. Like a jungle-style army barracks with row after row of tarped structures, it looked like greenhouses covered with thick black plastic to keep off the morning's heavy layer of dew. They provided us with military cots which allowed us to sleep off the ground and warned us to shake out our boots before we put them on in the mornings.

"Oh, and beware of the centipedes," they said. Certain centipedes had poisonous bites, and if we were bitten, we should immediately go to the first-aid tent.

Centipedes. *Wow, what next?*

I didn't sleep well that night. Certain there were spiders and centipedes crawling on my skin, I spent the night scratching and sitting up to shine the flashlight inside my sleeping bag. Since our boss wanted us to be one of the first crews up to receive our day's assignment, I was shaken awake in the wee hours of the morning right after I had finally dozed off.

According to my watch, it was not yet five and I was in a sleep-deprived daze. It was a cold, dark, damp October morning as we quietly dressed and packed our sleeping bags. My sweatshirt had dropped to the ground in the night. I grabbed it off the moist earth, shoved my arms into the sleeves, and pulled it over my head. Flipping the hood up, I felt something cold and hard fall onto the back of my neck under my ponytail. My sleepy brain thought it was a hair clip until I remembered I didn't have a hair clip and then the thing started to crawl. I froze.

Somewhere in the reservoir of my cerebral cortex, a primitive instinct for survival came surging to the surface with the intake of air for a scream that I had to stifle so as not to awaken every man in camp. The guys near me switched on their head lamps and turned to have a look as I tore off my sweatshirt. I shook my hair, swatted

at my neck, slapped at my shirt, and slapped at a 3-inch long hard, hairy thing. I stomped my feet on the ground, hoping to smash the trespasser.

"You alright, Hamberger?" came the quietly strained voice of someone behind a headlamp, trying to contain his laughter.

Disheveled, breathless, and on the verge of losing it, I hissed, "I hate this place!"

Giving the sweatshirt one more good shake, I pulled it back over my head. I heard some chuckling as I got in line to walk past many sleeping bodies to the camp kitchen. In line for breakfast, Nate approached and offered me a cup of black coffee. I accepted it with a shaky hand and took a deep breath.

"Thanks, Nate. It was a centipede… crawling on the back of my neck."

I glanced up at him, wondering if he'd make fun of me, but he smiled with kind eyes.

"What a way to wake up, eh, Crazy Kate?"

I smiled, thinking of Shakespeare's *Taming of the Shrew*.

"We all hate this place. We're getting one sucky assignment after another. It's as if the powers that be don't like us."

"Wonder what we're doing today."

"Word is, we're gonna hold a dozer line while they do a burn operation."

"Sounds simple enough…" I mused, while blowing on my wrist where spots from poison oak had appeared.

Did I mention that the worst thing to do is give in and scratch where it itches?

I had enough of self-denial. I wanted to go home. Home to Oregon.

Holding a friendly vine snake in Georgia

Trigger Points
Chapter 24

On a day off toward the end of the fire season, I walked to the library in Parowan. Tired and sore as always after a busy summer, the walk loosened stiff muscles. I pushed open the glass door and entered the bright, clean, air-conditioned open space, redolent with the familiar smell of stacks of books. I noticed a *Time/Life* picture book sitting on a table next to a comfy-looking chair. The cover showed a person receiving a shoulder massage. Thinking I'd pay a small fortune for a good shoulder massage, I plopped down to have a look. My mind also wanted distraction. My job was almost over and I had no idea about what came next.

In the book, pictures and diagrams showed techniques to achieve the goal of long, loose muscles, greater flexibility, and the release of feel-good endorphins. *Who doesn't want that?* What surprised me was how academic it sounded; the book referred to the people who gave massages in an office as therapists. Massage therapy, they called it. *How did I not know about this?*

Growing up in a small, rural town in Oregon in the 80's, I had never seen an office that advertised chiropractic care or massage therapy. I remember watching a scene in the movie *Chariots of Fire*, when the Olympic athletes got a massage before their race. That scene, and my mom asking me to rub her legs after a day of walking hospital floors, were my only previous experiences with massage.

Here I was, at the end of my firefighting days after five years of sore muscles, just now learning about a simple way to relieve muscle pain without ibuprofen. I knew about stretching and rubbing, but I didn't know there were specific techniques for specific results.

When I returned to our base clutching several books on massage, I approached the first group of guys I saw and announced that I was practicing massage techniques and did anyone want a massage?

Everyone raised a hand.

As I went from one set of shoulders to the next, they made jokes, saying things like, "You haven't quite got it. Five more minutes should do the trick…" When their joking veered south, I walked away.

I liked learning how to loosen muscles, but on days when my shoulder felt tight, I still had to back up to a doorframe and lean into my shoulder at just the right angle to find what the books called a trigger point.

That spot in a muscle or group of muscles that is especially tight and tender, or painful, is a trigger point. For these areas, sometimes the best thing to do is apply a bearable amount of pressure, hold it, and breathe. Usually, it softens and releases within seconds. I had developed a slight scoliosis from always using a pulaski with my dominant hand. As such, I was out of balance and carried a permanent knot in my right shoulder, a constant trigger point.

On my last day in Utah, Nate and I got a ride to Zion to visit the park one last time. Two other crewmembers were headed there to enjoy some hard-core rock-climbing on the park's crimson cliffs before they went home. We joined them for a farewell dinner at our favorite restaurant, the *Bit & Spur*, which they affectionately referred to as the *Spit & Bur*. As happy as we all were to finish fire season, there was a melancholic tone to the conversation. Our crew had been through a lot together. We'd seen a lot of country and fought

a lot of fire. We'd probably never see each other again. As this was my last summer fighting forest fires, I savored the reality of *This is it! My last night in Utah and my last night as a hotshot.*

After dinner, Nate and I returned to our campsite and sat on the tailgate of the truck I had been asked to drive back to Oregon. A spectacular fall sunset accented the red rocks at the top of the canyon. The sky morphed from royal blue to turquoise to orange to red to magenta. Crickets chirped in the quiet.

"It's been a year for the books," I said. I looked at Nate and pondered the year.

"I'm 23. I've graduated from college, lived in a foreign country, fought fire in the Alaskan Wilderness, and traveled from coast to coast. I started the year convalescing in Oregon but was able to study in Spain and travel to Portugal. Then, when hired to work with Alpine, we traveled to Nevada, Arizona, Utah, Alaska, Idaho, Colorado, Georgia. And now we're back in beautiful Zion. In two days, I'll be back where I started in Oregon."

I shook my head in wonder.

Nate stood up from the tailgate, turned, and took my face in his hands and kissed me. I felt an emotional trigger point. I tried to ignore my feelings for him and just enjoy the moment. Joy, but also sadness, rushed to my eyes as I kissed him back, wishing for more than a kiss. Our connection was special, and I lamented its brevity.

"I might miss you, ya know," he said.

"Maybe."

I sighed, aware of the fact that I had been the only woman within 100 miles of him for the past few months.

"You know," I said, "outside of the crew, we're not exactly compatible."

"Yeah? Why's that?" He moved to add a few sticks to the camp's small campfire.

"Hmmm, for one, do you believe in Jesus?"

He looked at me and snorted. I smiled.

"You might want to lead with that in the future," he said.

"I thought I was clear enough."

God's rules often seemed impossible to follow. There even seemed to be good arguments for ignoring them: Don't have sex before marriage; marry a fellow believer; etc. In the moment, what I wanted to do diverged from the Bible's instructions for relationships. But it was not for me to question God's wisdom. Instead of acting in the moment, I had to wait and hope that one day God would make good on his promise to give me the desires of my heart. I turned to face Nate, trying to imagine what he might be thinking.

"Trying to follow God has been anything but boring."

He returned to sit next to me on the tailgate. I leaned against him to gaze at the rising sparks directing our eyes toward the celestial display in the cathedral in which we sat. The presence of God surrounded us.

"Are you sure this is your last summer fighting fire?" he asked.

"Yeah," I said. "It's time to move on. Time to use that college degree I worked so hard for."

Privately, though, I was more aware now of the risks of being a hotshot. Each fire season had been harder than the last—more physically challenging, more dangerous, more emotionally confusing as I made friendships and then moved on. Yes, I did feel the need to explore a career; but I also wondered how much harder firefighting could get.

Absently staring into the fire, my mind flashed to the fear I felt at the Dude Fire. "That fire in Arizona scared me, Nate. I thought I wouldn't make it out of there. People below us died!"

I paused to consider the horror of that fire. Next to me, Nate stared up at the fading light on the rock cliffs and then shifted his gaze down from the sky to the immediate reality of the campfire. I wondered if he really would miss me. I knew I'd miss talking and

laughing with him. I refused to think about parting ways the next day. He was headed east to the Big Apple and I to the sage-covered hills of the West. I'd most likely never see him again. Star-crossed as we were, I would not forget our good times together. We ended the evening with a final card game. Bittersweet as it was, I'm sure he let me win.

The next morning, steering the truck to the curb at the Salt Lake City airport, I shifted into neutral, and we gave each other a farewell kiss. With a sad smile, I waved then watched him walk through the doors and disappear. Now the only things remaining from my summer of firefighting were my calloused hands and beat-up fire boots. Sighing, I turned up the radio and shifted into gear.

Following I-84 north, I made my way onto the endless freeway that stretched long and straight north to home. After hours on the road, I was treated to another spectacular sunset. I pulled over at Twin Falls, Idaho for a lonely night at a hotel trying to look forward to seeing the chubby cheeks of my little nieces.

That Christmas, Nate sent me a package. It felt like a book. Maybe a beautifully photographed picture book of Zion National Park?

Feeling transported by his thoughtfulness, I sat alone in my room and opened my gift: *The Joy of Sex.*

I laughed until I cried.

Modesto welcome sign. Photo by Carl Skaggs

Modesto
Chapter 25

November 1990. "Look! If you don't sell my sister *this* car at *this* price right now, I might have *this* baby in your office!" Amy said.

My sister was rolling up her sleeves and straightening her shirt over her very pregnant belly. Her due date was a week away and for three hours we had been sitting in a stuffy cubicle while she negotiated.

The salesman kept excusing himself to speak with his manager. We wanted to buy the "like new" two-door hatchback Honda Accord with 60,000 miles listed for $4,990. When the salesman walked back into the room, he looked defeated.

"Sales have been low because of the Gulf War. We're willing to agree to your offer."

A check for $4,500 of my hard-earned dollars was thrust into his hands in exchange for the keys and title of the Accord. We hurried out the door smiling.

Finally free, I was done with college and done with firefighting. I now owned my first car. And I still had plenty of money left in my bank.

The next morning, mom eagerly looked out the window to see what kind of car I had bought. Her face fell a little at what she saw.

"What's the matter?" I asked.

"Oh, nothing …" She smiled, shook her head, and waved me off.

"Seriously. Is there a crack in the windshield or something?" Worried, I moved beside her to look out the window.

"No, no… I just thought you'd pull up in a little red sports car is all."

"You thought I might drive home in a little red Corvette?"

I sighed. Sometimes I felt like nothing I did pleased her. Years later, when we revisited that conversation, she clarified that she thought her daughter was a badass and that her car should reflect that. Once I installed the Yakima bike rack, the car looked sporty enough for me. I drove it for another 150,000 miles without mishap or breakdowns.

That morning, at my parents' kitchen table, I searched the Want-Ads for a job to get me out of the house while I figured out how to pursue a career. There was an ad for training to be a massage therapist and an invitation to an open house at the East-West School of Healing Arts in Portland. Curious, I decided to go.

Wearing Levi's and a t-shirt with my old backpack slung over one shoulder, I pushed open the glass door and was transported to a quiet, calm place. Harp music piped through ceiling speakers. The faint fragrance of lavender and patchouli perfumed the air. The woman I sat next to wore long dreadlocks, several nose rings, and carried a brown suede satchel with long fringe.

At the front of the carpeted classroom was a plastic skeleton wearing a friendly grin. Arrows and Latin words marked origin and insertion points of tendons and muscles. It wasn't a coincidence that these marked points were where my own body was often sore. Fascinated, I decided then and there to register for the nine-month course. It was one of those rare times when I was eager to learn what the school taught.

Just before Christmas, my brother and his wife came to visit from Modesto, California, where he was studying to be a pastor. One afternoon, sitting at the kitchen table drinking tea, I shared

my plans to go to massage school in Portland. Out of the blue, he invited me to live with them in California.

Was he not listening?

"What about massage school? I want to go — I've just enrolled!"

"There are massage schools in California." He said it like, *Duh, it's where the whole movement started!* "There's also a huge career group at the church where I work. You should go to a target-rich environment if you want to find someone to marry and settle down."

His goofy smile told me he was joking. Mostly.

I snorted into my teacup, doubting that the environment could be any richer than where I had been in the last six months. But I knew what he meant. I hoped to enjoy a relationship with someone I'd have a spiritual connection with, one who loved Jesus as I did. *If God blessed a marriage, it had a better chance at happiness, right?* I thought about Paul, but figured the distance between us had killed whatever chance we had of a lasting relationship.

After Christmas, my brother and his wife returned to California. My classes at the East-West School of Healing Arts didn't start for two more weeks. In early January, the entire state of Oregon was hit with a snowstorm. Even Salem, with its rainy, moderate climate, got six inches. Between the fraught atmosphere at my parent's house (where I was staying), the cold weather, and a returning loneliness, I began to consider a move to California— with its sunshine, palm trees, beaches and ... big career groups. It might not be such a bad idea.

And just like that, I was on my way to California.

A week later, driving into Modesto on a frigid January day, the warm sunshine I expected was not there. Only dense, depressing fog, which lasted for days. I moved into the house my brother and his wife rented. He had a woodshop behind the house and had a small business building custom cabinets to pay for his seminary classes. My sister-in-law taught school and I enrolled in a massage school in the Bay Area.

I studied to be a certified massage therapist at the National Holistic Institute. The official address of the school was Emeryville, California, but I joked with friends and said I went to Berkeley to study massage. At school, the male-female dynamic was opposite of my last hotshot crew: there was only one man in a group of twenty women.

Toward the end of the nine-month program, we applied our skills in the school's massage clinic. Clients received discounted massage sessions and were expected to grade their therapist's performance afterward. A typical post-massage critique praised my work. In fact, all my massages received the highest marks in every category. Clients requested me. When someone got on the table complaining of shoulder or neck pain, I knew exactly what to do: I was all too familiar with shoulder and neck pain. I enjoyed the classes and it was a good school, but when I finished the expensive certification, I was saddled with a student loan that would require many massages to pay for it.

True to my word, I still wrote letters to Patrick, my Colorado friend from the previous summer. One day, he called with an intriguing proposition. In a town called Telluride, they were building a swanky ski resort and hiring massage therapists for their spa. His mom had an "in": if I wanted, I could work there. My clientele would be movie stars and millionaires from all over the world. It was a massage therapist's dream. It took me an entire second to respond.

"Yes, I want the job!"

Bursting with excitement, I ran to the woodshop to tell my brother, Jesse, the news, expecting him to share my joy. Instead, he turned off the giant sander, brushed sawdust from his shirt, and suggested we go for a drive. I chatted happily until he parked on a dirt road outside of town, along a canal. We stared at the water flowing by. In the heavy silence, I tried to guess what he was about to say and how I might argue.

"You've gotta' die."

He spoke quietly as if talking to himself, still staring at the water.

It was typical of him to say something completely unexpected. I chuckled and scrambled to guess his meaning. He smiled too, in a way that communicated he knew what he said was hard and counterculture. I didn't know whether I was talking to my pastor or my brother, but I figured he was referring to a spiritual death.

"What's your motivation for going?" he asked.

"What? Is this a trick question? I'm broke. It's a good job. I'm good at this!"

"Well, have you prayed about it?"

"Seriously? You've said yourself that when a door opens wide and an opportunity falls in your lap, it's usually a God Thing. Right?"

"Well, not always. Sometimes it's a test. It can be tricky to know which is which."

I sighed. I saw my brother as somewhat of a prophet or visionary. But I didn't like where this conversation was going. Seven years older than me, I had always looked up to him as being smarter, especially when he played guitar or designed and built something. I respected his theology and how he embraced the idea of living intentionally and doing hard things. I watched him give up an enviable position and a lucrative career with a construction company in which he traveled the country installing high end carpentry in hotels and office buildings. He gave it up to study the Bible and become a pastor.

Because he supported his arguments with example after example of ordinary people from the Bible who lived extraordinary lives based on faith, and because of his own life choices, I listened. Jesse had changed from a '70's pot-smoker in a rock 'n' roll band, with no use for school or his little sister, to someone who listened and cared. He saw me and my lack of parental guidance and tried *(maybe a little late)* to fill the role.

Years of practicing what he preached lent credence to his words, *but still...*

He continued. "A person who pursues God is called to die to self... our desires, our own agenda, money, fame, power, relationships, even comfort, must be held with a loose grip. We must be willing to let it all go if God guides us in a direction we don't expect."

My eyes filled with tears.

"So, you don't think this job opportunity is a God thing?"

"I didn't say that. Maybe it is. But are you willing to take the time to listen, and then obey if it isn't? Are you willing to consider that God may have something else in mind for you? Something way beyond what you could ever imagine?"

I stared out at the water for what seemed like a long time while I weighed and measured scenarios that I hadn't considered.

"What would God possibly have against me giving massages to millionaires and movie stars?" I smiled, as I wiped tears off my face. My imagination had Brad Pitt proposing to me after a massage.

My brother's words held wisdom. I fasted and prayed, asking God to confirm that I should go to Colorado. But no such confirmation came. I did not have peace about it and I knew that when there's no peace in a decision, it's a sign to wait. Waiting is harder than going for it. The phone call to Patrick was brief and awkward, as I could hardly explain to him what I barely understood myself. To tell him, *"It just wasn't where God wanted me to be,"* sounded weird, even to my own ears. It went against logic, and not only did I give up what I thought would be a sweet job, but I said goodbye to Patrick. I couldn't endure another long-distance relationship.

And there were more hard questions. Did I want to venture again into the unknown to start a new life with a potentially permanent career, so far from home? I was ready to put down roots, but where did I want those roots to grow? I didn't want to be permanently separated from my family or the country where I

was raised. Eventually, I appreciated my brother's concern for my tendency to act without a good amount of prayer and consideration of possible outcomes.

So I waited. I spent the next two years trying unsuccessfully to have a massage therapy business, determined to pay off my school loans before returning to Oregon. As a member of the Bay Area Sports Massage Team, I learned how to work on athletes, sometimes traveling to sporting events with my massage table. I did 15-minute massages for $15. Wealthy athletes from the Silicon Valley appreciated my work and asked for directions to my office, but when they learned I lived in Modesto they backed off. It was too far to drive.

At my first official job as a massage therapist in a chiropractic office, a woman injured from a car accident got on my table. We both assumed her insurance would pay for treatment. She came for massage three times a week for several weeks. As we talked, I learned that she raised Arabian horses.

"Of all the breeds, Arabians are my least favorite," I said.

"What? Why? They're the best!"

"They have a reputation for being nervous, stupid, and downright dangerous."

"Well, I need to dispel that myth right here and now! No, tell you what, come out to my ranch Saturday and I'll show you the opposite is true."

I went to her horse ranch and fell in love with Arabians. It was hard not to smile at their petite heads, graceful lines, and intelligent spunk. After my first visit, I returned to her ranch often to lean against the railing and converse with her black stallion. She told me the gentle giant was sired by Khemosabi. I raised my eyebrows to look impressed but didn't know anything about the Arabian horse world or that Khemosabi was famous for being awarded the Legion of Masters, the highest award offered by the Arabian Horse Association.[1]

Then, a couple of weeks later, the chiropractor pulled me aside to tell me that this client's insurance company was not going to pay for any of the massages. When I explained this to her, she thought fast.

"What if I give you one of my stallion's foals in trade?"

"What? No! I can't afford a horse. Where would I put him? And I've never trained a horse. That's not a good idea."

"You wouldn't pay anything. We'll call it even. You can board him at our ranch and I'll teach you how to train him."

I stood there shaking my head. I struggled to pay rent these days. I needed cash.

"And how much would you charge me for boarding this horse and training?" I asked.

"Come out to the house with your table for two massages a month. Sound fair?"

"Please!" she begged. "Money's tight right now. You can own a purebred Arabian! If you register him, he'll be worth a whole lot more than what I owe you. Come out and have a look at the foals. See if any of them strike a chord with you."

Sure enough, when I returned to the ranch, a three-month-old little bay colt with a black mane and tail caught my eye. The runt of the pack, at feed time he would trot around the circle of yearlings looking for an opening to the trough. He'd squirm his way to the manger for a mouthful before getting nipped and pushed away, only to try again elsewhere. I admired the little scrapper's pluck.

On the second day of standing for hours shaking grain in the can to try to get the little guy to come to me, my client's husband lassoed him and pulled the rope tight. Every time the little horse tried to run away, the big rancher yanked on the rope, flipping the horse over backward. This happened several times until the yearling struggled to stand up and swayed back and forth, dizzy and unable to walk a straight line.

I named him Vertigo and vowed to never treat him the way he had just been treated. Training Vertigo became the sweetest part of my days. In time, I left the chiropractic office and moved into my own space at a fitness gym. My "office" was a remodeled storage closet next to the indoor pool. There was just enough room for a massage table, a cabinet, a boombox, and me. My clients had to walk past splashers and seniors doing water aerobics. The room was always warm and a little steamy. I played Enya's music and her soft, siren singing calmed all who came for a massage. I stretched a coral-colored fabric over the hideous fluorescent light and, on the largest wall, hung a framed poster of a forest with a carpet of wildflowers; rugged, snow-capped mountains could be seen in the background. It looked like wilderness, maybe Idaho.

Not knowing that one ought to research the demographics of a market, I tried unsuccessfully to advertise massage therapy to blue-collar workers who could barely afford a gym membership in the economic recession the country was in. My struggle to pay rent had me constantly checking the nearly empty schedule book for clients. One day, a unique client knocked on my door: he was a bullfighter from Spain.

Several Portuguese dairies around Modesto enjoyed private bullfights on their farms. When I was in Spain, I had no interest in watching the gruesome death of a bull, but during my brief visit to Portugal, I happened to walk by a bullring just as a bullfight was starting. From what I could see from the street, there were several horses galloping in the ring. Curious, I bought a ticket and found my way into the stands. In Portugal, they only kill the bull symbolically, choosing instead to emphasize the skill and horsemanship of the *cavaleiros*, who assist the matador. It was hard to stay seated in the excitement of the dangerous dance between the horses, the riders, the matador, and the bull.

In the massage room, Eduardo could not raise the arm that held his red cape. Pleased that I spoke enough Spanish to understand

him, Eduardo explained that he'd lose his job if he couldn't hold up the cape for his next performance, which was in six days. He pulled the t-shirt off his lean, lovely body and stood with a crooked shoulder line. He was protectively holding the right side of his body higher than the left.

Eduardo climbed onto my table, and I set to work increasing circulation and warming the affected muscles. We didn't talk while my hands moved from one muscle group to the next, starting at the levator scapula, then the trapezius, the supraspinatus, infraspinatus, teres major and minor, the rhomboids, the subscapularis, posterior and anterior deltoids, and finally the pectoralis major and minor, pressing, kneading, and stretching until his muscles softened and lengthened, and the tension released.

When I finished, he stood, looking relieved; the pain and spasms were gone. I suggested that he ice his shoulder, rest it, and return in two days. After the second massage, he left with hope in his eyes. By his last massage, the day before the bullfight, he smiled as he raised both arms pain-free with a straight shoulder line. He gave me tickets to watch him in action and left the gym grinning.

To get more clients, I practically gave away massages. Each night, I drove home exhausted, defeated, and hungry, wondering how a college graduate was struggling to support herself. With my bank account near zero, and the rent due at the first of the month, I'd fight panic as I scanned my almost blank schedule book.

In Psalm 50, the psalmist asserts that it is God who rules over everything:

For every beast of the forest is Mine,
The cattle on a thousand hills.
I know every bird of the mountains,
And everything that moves in the field is Mine.
If I were hungry, I would not tell you,
For the world is Mine,
And all it contains.

It was to God that I turned. I prayed about my sputtering business and financial straits on a frequent, regular basis. More than once, I got on my knees with my forehead to the floor asking the God of the cattle on a thousand hills if He could just direct a fraction of His wealth toward my little office. Then it happened. One day, my two measly clients both bought the special I offered: buy four massages, get one free. It strengthened my resolve to trust God. Of course, I still fought doubt and feelings of failure.

Toast with jam and other cheap, empty carbs became my go-to comfort food. Poor and plump, my insecurities were at an all-time high, with the devil whispering that something was wrong with me. Despite everything the Lord had safely brought me through, despite everything I had learned, I still failed to be the successful, worthy person I knew I should be. The fact that I wasn't dating anyone seemed to confirm it. At one point, the career group's pastor at church suggested I might intimidate the guys in the group.

"Are you serious?" I said, finding it hard to believe.

"Being too independent and too outspoken can be a real turn-off," he said.

His words stung. It was a direct criticism and rather than be outraged, I saw my independence as a flaw. This new glimpse of how men might view me messed with my head until I had no desire to date anyone from that church.

This was my state of mind when, out of the blue, Paul called.

P-3A "Orion" National Archives

Goodbyes
Chapter 26

We hadn't seen each other in almost three years.

In his first phone call, I learned Paul still lived in Hawaii, but often flew to the Moffett Naval Base in Mountain View, California, for flight training and exercises. Mountain View was just over an hour's drive from Modesto. With his new proximity, I hoped we could see each other. I imagined telling him all about my progress training Vertigo. I could share my struggle to have a massage therapy business. I looked forward to just being with him and hoped it would be as easy to be together as it was when we were in high school. Though he never spoke of it, I wanted to know how Operation Desert Storm, affected him. I knew nothing about his military life. I wondered if it were a little bit like being on a hotshot crew, where I could be surrounded by people and sometimes still be lonely.

We decided that the next time he was in Mountain View, he would drive to Modesto. On his first visit, I introduced him to Vertigo. On a later visit, we went for a short hike on the Knights Ferry Trail outside of Oakdale and ate at my favorite Mexican restaurant. The time we spent together was easy and comfortable. It was great to be with him. One time we went with my mom, who was also visiting, and brother to hike through the Redwoods, north of San Francisco. We held hands in the back seat as we drove over the Golden Gate Bridge.

Another time Paul flew in from Pearl Harbor and drove to Modesto in a borrowed pick-up truck. He knocked on the door and entered the house all tall and pilot-y, while I was still debating, *do I just hug him or kiss him too?* I wanted to kiss him, but my brother was there, and my sister also happened to be visiting, so we had an audience which meant a hug, no kiss, and a quick departure. We were off to tour San Francisco.

At some point in the drive, Paul pushed in the cassette tape to play the Fine Young Cannibals song "She Drives Me Crazy." He sang the lyrics to me. That was fun. But I didn't want to drive anyone crazy. What I wanted was to spend more time with him.

When we first met, on the mission trip as teenagers, I worked every day with Paul, sat beside him at meals, hiked with him, and sang with him. We did Bible studies together and were completely at ease with each other. Now, as adults, we had to work to get there each time. Our expectations were different. We were asking ourselves different questions and were seeing our way to different answers. We weren't the same people. *Were we still compatible?*

Listening to the peppy beat of the song, I raised my eyebrow, then laughed and nodded my head to the rhythm. On that same visit, we laughed over dinner at TGI Friday's. Returning to his friend's apartment in Mountain View, where we stayed, Paul turned on the TV and went to the kitchen. Slipping my shoes off, I crossed my feet on the coffee table while he brought us drinks and joined me on the couch. He saw the band-aids over eight of my toes.

"What's going on here?" He pointed at my feet.

"These shoes rub my toes raw!"

"Why'd you wear them?"

"They're the best I had for the occasion and they're actually comfortable… apart from the toe thing."

He shook his head, smiling as he studied me. "There's no arguing with that logic."

We shared a smile, and I felt a little ridiculous as I saw my toes through his eyes. I picked up one of the flats. "Feel how soft the leather is. Made in Italy."

He felt the leather and then his hand caressed mine.

"You're something else, you know that?"

Looking into his jade green eyes, I saw eight years-worth of intensity looking back at me. I reached for my drink. Settling back on the couch, I leaned against him. Our eyes were on the news on TV, but we weren't really watching. At least I wasn't. I was trying to keep things calm—just enjoying the sensation of sitting next to a man who had been a part of my life since I was 15. Eventually, maybe from the sleepy drone of the TV and a week of work and anticipation, my eyes started to glaze over. We both must've fallen asleep because the next thing I knew, Paul's body jolted awake.

Shaken awake by his body's jerk, I asked, "You alright?"

"Yeah, I just had one of those falling dreams. I've been working in flight simulators all week. Guess I'm pretty tired." He yawned and rubbed his eyes.

I yawned too. Condensing years of catching up into his brief visits was not enough. I wanted to see him more often; like on a daily basis. Figuring out how to make this happen made me tired. I wanted us to be done with trying to have a long-distance relationship. I didn't know if moving to Hawaii was the answer or not. Thinking about how and when to start the conversation made me quiet. Also, it was late. I wanted to go to bed but didn't want to at the same time.

The apartment only had one bed. He insisted I take it. When he knocked on the door to say goodnight, I suggested he join me. I hoped that being next to each other physically would create a closeness and ease of conversation, but I wasn't sure if we were still on the same page about what came next. *Was he still honoring that "no sex 'til marriage" contract that we both signed years before?* Everything I knew about him made me think he was.

He slid in beside me in his t-shirt and boxers. I turned onto my side to face him and adjusted my twisted t-shirt.

"So where should we go tomorrow?" I asked.

"Where do you want to go?"

"Well, there's the beach—Santa Cruz is just down the road. There's Golden Gate Park, Fisherman's Wharf, the Italian District, crooked Lombard St., China Town, Hippie Haight St...." I rattled off too many tourist sites and possible To Do ideas. He was quiet. *Was he asleep?*

I reached for him to say goodnight. We kissed. Then again with passion. A sudden wakefulness. One thing kept me from tearing off my clothes. *(Again, with God's near impossible standards!)* Finally stopping for a breath, he pulled away and slipped out of bed. I could hear him on the floor in the dark, breathing hard, doing push-ups.

It seemed that after all these years, we both still had a desire to honor God. Of course. That must be it. He was waiting to propose before we went any further. I couldn't claim to love God but ignore God's precepts. Believing this way was unbelievably counterculture, but ... I was willing to wait a little longer.

Beyond frustrated, I rolled over and feigned sleep, and so did he. My last thought before drifting off was that if I got another invitation to visit him in Hawaii, this time, without hesitation, I would go.

The next day passed quickly. We drove through the fun parts of San Francisco, rode a streetcar, stopped for a bread bowl of chowder at Fisherman's Wharf, and meandered through parts of Golden Gate Park. At the end of his visit, we made plans to meet again in a few weeks. He was to return to the Bay Area to attend a wedding and I agreed to meet him to drive together to the ceremony. We parted with a kiss and a promise to see each other soon.

Driving into the naval base, I was happy to see him, but grumpy. My outfit was frumpy. It made me feel unattractive and self-conscious. I wished I'd gone shopping. Not that I had money to buy nice clothes. All

my clothes fit in a suitcase, were travel worn, and not at all wedding worthy. If only I had said, *Hey, let's stop somewhere. Help me find something nicer to wear.* That connection and vulnerability would've been worth the Visa bill. But being me, I didn't ask for help.

My mood didn't improve on our drive from the base to the wedding. I steered my struggling four-cylinder Honda into the slow lane and shifted down as we moved up a steep grade. As cars whizzed past, he snorted and commented that my car was gutless compared to his Porsche. I remembered then that he wrote to me about rebuilding the engine on his classic car. Maybe his comment was a mere observation, but that's not how I took it. Bristling, I snapped back something defensive like, *"Well, we can't all drive Porsches!"* which made him bristle, and we both stared in opposite directions at the grass on the hills blowing in the afternoon wind.

It went downhill from there. I didn't know a soul at the wedding, and I was uncomfortable in my ugly skirt and plain blouse, the uninspiring color of wet sand. Paul was quiet too, and sitting together listening to the exchange of vows made by the happy couple magnified the fact that we were *still* not where they were. It wasn't long before I had a raging tension headache. We should've gone to the beach instead; built a campfire; watched the sun set; had a conversation.

But disillusionment and insecurity left me mute. He was sober. While other people danced, he looked at the floor and suggested we leave.

In the span of a few hours, we had become strangers.

Maybe what I'd feared all those years was happening: We could not measure up to the people we knew only through letters and a lot of imagination.

In silence, I drove him to Moffett Field, where his plane waited.

I didn't want him to leave. Not like this. *Would there ever be a time when we could be together without the pressure of a looming departure? Is this what life is like married to a military man?* But he had no choice;

he was due back at the base. I knew it was useless to complain about something over which he had no control. Gloomy thoughts of our separation swirled in my head. Just before he got out of the car, I turned to him and said something I had never said before:

"I think… I'm beginning to fall in love with you."

To me, saying "I love you" meant *"I would marry you."* It meant *"You are the one for me."* After holding the torch for him for eight years, I was finally brave enough to utter those precious words to him, but it didn't come out right… and he didn't respond right. In the quiet that followed, I waited for a response that did not come. He sat staring out the window, clenching his jaw. The temperature in the car dropped thirty degrees. My declaration had the opposite effect of what I intended. Infinite space separated what I said from what I meant, as he tried to discern what our relationship had been about for the last eight years, if not love.

Why was it that I could say the Latin names of every muscle in the human body, but struggled to say how I felt about him? I had always loved him. I just hadn't been ready for the next level of commitment. Now, I thought I was. Why couldn't I just tell him this? Why couldn't I just say, *"How 'bout I come visit you in Hawaii?"* Owning up to my feelings for him was new and scary. Clearly, I had failed in my attempt. In this moment, he needed me to fight for him, but with all my insecurities, I didn't. Instead, judging from his reaction, I was convinced that sharing my feelings had been rash and hasty. Because of his silence, I began to doubt his feelings for me.

My mind reeled and I struggled to think of something else to say. After an unbearable silence, I blurted out, "What kind of plane is that? It's enormous." I nodded out the window toward his plane. After a long pause, he said, "It's a P-3 Orion. The Navy uses them to search for submarines."

And then the unbearable silence returned. I felt myself beginning to shut down in the overwhelm of conflict and emotion. I didn't know what to say to change the outcome. Taking a deep breath in order to hold

it together, I got out of the car and met him for a proper kiss goodbye. I wrapped my arms around his neck and kissed him, grateful for all the years he had supported me.

"Goodbye, Paul," I said.

"Goodbye, Katie."

And with that, we turned and walked in opposite directions.

On the drive back to Modesto, my heart physically ached. I wiped tears from my face. Though we would exchange a last brief, heavily guarded and impersonal letter, it was clear we both had come to the same decision. We were discouraged, both by the constant distance and by doubts: it was over.

Reflecting on that breakup, I don't know why I couldn't say what I meant. Paul once pointed out what was wrong with me years earlier and he'd been right.

"You don't trust me!" He said.

At the time, he had been leaning against the wall in my quad at UO back in 1988. His eyes met mine for a moment before I looked down at my hands. I wasn't sure what he meant by trust. He had reached into the core of my vulnerability. His words succinctly uncovered my brokenness. I was the youngest in a family of six, with four older brothers who held Dad's attention on the rare days that he gave it at all. I didn't understand that I kept those people who became important to me at arm's length, to protect myself from being disappointed.

In my room that day, instead of opening up and being vulnerable, I got angry, thinking he was accusing me of jealousy. And I told him so. He looked to the heavens for patience, shook his head in frustration, and left. He was a good man and I loved him, but it was true, I didn't trust. I was afraid he'd lose interest. I didn't know it then, but I had acquired a sense that I was not worth a man's continual love and attention.

My dad was the opposite of demonstrative and never seemed all that interested in me. When I ran track in high school, Dad almost never

came to home meets to watch me race. A cluster of parents always sat in the stands watching their kids at every competition, but my parents had to work. It's a legitimate excuse, except that my dad's office was right across the field from the track. He worked for the school district. No one would've stopped him from walking over to watch me if he had wanted. I remember getting ready for the 200-meter dash which started at the track's closest end to his office. Shaking my legs, stretching… casually glancing over at his office window. Blasting first from the starting blocks, I hoped he was watching out his window… but he wasn't. He didn't see me. He didn't look. I wasn't interesting enough.

Some say that fathers teach their daughters that loving trust. If there's a disconnect there, girls can grow up handicapped by insecurity. If there's no one in her life to demonstrate that kind of love, all manner of self-destructive behaviors can shadow her life. I didn't understand the basic tenets of love. It didn't occur to me to get counseling; I was raised in a culture where "shrinks were for psychos." My heart was damaged, but I did not recognize my problem or that it was fixable. The Bible's metaphor that we are fragile jars of clay dependent on God's healing power resonated with me. (2 Cor. 4:7-12)

I focused instead on being a good student, firefighter, and massage therapist. I could be proud of those accomplishments. Being someone's partner and allowing myself to be vulnerable to love, however, proved elusive.

The break-up with Paul left me with a broken heart. At the same time, life turned grim. Business went from bad to worse. I couldn't pay the bills and couldn't find clients. This was a one-two punch, as I found myself chronically poor and emotionally exhausted. I wasn't used to failing.

One Saturday, desperate to make rent, I drove to the Bay Area to do sports massage at a cycling event. After doing a dozen 15-minute massages, I barely had strength left in my hands when a wealthy-looking man in his forties approached my table.

"Those last twenty miles about killed me. You have no idea how bad I hurt!" he said.

"I bet I do," I said, mustering a smile.

"I doubt it."

With that, he climbed onto my table and described in detail the pain he felt. I didn't use my elbow often, but for this guy and his pain, I found a trigger point in his shoulder and leaned in using slightly more pressure than necessary until he stopped talking.

After the last massage, I could barely lift my table into the car. My fingers were so tired I couldn't grasp the stick shift and shifted with the flat of my palm. I had never felt more drained, so completely poured out. My pockets were stuffed with enough cash for the month's rent, a full tank of gas, and rice and beans for the week. Yay.

Somewhere around Gilroy, the garlic capital of the world, I pulled over for caffeine. In the mini-mart, I trudged around as if I was carrying a 50-pound pack. Paying for the soda, I made eye contact with the middle eastern man who gave me change back and he smiled.

"God bless you!" he said through his accent.

I almost winced when he said it and steered back onto the freeway wondering what I had done wrong to be in a place in my life that felt like the opposite of blessing. I had failed at love and was failing at life despite such hard work.

Lord, I prayed, *I'm messed up. I've got nothin' and nobody. I've tried to trust You, to honor You, but I don't feel blessed, I feel… broken. Bereft.*

I teared up on the downhill side of the pass. The road curved ahead and a dismal thought entered my mind. *What if I just kept going straight? What would it be like?* I knew better than to think like that, but in the darkness of the moment I wallowed in my pain.

When I allowed such self-pity and lack of faith to creep in, my thoughts sank in despair. I remembered desperately crying out to God once before at a forest fire. Now, my cries were similar. *If my life was to be a series of failures, why am I still here?*

Life wasn't working out like I had imagined. I struggled to find faith, to believe those Bible verses offering hope.

> *"I know the plans I have for you," declares the Lord.*
> *"Plans to prosper you and not to harm you,*
> *plans to give you hope and a future.*
> *Then you will call upon me and come*
> *and pray to me, and I will listen to you.*
> *You will seek me and find me when you*
> *seek me with all of your heart."*
> *Jeremiah 29:11-13*

> *"See, I am doing a new thing!*
> *Now it springs up; do you not perceive it?*
> *I am making a way in the wilderness*
> *and streams in the desert…"*
> *Isaiah 43:19*

As I wandered in a wilderness of confusion and sadness, a choice was before me. Either trust what was written 2000 years ago and believe God had good plans for me or succumb to fear and despair. Descending into the San Joaquin Valley, a dense fog enveloped my car. Visibility was limited to the glowing white line leading me through the heavy grey mist. It brought to mind the verse *"Your word is a lamp for my feet, a light on my path."* (Psalm 119:105)

I chose to trust God and his promises to show me love and blessing, which the Bible says is better than anything else in the world. Taking one day at a time with a brittle faith the size of a tiny mustard seed, I waited to see some sign of blessing.

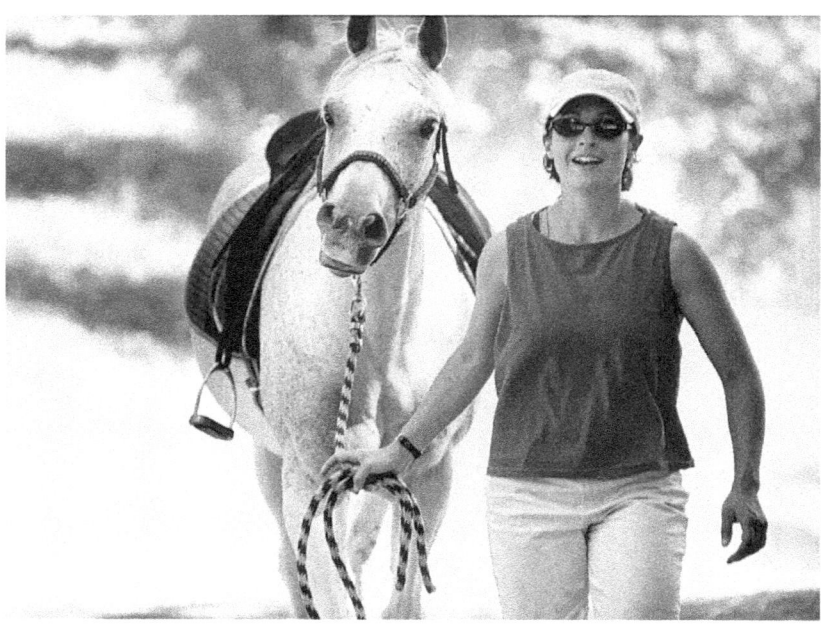
Vertigo and me. Photo by Kelly James Photography

Blessings
Chapter 27

Days later, I met Veronica at a Bible study. She eventually invited me to be her roommate. She lived in a mobile home on her parent's almond farm. While attending college, she cut hair for cash. Because we were both broke and without TV, we recited poetry for fun. I read to her "The Cremation of Sam McGee" by Robert Service and Emily Dickinson's "I Heard a Fly Buzz When I Died." She recited Henry Wadsworth Longfellow's "The Day is Done."

I later read that Longfellow poem over and over while Veronica juiced, until I had memorized it. She offered me glasses of carrot juice until I suggested she look in the mirror as her skin was turning orange. We laughed about that, and she turned into my best friend. When my horse boarding arrangement fell through, (it *was* too good to be true), she helped me acquire corral panels that we fastened together for a pen for Vertigo. Each day she helped me move it to grassy spots between the almond trees.

One day, Dave Zuares from the Alpine Crew surprised me with a call to say he had been smokejumping in Redding, a few hours' drive north of us. He agreed to come visit. I hadn't seen him since I left the crew two years prior, but as soon as he stepped out of his truck, I saw that unlike me, he hadn't gained a pound

While reminiscing, he brought up a special time when we worked together. He and I had been paired as a saw team at a state

park. Our job was to fell big, diseased poplar trees. As we walked together with the Stihl chainsaw on his shoulder, my legs stretched to match his ground-covering stride.

When we approached an old poplar, he handed me the saw. The old tree had an odd lean that required some skill to fell. He helped me get the correct angle of the face cut, so the crooked tree would fall in the right direction. And it did! I was exuberant afterward, since it was the largest, most difficult tree I had ever felled.

After I cooked him dinner in our small trailer, he and I talked about friendships and futures. When Veronica entered the house, I smiled at the sudden sparks between them. Veronica was attracted to his almond-shaped, hazel eyes, and olive skin, but especially appreciated his ability and enthusiasm for building things. Sure enough, it was just a matter of time before he set to work replacing the rickety steps that led up to her front door with solid stairs he built from old railroad ties he found on the farm. As their friendship grew, it seemed I might need to find new living arrangements.

In the meantime, I got a call from the woman at the Arabian horse ranch.

"Kate, I'm calling because I'm desperate. I'm getting a divorce and need to sell my horse, Apache," she said. She had purchased and boarded her young stallion at the ranch and had named him after her tribe.

"I'm sorry to hear that, but I can't possibly take on another horse."

"Please! I saw how good you are with Vertigo. I want you to have Apache. I know you'll take good care of him."

"Even if I had a place for him, which I don't, I have no money."

"I have to sell Apache by tomorrow! Make me an offer! Anything!"

I got sucked into her crisis when she mentioned an auction. I couldn't bear the thought of Apache's life ending at the auction.

I had heard that if no one bids on a horse, he becomes dog food, or maybe someone cruel would bid on him. I wondered what she meant by "Make me an offer!" *Did she mean she would sell him for twenty dollars?* I had $300 in my bank account. I knew that a registered Arabian stallion as handsome as Apache was worth a lot more. If Vertigo was the runt of the herd, Apache, his half-brother, was the Alpha.

"Well, I could only give you $200 or $250 for him."

"Sold! I'll take $250 and leave his registration papers at the ranch, but you must pick him up by tomorrow!"

I hung up the phone and looked at Veronica.

"Lord help me! I just bought another horse. With next month's rent."

Some people are good horse traders. I was not. I also did not have a truck or a horse trailer … or a pasture. Gary, a neighbor across the road had an old horse trailer. I pretty-pleased him to help me bring the horse home.

Apache's previous owner failed to mention that he was not trained to load into trailers. The first time the yearling reared onto his back legs, his front hooves striking at us, Gary looked at me like I would get him killed. Not long into our efforts, we were both suffering from rope burns across our palms. When the horse reared so high, he fell over backward with all his weight, I was sure he had broken his back right there in the gravel. So certain, in fact, that I let go of the rope and before I knew it, he had jumped up and bolted toward the highway with lead ropes dragging behind.

"You didn't tell me you were buying rodeo stock!" My patient neighbor tried to joke.

The next half hour was spent trying to catch my wild brumby and we had to fight with Apache for another hour to get him into the trailer. As we finally drove toward home, Gary asked where I would put my crazy horse. I looked at him with pleading eyes. He

had a big pasture below his house and two horses could be very happy there amongst his cows.

"I'll probably have to sell Apache, but in the meantime, how much would you charge to board both horses, keeping in mind that I have no money?"

We settled on an amount I thought I could swing and a promise that when I did sell Apache, he would get first dibs on buying him for the price I had paid. Months passed and winter came. The inevitable happened: I could not afford hay for both horses and saw no alternative but to sell Apache to my neighbor. We shook hands on the deal. I had added the condition that if, by some miracle, I could buy him back within the year, he would sell the horse back to me. I had grown attached to the spirited Arabian with the big personality. With a final pat on his neck, I handed Gary the lead rope and walked away.

My sadness must have come through in the letter to my parents, because a few weeks later I got a letter from my dad. To my amazement, there was a check for the amount required to repurchase my horse and buy enough hay for rest of the winter with a brief note.

"Get your horse back. Love, Dad."

It was such an uncharacteristically kind and thoughtful gift that I was inclined to joyfully run to buy Apache back. But I wondered why my dad thought I needed Vertigo *and* Apache. I may have mentioned my ridiculously romantic idea that when I married, Apache would be my gift to my future husband. Was my dad sentimental and naïve about the cost of maintaining and training two horses? What if I had to sell Apache again?

After much deliberation, the transaction with my neighbor was reversed. Of course, I wondered if I was being reckless with my horses' welfare and why my dad had been strangely adamant against better judgment. That is, until I received another letter from him. It

was a rather formal handwritten note explaining his choice to give his kids our inheritance early, along with a check for $10,000.

I used more than half of it to pay off my student loan for the massage school and my credit card bill. For decades, I believed that each of my siblings had also enjoyed this happy surprise, that is, until my sister read this and assured me that I was the only one in the family to receive such a gift.

So, there I was, at twenty-five, with two yearling Arabian stallions with stellar bloodlines, but not a clue how to train them. Both needed regular hoof trims by a farrier. Luckily, I was introduced to Tom, a farrier who spent his summers at a pack-mule station, giving tourists rides through the Sierras. Tom was the most patient, calm, even-keeled person I had ever met. Maybe it was because while he worked, he listened to classic country music and Bob Marley's reggae.

I looked forward to seeing his truck parked at the pasture gate for Apache and Vertigo's regular eight-week hoof trims. Both Arabians and I relaxed when we heard the tropical rhythms of "One Love" playing in the cab of his truck. Tom said he enjoyed massage.

"Tell ya what, I'll train Apache in exchange for a weekly massage."

"You sure?"

"Yeah, I've never trained a horse from start to finish. I can tell Apache's extra smart. He'll catch on real fast."

"Yeah? How can you tell?"

Tom pointed at the double helix swirls on Apache's forehead.

"That's a sure sign of intelligence."

That happy arrangement was like a kiss from God.

I felt God's blessing again when I received a call from a Modesto woman in search of a sports massage. After pedaling the 65-mile Cinderella ride in the Bay Area, she had asked around for a massage therapist and was given my number. She enjoyed the massage and

became a regular client. I told her I was willing to take my table to her house. When I shared that I needed a cheaper place to live, she offered me a room at her house for $200 a month, and I could trade my massages for lower rent.

Karen Painter, Ironman athlete and my new roommate, lived in a new three-bedroom house. When her son had joined the military, she realized she didn't like living alone. We were both happy with my new address. During the week, she was an executive for the phone company, but on the weekends, she was a road warrior on her bike. She was gone so often, I missed her. Karen brought me massage clients through her cycling club, set me up with my first cell phone, and listened like a sister. I could not have imagined a better living arrangement.

Sitting alone in Karen's kitchen one day, I read through her *Cycling* magazine. An article caught my eye about a man who rode his bike across Uganda and other parts of Africa. It was a brilliant story with a cliffhanger ending and great photos. I was so moved by the author's account, I wrote to the editor to compliment it. (Something I had never done before or since.) The editor forwarded my note to the author and suddenly I had a pen-pal in Massachusetts. He wanted to know if I was single and what I looked like. His directness made me laugh while I reached for pen and paper.

I was so taken by the article that I began to wonder if I could write an article as moving as his. A week later, I sat in front of an editor of the *Modesto Bee*, the city's newspaper. I wasn't surprised that they weren't interested in hiring me, given my lack of experience. I asked how to get started. He pointed out of town and said I needed to work at a small-town paper, covering high school baseball games and utility board meetings. Yawn. Maybe I hoped he would say, *"You need to ride your bike through Africa…"* because that sounded more interesting. I was an idealist and wanted to write about things that would interest my 26-year-old self.

When Karen met her future husband, it wasn't long before I had to find another room to rent. When that roommate got engaged, I moved again. In fact, during that difficult year, I moved three times. Sometimes my Massachusetts pen-pal would call long-distance because he said he liked the sound of my voice, but it might have been because that was a year I tried to do more listening. I listened to Tom's instructions on horse training. I listened to massage clients talk about their struggles. I listened to the pastor teach about the love of God at church every Sunday. Sometimes those three conversations would intersect, or a theme would repeat itself until I was forced to say, "Yes, Lord, I HEAR you!"

Like when Tom talked about how important it was for my young horses to trust me and then a client would get on the table and talk about her trust issues. Then on Sunday, the pastor spoke about Bible passages that required ordinary people to trust God and when they did the result was extraordinary.

My own ability to relax and trust was challenged when it came time to train Vertigo from the saddle. Some horses are buckers and some like to rear on their hind legs. Apache was a bucker, but Tom stayed calm through the bucking episodes. I watched, impressed, as he made it look easy to calmly trot around the corral riding a horse, an Arabian, that had never before had a saddle on his back.

When I swung my leg over Vertigo's saddled back that first time, I expected the same ease. Not happening. After Vertigo crow-hopped across the corral, completely out of control, I was a nervous wreck and so was my horse. We both quivered until I got off. After some argument, Tom made me get back on. Vertigo had his second wind by then and dumped me with a vertical rear. I climbed on again and when he reared this time, I stayed on by standing in the stirrups, leaning forward until my face was right behind his ears.

"Next time he does that, smack him right between the ears as hard as you can! He's got to associate pain with that behavior!" said Tom.

"What do you mean, next time? I want off! He's trying to kill me!"

"And he may succeed if he falls over backward on top of you," Tom grinned.

"You're smiling when I'm about to die?"

Again, we crow-hopped around the ring, and I watched Vertigo's ears and kept a tight rein. When his ears went flat back, he bucked extra hard. Round and round we went, testing each other for control.

"Relax!" Tom offered. "But don't let him drop his head!"

"I. Don't. Have. Insurance." I gasped, between bucks and rears.

"Remember everything moves away from discomfort. When the consequences for his behavior are painful, he'll eventually stop doing it."

"How long will this take?" I asked through gritted teeth.

"Depends on how smart your horse is," Tom said, shrugging.

Vertigo went vertical as I clung to his mane and hit him between the ears with my crop. He came down on all fours and snorted, shaking his head.

"Good! He didn't like that. Now you have to stay on and gently, quietly, keep urging him forward. If you stay at it, this may be the last day he rears on you."

All played-out, Vertigo finally stopped fighting and relaxed into a smooth trot around the corral. I encouraged him with much praise and pats while he snorted and his ears twitched forward and back as he listened in attentiveness. I was delighted to discover Vertigo had near perfect conformation, which made him the smoothest horse I would ever ride.

I knew there was a spiritual application to what had just happened. Thoughts like the peace I experienced when I lived in trusting dependence and obedience to God's way. As long as I surrendered to the idea that God was in control, it was easier to obey. But if, in my stubborn independence, I thought I knew better, and acted on that "knowledge" even though it did not align with God's ways, I was destined to experience painful consequences.

By January of 1994, even with the blessings that had come to me, and even though I was still working to establish a steady clientele as a massage therapist, I was restless and missing my family in Oregon. I also missed fire pay-checks, and the camaraderie I found on fire crews. I sent an application to work again with the Prineville Hotshots, and hoped and prayed. I wanted out of Modesto. I wanted out of being broke and alone.

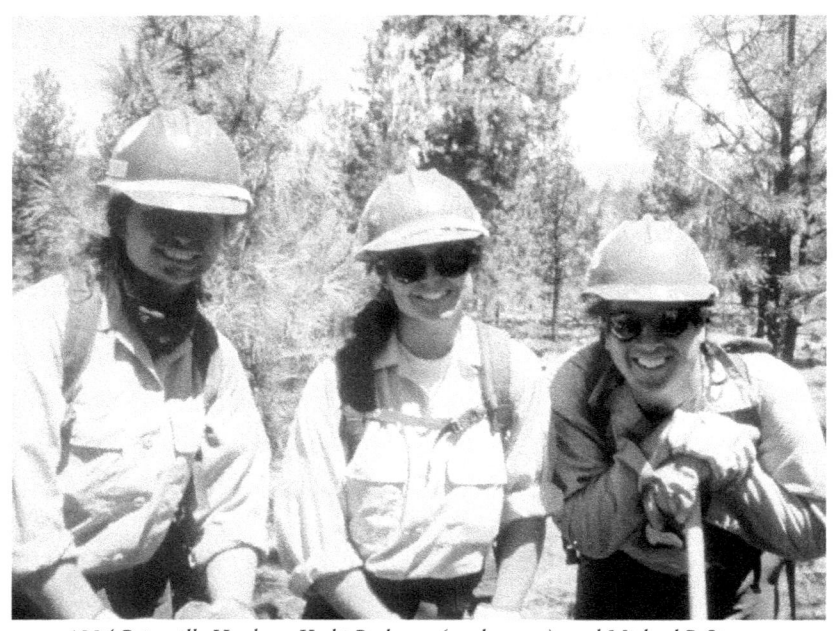

1994 Prineville Hotshots: Kathi Beck, me (as alternate), and Michael P. Simmons

Lightning Strikes
Chapter 28

JUNE 1994. In the heart of the Ochoco Mountains, the ranger station where I was hired was twenty-five miles east of Prineville. It's not there anymore, but at the time it sat across from the trailhead of Lookout Mountain, amid the pungent scents of ponderosas, junipers, and sagebrush. I was happy to be back in the country where my life with fire had begun.

Hope for the future had quickly improved when I answered the call from the Forest Service offering me a job with the Ochoco Ranger Station's engine crew. I arranged to board Apache with the nearest rancher; Vertigo stayed behind in Modesto, not yet trustworthy enough to ride in the backcountry. Apache was my rock star. We explored the forest for miles at a gallop. That sense of freedom was enhanced when I thought of all the time I had spent in my tiny massage therapy office in that crowded California strip-mall.

Just before Memorial Day, I shook hands with Jim, my engine boss. Strangely, we knew each other from long ago. Twenty years earlier, he had visited my family. I was a young girl. Jim had served in the Navy with my oldest brother, and they had worked together in Hawaii on a submarine. He had come to visit with my brother.

I could not fathom living confined under the weight of the ocean in unnatural light and sound. Being slightly claustrophobic,

I wondered if he came here to the open forest and prairie to balance out that time of his life.

The good impression I had from my childhood remained after my first day of working with him. During the lunch break, we sat on a log in the sunshine and listened to the breeze through the pines. He wore a faded blue flannel shirt rolled up at the sleeves tucked in to his nomex pants. I watched with amusement as he cut thin slices from an apple with his pocketknife, eating each perfect slice with a bite of cheese stick.

Two weeks later, Jim came out of the ranger station to tell me he had just got off the phone with the crew boss of the Prineville Hotshots. He had asked if I would want to join them as an alternate on the crew.

"They're down a person and they're headed to the California fires. You wanna go?"

I was honored by the invitation. I had called Tom Shepard, the Prineville Hotshot Superintendent, in early spring to ask if he had filled all the positions for his crew. He said he had, but he also said he'd call if he needed an alternate. He was true to his word. It was a great opportunity, but I had two nagging concerns.

"Jim, that'll leave you down one. Are you okay with it?" I asked. Then I paused again, to think about it. "You think I can do it? I'm not in hotshot shape."

"We'll be fine here. There's not much fire activity this early in the season." Then he smiled, "If you're not in good enough shape now, you will be soon. And remember, most engine folk jump at a chance to work with hotshots."

I looked up at Jim with a grin. I knew this, and I also knew that the money I'd make in overtime and hazard pay would make it worth the jump.

"Well, go on then," he encouraged. "If you're gonna do it, you best grab your gear and get over there."

Before I could go, there was one more thing: I was worried about leaving my horse. There was enough grass in the mountain pasture for him and it had a spring running through it. He should be fine for a couple weeks. To be sure, I asked Jim and my engine partner to keep an eye on him. I waved as I headed to my car. Jim gave me a mock salute with a sideways smile.

I bit my lip in anticipation as I drove from the ranger station to the hotshot's station in town. Walking toward the hotshot headquarters, I recognized that in the nine years since I started as an 18-year-old rookie, I had come full-circle. I was older. Maybe wiser. One thing I knew for certain: working alongside the hotshots would be hard. My body was going to hurt.

I smiled, delighted to see Jon Kelso leaning against the railing of the landing, peeling an orange. As rookies, he had teased me for the lack of salt stains on my t-shirt, but I could count on his friendship. He looked up and grinned.

"Where you been, Hamberger?" His voice affected a quiet nonchalance as if we had just talked last week instead of seven years ago.

"I've been everywhere, Jon, I've been everywhere!" I spread my arms wide and sang to the military tune.

I embraced my crew brother with a bear hug. The door to the station stood open and while we hugged another crewmember approached.

"What's going on out here?"

I turned to face a young hotshot who stuck his hand out to shake mine while Jon introduced us with his arm still around me.

"Levi, this is Katie Hamberger, our alternate."

"Actually, I go by Kate now," I said, bracing for more teasing.

"Huh! Since when?"

"Since I've grown up!"

Levi seemed reluctant to let go of my hand.

"Well, Katie, Kate, Katherine, a friend of Jon's is a friend of mine … we should probably hold off on the hugs, though, until we know each other, right?"

I smiled.

"Hey, Levi, you're looking a little flushed," Jon teased.

"Yeah, I'm hot! Cause I'm a Hot. Shot!"

As we walked into the station, Levi turned back to me smiling, as he asked, "You see what I did there?"

"Yeah. Clever word play," I assured him, pleased to already have two friends.

The next person I recognized was the crew foreman, Bryan Scholz, also a friend from the first year on the crew. He smiled in welcome, but immediately got down to the business of equipping me with the pack and tools I would carry. We were flying out that night to a canyon in central California. As I gathered canteens, pack, and hard hat, my hands began to shake. I hoped I was strong enough for whatever was coming.

The station bustled with activity as sawyers fine-tuned their chainsaws while others sharpened tools and gathered extra supplies. Every hotshot knows the way it works. We might be headed to one fire, but often were rerouted to other fires. We could be gone for days, weeks, or months.

That night, we waited hours for our flight in the Forest Service's section of the Redmond Airport. With news of a delay, many crewmembers stretched out on the floor to sleep. Sitting next to Kelso, I listened while he caught me up on his life since I saw him last. He had graduated from Oregon State University with a degree in Wildlife Sciences, but was working on another degree in civil engineering. I loved hearing about his friends, our former high school classmates, people I hadn't seen in years.

I told him about working in Yellowstone on the helitack crew, the Horseshoe Crew in California, and the Alpine Crew out of

Utah. I told him about traveling in Spain and working as a massage therapist in Modesto.

"So, Hamberger, why aren't you married yet?" He teased.

I didn't want to detail my idiosyncrasies that had made me slow to marry. I was still trying to figure it out for myself.

"For one, I'm looking for a guy who reads the Bible more often than … never. He's gotta love Jesus, you know, like the Tom Petty song."

"You mean, 'Free Fallin'? It's the girl that loves Jesus, not the guy."

"Yes! And why is that? Those lyrics have always bothered me."

Jon smiled as he looked across the sleeping hulks of our crew.

"Hmmm. Your requirement narrows the playing field a bit."

"A bit? That's like the understatement of the decade!" I sighed and stared out the window. "The kicker is I've known some good ones."

"Yeah? What happened?"

I made the sound and motion of a bomb going off and shook my head. Jon laughed. I lay on my side and propped up my head.

"What's the story on Levi? He's a character," I asked.

"He's new to the crew. You know he's one of triplets? Came from an engine out of Burns. He's a psych major and he's funny. We like him."

"Triplets! His poor mother. So what about you, Kelso. Why aren't you married?"

"I'm working on it. There's this girl…"

He took a deep breath and rolled his eyes to indicate that it was too long of a story for the night and we both smiled. We knew we should take advantage of the chance to stretch out and sleep. It wasn't long before Jon pulled his hat over his face and I rolled over, but I couldn't resist.

"Goodnight, Jon-boy," I teased.

"Yeah. Like that doesn't ever get old…" He muttered under his hat.

Joining a hotshot crew as a substitute or "alternate" can be a hard, lonely business. Crews develop camaraderie amongst themselves and often view the newcomer as an outsider. Fortunately for me, the Prineville crew was a warm, welcoming group. I enjoyed working with them, even though I dreaded the soreness and likelihood of blisters while adjusting after three years away from the fireline.

Our plane touched down at dawn in Bakersfield. After waiting hours for our ride and other logistics, we loaded into a school bus. Doug Dunbar sat sideways in the seat in front of mine leaning back against the window with his legs stretched out. He was quiet, and at some point, I noticed his head was down and his eyes were closed while he did something funny with his fingers in front of his chest. When he opened his eyes, he caught me staring at him and grinned.

"I'm a musician. I play the saxophone." I later learned he was an award-winning saxophonist and had a bright future playing the music he loved.

It took almost an entire day to drive up the narrow, winding mountain roads to the fire's base camp. At dusk, we were finally gathering our gear to go to work when I noticed how friendly and helpful this crew was. I bent to pick up a five-gallon cubie of water, but Scott Blecha, who had served four years as a Marine, saw me struggling with it. He took it from me and grabbed another cubie, to carry them to the nearest picnic table for us to fill our canteens. He hefted both forty-pound containers as if those eighty pounds were two bags of chips.

While we filled canteens and put on our packs for the night shift, we joked around, enjoying each other's company. My position on the crew's line-up was toward the back, next to Kathi Beck. Her quiet enthusiasm reminded me of how I was in my first summer. She was a rookie with no previous fire experience, but she

was older, taller, and stronger-built than me when I started. She had long, wavy, auburn hair and a reputation as an outstanding rock climber. She seemed fearless, and shared that she had been majoring in psychology at the U of O when she got a yearning to see Thailand. She loaded her backpack and went. *Carpe diem!* she said. She thought her new summer job of spontaneous departures was perfect.

"Where else can I be paid well to get into the best shape of my life, make good friends, and work in the beauty of nature?" She grinned.

A few days later she liked her job a little less. Grimacing, she walked with a stiff gait and pulled back her sleeves to show me the wide, angry welts with crusty edges oozing around the inside of her wrists and elbows. Poison oak! I had it, too. That first sweaty night in the California Sierras, we had hiked in the dark through brush and patches of poison oak without realizing it until it was too late. Half the crew was now covered in the itchy rash.

Sure enough, those first three days of digging line and hiking miles in intense heat caused me to question my ability to endure. I sported salt stains on my t-shirt whether I wanted them or not. At one point the diggers in front of me paused for a quick breather. I looked ahead to see several crewmembers gathered around the other rookie, Terri Hagen. She had served as an Army Reserve medic before becoming a hotshot. They were staring at something she held in the palm of her bare hand. I walked forward to investigate. She held a shiny, fluorescent green beetle. "Isn't it great?" She smiled. The rest of us looked at each other with smiling eyes. Terri was studying at Oregon State University to finish a degree in Entomology.

Early one morning, around two a.m., Squad Boss Tami Bickett and I talked quietly while the rest of her squad rested. On top of a ridge, we looked up at countless stars and down at pockets of hot embers glowing like rubies on black velvet. As a full moon rose above the canyon, I asked her why she chewed tobacco, wondering if she

actually liked it. This former pageant princess of her hometown's Strawberry Festival was pretty, except for the spitting. She told me crewmembers had dared her to try chewing tobacco during her first year. It happened on a sleepy night shift when the fire was mostly out. The guys told her that if she could handle chew, it would help her stay awake. She won the dare and stayed awake easily on the following night shifts, but then it became a habit.

After a week on that fire, we were sent straight to another one in Kings Canyon. Late one afternoon, we climbed back to the top of the canyon in triple-digit heat to fly to another part of the fire. When I finally reached the landing zone, I was struggling to swallow another mouthful of hot canteen water. Levi Brinkley approached with two paper cups full of Dr. Pepper on the rocks. One for me, and one for Tom Rambo, who was limping on sore feet. He liked to say his "dogs were barkin'!" Where Levi found the soda, cups, and especially the ice on that hot helispot, we'll never know, but Tom expressed my sentiments exactly.

"Ah, buddy! I could kiss you right now!"

"Me too!" I said. "Just let me wipe the dirt off my teeth."

"Happy thought! But how 'bout some rain checks?" Smiling, Levi handed us the cold sodas.

"Sorry, man. It's now or never for me," smiled Tom.

While he gulped his soda, I fished out some ice to press against the back of my neck. While we drank, we compared new patches of rash from the poison oak on our arms, in that strange paradox of simultaneous happiness and misery.

Late the next afternoon, I made my way up the fireline toward Kathi, stopping to lean on my pulaski and catch my breath. It was so steep that the ground upslope was only about three feet from my face. Panting while bent over, my eye caught movement on the ground near me. A scream froze in my throat. A rattlesnake coiled to strike. I slowly stood and raised my pulaski in an effort to shield

my shins. The snake's tail began to rattle in earnest as his head moved sideways parallel to me.

"Oh, Jesus!" I whimpered.

The snake and I stared at each other. It flicked its forked tongue. I braced myself. My own body vibrated with dread and adrenaline. While I was paralyzed with fear, the snake decided it was too hot to strike and slithered into a nearby hole. Flagging it to warn others, I moved quickly up the line with my new snake energy to see Kathi.

She and I finished constructing cup-trenches to stop burning cacti from rolling downhill. We stirred the vestiges of embers with a layer of cooler dirt and spread out the ashes. In a haze of fatigue, we worked methodically, stirring and spreading hot ashes. We hiked from one hotspot to the next, along our section of fireline. When finished, we took off our packs and sat on a rock outcropping. I pulled out my trail mix to share a snack.

The view at sunset was spectacular. Smoke filtered through the canyon painting the granite cliffs a smoky pink while our elevation left the sky an azure blue. It was yet another canvas reflecting the Artist. A resounding silence surrounded us. We responded with muted voices. I asked Kathi what she thought about God.

"Hmm… well, I've been studying the different religions of the world. I'm not ready to commit to any one way of thinking yet…" She adjusted her position so that her feet dangled off the edge. "Anyway, I've got plenty of time to figure it out."

After a long day, we returned to fire camp. The crew collected firewood for a warming fire in our sleeping area. Someone got out a deck of cards to play Speed and Shoot the Moon while others stood in a circle playing Hacky Sack. We took turns spraying each other with bug repellent while trying to guess which state they'd send us to next and how much overtime we'd make.

Rob Johnson commented on how we could maximize our paychecks' tax refunds. He had worked as a firefighter since 1987 to pay for college and had graduated with honors from Oregon State

University with a Bachelor of Science in Business Administration. He had just passed the Certified Public Accounting Exam on the first try, which had us paying attention. Since several of us had to stand in line at the medic's tent for a steroid shot in the backside to stop the spread of poison oak, we wanted out of California.

While absently rubbing my hip from the needle poke, I stood next to Bonnie Holtby who was laughing at something someone had said. There were traces of dried white salt stains on her temple and on the front of her t-shirt. I asked her how she stayed so cheerful. She said she made a constant choice to override negative emotions that brought her down. I knew she was a praying woman and we compared Bible verses on how to stay strong.

When we flew back to Redmond, we were called to a local fire the next morning near Bend, OR. We were in high spirits at this fire because, for once, it was in relatively flat terrain with no poison oak, no snakes, plenty of shade, and temperatures under 90 degrees. It was windy, though. With the help of other hotshot crews and local hand crews, we worked alongside the engines to line it and knock the flames down and out before it made a major run.

Ominous reports of Red Flag Warnings for lightning storms sweeping across Colorado had the guys talking excitedly about the prospect of big paychecks. That forecast accurately predicted what scientists later counted: on July 2, a whopping 5,600 dry lightning strikes hit western Colorado and dozens of fires ignited throughout the drought-stricken state.[1]

When we returned from the fire near Bend, the hotshots expected to travel to more out of state fires. I would not be going; my "tour of duty" was over. At the end of the day, the boss sat us down to talk about what would happen after the crew's mandatory day off. To my surprise, just as I was preparing to leave, he invited me to join them as an official crewmember. I looked around the room at the mostly younger crew. They were teasing and joking

with each other. His invitation meant a lot. And even though my body hurt, I would have accepted the position if not for my horse.

Until that summer, Apache had lived in the flat pasturelands of Central California. He wasn't used to the life of a wild Mustang grazing alone in forested terrain. I was supposed to be caring for him. Reluctantly, I declined the offer and returned to work at the Ochoco Ranger Station.

Two days later, back with my engine crew, I was sitting in a local school cafeteria at a day-long pump class with all the district's engine crews. We were reviewing how to calculate a pump's water pressure necessary on any given slope and length of hose line. The entire class was yawning its way through the lecture when the hotshots stopped in unexpectedly on their way out of town. There was a brief meeting among the bosses. Everyone took a break, and I walked outside to visit with the hotshots. Levi jogged up behind me and I felt his hand, briefly, on the small of my back, as he leaned in and asked if I would have dinner with him when he got back.

"Yes, I would," I said, smiling.

As he stepped back into the bus, I had a thought.

"Levi, do you like riding horses?"

"Yeah," he said. And then paused. "… and I like Jesus too."

He winked and smiled. As their rig began to roll, some made fun of how I had become an "engine slug." In a flash, I remembered I owed Jon lunch money, but only had a dollar in my pocket.

"Hey Kelso, I'll pay you back for lunch next time I see you!" I yelled while waving goodbye.

Someone yelled, "YOU'RE MISSING THE BIG ONE, HAMBERGER!"

I stood alone, waving as they drove away, and wondered if I'd regret my decision not to join the hotshots.

The sharp rap on the bunkhouse door at dawn on July 7th, woke me instantly. Running to the door, I reasoned that a knock this early

in the morning could only mean one thing: Fire! *Lightning strikes during the night must be putting up smoke that the lookout spotted.* I opened the door to face a tired-looking Tom Mountz, the forest's fire manager.

"Kate, there's been an incident with the hotshots. As soon as you're dressed, meet me at the station."

With that, he turned and walked briskly to his truck. My heart pounded as I shut the door, knowing that for him to come to me, personally, whatever the incident was, it was bad. That's when I remembered that my bunkhouse roommate had returned from work the day before saying she had heard that some firefighters, including hotshots and smokejumpers, had been trapped and killed at a fire. A rising panic forced me to protect myself with denial. *News reports were often wrong! Not my friends. Hotshots don't die. Sometimes they have close calls, but they don't die.* I shoved the information out of my mind and didn't think of it again. Now, with shaking fingers and a sickening sense of dread, I laced my boots.

Entering the station, I was hit with the stink of burnt coffee. More people than usual were milling about, dressed in official Forest Service garb. In Tom's office, several men I didn't know stood leaning against a filing cabinet, the desk, and the windowsill. I sat in the chair next to Jim, who was mostly looking down with his chin in his hand. There was a lot of clearing of throats and watery red eyes staring at the floor. Someone asked if I had heard the news. I shook my head no. We didn't have a TV at the bunkhouse, and I hadn't turned on the radio.

Nobody spoke. My heart pounded and I wanted to cry, but didn't know why yet.

"The Prineville Hotshots were on a fire in Colorado," Tom began.

Oh, God.

"Yesterday, that fire, known as the South Canyon Fire, took the lives of 14 firefighters, including nine of the Prineville Hotshots."

Tom paused to gain control of his emotions. His voice had cracked and the paper he held in his hand fluttered. I sucked my breath in sharply as he began to read the names of the deceased. One face after another flashed in my mind.

 Kathi Beck Tami Bickett

 Scott Blecha Levi Brinkley

 Doug Dunbar Terri Hagen

 Bonnie Holtby Rob Johnson

 Jon Kelso

By the time he finished, everyone was crying. My hand went to my forehead as I fought to control my pain. The images stopped at Jon's face. I couldn't help myself: I couldn't help but imagine what the last minutes of his life were like. I needed air. Rushing outside, I took deep breaths and sobbed. In time, Jim joined me. Together we sat on the bench, both just managing to breathe. Tears wet our faces.

When I finally joined the crew at the shop behind the station, my tears continued to fall. With my mind reeling, I started to roll hose but did it wrong. A crewmate took it from me and handed me a gated Y to put away. Wandering around the shop, I forgot what I was doing and where it went. Tears flowed as I pictured the hotshots working on the fire and then imagining that fire blowing up. I remembered the Dude Fire in Arizona.

I wandered to a bench outside to sit. I was numb and absently turned to look for the blue jay making a racket in the trees. The towering ponderosas with their pale-orange bark and long needles were dew-kissed and shining in the morning sun. They stood as hovering sentinels over the baby trees which were wrapped in a

protective plastic netting. If not for the netting, porcupines would eat the tender saplings' bark, killing them. But with time, that netting could bind their growth and the poor trees became twisted at odd angles. Sometimes it took decades for them to straighten and recover. I'd learn that like that netting, grief can be the cruel grip from which some will never recover.

Days went by in a mental fog. Eventually, I walked into the ranger station and asked if there was a computer available. There was, and I took the rest of the day off to write. Wanting to share my experience of working with the Prineville Hotshots, I sat at the keyboard, staring at the screen. Many of the hard truths about the circumstances of the last fire they fought would be revealed years later from research and dozens of interviews conducted by author John N. Maclean for his book *Fire on The Mountain: The True Story of The South Canyon Fire*.

The hotshots had arrived at the South Canyon Fire near Glenwood Springs, Colorado, just after noon on July 6th. Using a mostly alphabetical crew manifest, the first group of hotshots was flown by helicopter to the top of Hell's Gate Ridge. Their assignment was to help the smokejumpers construct fireline on the mountainside flanking the fire below. The extremely steep terrain was covered in tall, thick brush, mostly scrub oak, known as Gambel oak. When dehydrated, which it was from Colorado's severe drought, it's dangerous around fire as the plant's leaf oils become highly flammable.[2]

The rest of the hotshots had to wait for their ride while the only helicopter assigned to the fire dropped water on flare-ups. When the second half of the crew was finally flown to the helispot, their assignment was to join a local hand crew in the task of cutting and clearing the entire ridgeline. What none of them knew was that a storm was brewing.

A National Weather Service forecaster stationed in Grand Junction, Colorado, broadcasted an updated Red Flag Warning for high winds; 40 to 50 mph gusts expected by that afternoon. This forecaster understood the vital importance of his forecast to firefighters and personally telephoned the Grand Junction BLM's district office to warn them. The office was grateful to receive it, but a communication breakdown caused that game-changing, extremely important message to be lost. It was never relayed to the firefighters on Storm King Mountain.[3]

At four p.m., those high winds hit the fire without warning.[4] When it exploded, the firefighters building line had only minutes to hike the almost impossible distance uphill to the ridgeline through thick smoke and roaring wind. The nine hotshots, the smokejumpers Don Mackey, Roger Roth, and Jim Thrash, and the helitack crewmembers Robert E. Browning Jr. and Richard Kent Tyler did not survive the raging blast of flames that raced up the steep slope.

The second group of hotshots, the local hand crew, and several smokejumpers working on or near the ridgeline experienced a narrow escape by diving off the ridge into the East Canyon. They hiked along the drainage to the Interstate 70 while wondering if the first group had made it. It happened so fast that all involved and the entire firefighting community were stunned and stricken. The fourteen firefighters that died came to be known as the Storm King 14.

Maclean summed up the tragic fire's final statistics: "Dating from the lightning strike on July 2, the South Canyon fire burned for ten days. It took fourteen lives, cost more than $4.5 million and destroyed 2,115 acres of commercially worthless scrub brush."[5]

While I sat at the computer, mental images gradually changed from firefighters trying to escape an inferno to mental snapshots of the good times I shared with the hotshots on previous fires.

Pictures flipped through my mind like a slideshow. I smiled through tears as I typed. Like the night in California, when we sat watching the beauty of the fire across the ridge, like so many rubies on black velvet, or when we compared our patches of poison oak rashes or played Shoot the Moon. I remembered the treat of the icy cold Dr. Pepper on the hot helispot. These were snapshots worth sharing.

It took all day to finish my article. The next day, I drove into town, walked into Prineville's newspaper office, and handed my story to the editor. Others who were grieving needed to read about the lighter side of the men and women who gave everything for the work they loved.

On July 14, 1994, The *Central Oregonian* printed the article on the front page, giving it the title, "We Know the Beauty and the Power of Nature". It wasn't great writing, but I tried to communicate my heartfelt sentiment in the first sentence:

> "To all the family and friends of hotshots who have never understood the attraction that holds firefighters to a summer of digging fireline under countless adverse conditions, I dedicate a few of my memories as a hotshot…"

It was easier not to think about my grief during the day, as we drove gravel roads, putting out small fires or tending to other forestry work. But emotion emerges from the body one way or another. Sitting in the stands at Jon Kelso's outdoor memorial service, my stomach ached when I saw his family at the front of the crowd; the stooped shoulders and bowed head of his mother sitting next to his father and his older brother, also a former hotshot.

Fighting a sore throat two days later, my forehead felt hot as I sat through Kathi's memorial service at Timberline Lodge on Mt. Hood. It was in the outdoor amphitheater. One speaker remarked

that Kathi preferred the outdoors, a common trait in wildland firefighters. My legs shook as I walked to the podium to say a few words about her strength and love of life.

Two days later, I had a doctor's official diagnosis of strep throat. I was put on antibiotics and light duty. My body shrank to my rowing weight, while I pondered who I had to thank for missing the South Canyon Fire. *My horse, Apache, who kept me from joining the crew? Sweet Tom, who trained and trailered Apache and drove him to Oregon for me? Was it my dad, who sent money to buy Apache for the second time? Or was it the friendly family of nearby ranchers who agreed to board my horse for the summer?* I'm grateful for all of them. I still struggled to understand what happened and wrestled with futile questions that all began with the same word: *Why?*

I wanted to attend other memorial services but didn't want to at the same time. I opted to send cards of condolence. While waiting for the antibiotics to work, I lay exhausted in my bunk, listening to Garth Brooks sing "The Dance," over and over again. I resonated with the lyrics and did not regret my summers of fire: memories of intense challenge, travel, adventure, and camaraderie. On the contrary, I knew I had been blessed to be able to work with hotshots since I was eighteen. Working as a hotshot raised the bar for future endeavors.

By August, I thought my health had recovered enough to work with the engine crew at full capacity again. I was invited to rejoin the Prineville Hotshots as an alternate. Though they had been given the option to disband for the remainder of the summer, all but two had chosen to stay together to finish the season. Now they were looking for people the crew knew to join them and the Redmond Hotshots for a fire near Hells Canyon on the Idaho border. I wanted to go; I thought it might be healing to rejoin them.

When I boarded the crew carrier, my heart hurt knowing that I sat in a seat that didn't used to be empty. Everything felt different. There was little conversation, the mood somber. Not long into the

drive, I was struck by how sick they sounded. Everyone seemed to have the cough of a chain smoker. Their lungs were still recovering from the smoke they inhaled on Storm King Mountain. When I voiced my concern to a crewmember about their general health, he reached into his breast pocket and pulled out a prescription of antibiotics. Then he smiled, rested his head on the back of his seat, and closed his eyes.

I'd learned at massage school that the lungs are the organ associated with grief. It wasn't a big surprise when, a few days later, after hiking to the bottom of the canyon, I coughed up green. The last thing this crew needed was another person leaving. But green phlegm was not a good sign. If I were sick, I would be useless, miserable, and a hindrance on the line. Despite feeling guilty for being a burden, I had to tell the boss. Later, I watched as the hotshots hiked single file toward the fire as my last helicopter ride lifted me out of Hells Canyon.

The doctor I saw in Joseph, Oregon, listened to my chest and ordered X-rays. As he suspected, I was on the verge of pneumonia. He insisted it was time to hang up my fire boots for good. I agreed, but wasn't ready to leave the forest. I stayed to heal in the beauty of the Ochocos and the simplicity of my life at the ranger station. I wanted to finish the season with Jim and my other engine crew friends. As time passed, my lungs recovered. But neither my spirit nor my body was healed.

During the remainder of my time with the engine crew, if there were no local fires, we would drive out to the remote parts of the forest to pull Vexar, that protective plastic netting, off the trees that had outgrown it. I knew there was still something physically wrong with me when the crew had to climb a small hill and I quickly fell behind. I had to stop; there I was, mid-hill, bent over with my hands on my knees, panting and dizzy. The guys turned to tease that maybe I needed extra PT, implying that I was out of shape.

"Do you like spinach in your Wheaties, Kate?" a crewmate teased.

I tried to laugh with them. Popeye's diet might help. I went back to the doctor for blood tests to learn why I had a headache every day and was always tired, unable to climb small hills without stopping to slow my racing heart.

Those tests showed what I already knew: grief had stolen my strength. My body was anemic. The doctor injected me with liquid iron.

"So, how's your summer going?" she asked.

"Well…it's been a hard one."

I sat on the crinkly paper of the exam table, screwed my eyes shut, pursed my lips, and took a deep breath to hold back the sudden flooding emotion. As much as I wanted to control my tears, I couldn't. My exhale turned to weeping—hard and long enough that the doctor left the room. When she returned, I told her about my friends killed on Storm King Mountain. She shared my sorrow. I told her that if it weren't for my horse, I would've joined the crew… and that if I had joined them, my name might be on the list of deceased, between Terri Hagen and Bonnie Holtby *and why wasn't it? And if my name were on that list, maybe Jon's wouldn't be…*

After a long pause, the doctor mentioned survivor's guilt as being a common struggle for those who don't die from a traumatic event. I also questioned God's goodness. It was the premise I lived by, and it had been shaken to the core. *What good can come from this? How should I respond? How should I live the rest of my life? What should I do? Where should I go?* All the doubt and confusion made me tired. I left the doctor's office with a bottle of iron supplements, and steeled myself to finish the last month of my final fire season.

Kathi Beck

Tami Bickett

Doug Dunbar

Terri Hagen

Jon Kelso

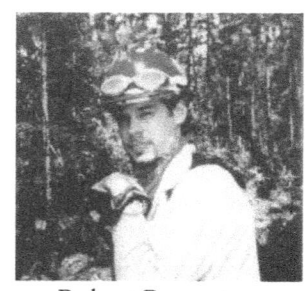
Robert Browning

James Thrash

Richard Tyler

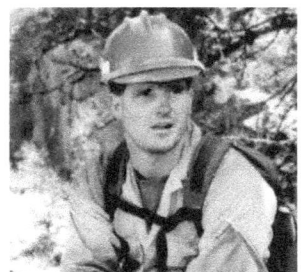
Scott Blecha

Levi Brinkley

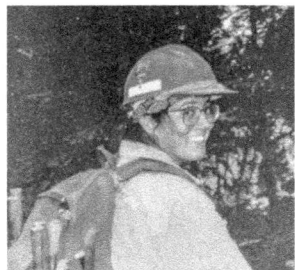
Bonnie Holtby

Rob Johnson

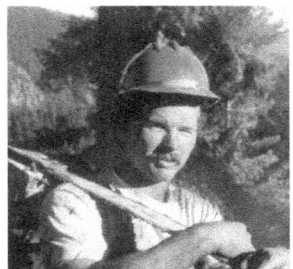
Don Mackey

Roger Roth

Lightning Strikes

Passion
Chapter 29

Dennis, my engine crewmate, gave everyone nicknames. Mine was Big-Talk. I chose not to delve into his reasoning as long as he said it with something resembling affection. He came from a big and tall farming family of mostly older brothers from Kansas. At 6'4", he was the shortest son. What he lacked in height, he made up for in intellect and enthusiasm. The editor of his college newspaper, he was a fast thinker and could out-pun and out-rhyme anyone, making it hard to keep a straight face when he spoke.

I admired how he bucked conventions and did not concern himself with how others saw him. He drove his jalopy across the continent with a sage smudge, rosemary sprigs, and maps littering his dashboard. He knew of every hot spring on this side of the Rockies and saw irony in circumstances way before I did.

Dennis and I were verbally jousting in the station, when I was summoned for a phone call. Surprised, I lifted my eyebrows at Dennis. Picking up the phone, I said, "Hello?"

"Jesus! You're harder to reach than I am!"

(Long pause.)

"Keith? Is this Keith? My pen-pal?"

"Yeah, this is Keith. I've decided to meet you in person. Thought I should come before something else happens or you move again.

If it's okay with you, I'll take the red eye into Portland and be there in a few days."

"Oh! Well! I'd like to meet you, too, but... you're coming here? To the ranger station?"

"Yes. I'll see you in a few days."

"I hung up the phone with my heart pounding.

"Wow!"

"What's the matter?" Dennis asked.

"Remember the guy I told you about? The super-smart engineer turned photojournalist?"

"Your pen-pal?" Dennis grinned.

"Yes. He's flying here from Massachusetts. He wants to meet me," I said, taking a seat and rubbing my temples.

"He's coming here?" Dennis pointed down at the floor.

I nodded.

"Do I hear wedding bells?"

"I don't think so," I said, smiling.

"Is he aware that you read your Bible every day?"

"I don't read it every day... but I should. I feel better when I do. And yes, he knows. In the first letter he sent me, he asked for a photo. I sent him a Bible verse about how the Lord looks at the heart instead of the appearance of a person and maybe he should too. It was an avoidance tactic. All my stuff was in boxes and I didn't feel like rifling through them to find a picture worth giving to a professional photographer. No such photo exists."

"So, he has no idea what you look like?" Dennis leaned back in an office chair. He crossed his arms, looked at me, and considered the situation.

"I eventually sent him a photo. It might've been the one where I'm standing on the fireline wearing Nomex, sunglasses and a hard hat."

I knew *he* was good-looking. I saw his photo at the end of the magazine article I read in Modesto where he stood next to his mountain bike in the jungles of Africa.

"So, how well do you know this guy?"

"Well … since we've never actually met, not well at all. I know that he's a brilliant photographer, that he flies by the seat of his pants all the time…today he's in Uganda covering government-sponsored war crimes; next week he's in Mongolia covering corporate greed robbing a peoples' way of living. He takes risks with his life. He's impulsive and brave because he cares about people."

Keith was gifted with both seeing the bigger picture of world events and narrowing his focus to what I thought should be a prize-winning angle. His photos captured his subject's essence. Working through those lonely days in Modesto, I loved looking at his photos, reading his stories from faraway places, and hearing his friendly voice when he occasionally called. But his visit could get awkward. There was an empty room in the girl's bunkhouse where he could sleep, but still … I wasn't sure why he was coming.

Apparently, I wasn't the only one wondering.

Three days later, word had spread through the station that a man I had never met was flying across the country and hitch-hiking from Portland to meet me. I stopped to look whenever a car pulled into the station. My crewmates made jokes about what kind of man my pen-pal might turn out to be, which left me irritable and jumpy.

Keith arrived quietly just before quitting time. No one heard his approach. He had planned to hitchhike all the way to the ranger station, but sometimes, like on that day, ours was a road less traveled. He'd had to walk the last five miles. He wore dark sunglasses, shorts, t-shirt, sturdy hiking boots, and a big backpack. Sitting on the bench behind the station, he looked dusty, hot, and travel weary. I sat down next to him, and we had a good look at each

other. *What are the chances?* This being my only pen pal experience, I didn't know how common it was for pen pals to meet.

Overwhelmed with his presence, I didn't even think to offer him a glass of water. I waited for him to take off his sunglasses so I could see his eyes. He had deep dimples, curly light-brown hair, and his voice was even more pleasant in person.

My pen pal, Keith Snow

When we walked side by side to the bunkhouse, I started to worry about what to serve him for dinner. I had planned for us to drive to town and eat at a restaurant. Seeing how tired he looked, I knew we weren't going anywhere. With a bit of panic, I hoped there was food—any food—in the bunkhouse fridge. I'd delayed buying more groceries, which clearly had been a bad call on my part. I scanned the slim pickings of the bare cupboards and refrigerator. I found tuna, but no bread and no pasta. There were some old potatoes and a sprouting onion. I sighed. This was no way to treat someone who had just traveled across the country to meet me.

He sat against the wall watching me, possibly (hopefully) with weary amusement. As I leaned on the open refrigerator door with a

flushed face, I looked over at him and apologized. I explained that I had planned on taking him out to eat because I wasn't very good at cooking and talking to important people at the same time.

"Am I important?"

"Yes." I smiled.

Then he told me to get out a pan, turn on the oven, and pull out those old potatoes, the onion, the cans of tuna, and some nutmeg and he would teach me how to make a dish from Africa. Over the delicious dinner, we laughed as he described his hitch-hiking experiences that day, having to catch rides with more than a few drivers to get to the ranger station from the Portland Airport. He had to explain to each driver where he was from, where he was going, and why. They all wished him well, saying things like, "Give that hotshot gal a kiss for me!"

Because my first encounter with Keith had come from reading his magazine article about cycling in Africa, I could almost hear Paul Simon's *Graceland* music while we talked. Especially the song "Diamonds on The Soles of Her Shoes," which weaves a hint of melancholy under a playful rhythm, which seemed to fit the occasion.

The next day I had to work. He promised to give a slide show in the evening and anyone interested could come and see his photography. I told the engine crews about this, thinking they would want to see amazing photos of people and places from around the world, but only Dennis came. Most of Keith's photos demonstrated awe-inspiring art. As I looked at them, I kept thinking *now he's here, with me!* I tried to remember what sort of things I wrote in my letters that would interest him enough to come. I hoped I had not given him the wrong idea about who I was. The likelihood of his disappointment made me uncomfortable.

Peppered throughout his nature photos were those of a darker theme. Suffering people in war zones. Drought ravaging a village

in Africa. Pollution in Thailand. Oppression everywhere. He cared deeply about social justice and was an advocate for those without a voice. As he talked about the photos, I realized that I had never met anyone with so much passion. His photos made me wonder why he was not rich and famous. Perhaps the difficult content made him a pariah or he fought against compassion fatigue. He was eight years my senior, but had recorded a lifetime's worth of images. They featured nature's beauty, as well as man's inhumanity to man. I would've liked to talk to him about loss, but didn't know how to start the conversation, and wasn't sure I was ready to go there.

The next evening after work, I took him on a date. After a short ride through the forest on Apache, we went to the movies and were swept away by the story of *Forrest Gump*. I thought about that movie long afterward, relating to how Forrest kept finding himself with interesting people doing interesting things.

Back at the bunkhouse that night, I said goodnight and turned to enter my room. He took my arm, lightly, pulled me into an embrace, and kissed me. While grieving the loss of my friends, I saw before me a friend, alive and well. He was willing to be in my life, but I resisted. That voice in my head reminded me that he was "not mine" and, as far as I could tell, he did not share my love for God.

We drove to the Bonneville Dam fish hatchery beside the Columbia River on my day off. My oldest brother, Stephen, lived and worked there. It was the weekend of their annual salmon bake and I wanted my family to meet Keith. A welcoming host, my brother grilled the fish while Keith pulled a saxophone from his pack. *What else does he have in that backpack?* He played for us while we sat on the lawn enjoying the fish, corn on the cob, and watermelon. My nieces and nephews ran through sprinklers on the emerald lawn. Watching him play, I was uncomfortable with trying to define our relationship to my sister who struggled to get past the fact that he wore overalls without a shirt.

Early in the morning, I drove him to the airport. We said goodbye in a fog of fatigue after a late night. It was a pleasure to meet him and call him a friend. What a gift to have been able to meet him in person.

Driving home, however, I realized I was going to be late and started to worry about my boss's reaction. And I was late, a half hour late. My boss was okay with it, but my boss's boss was fuming. He let me have it with his 'firefighters are never late" talk, while he drove me to the job site where the crew was pulling old Vexar netting from young trees.

As we bounced over wash-boarded gravel roads, I barely heard his lecture. My mind swirled with thoughts on the recent events in my life, starting to see metaphors everywhere. I had wrapped my heart in a protective netting, but was that netting now stunting my growth? After the summer's lesson on the brevity of life, I wanted to belong somewhere with someone. *Had I missed my chance for a marriage of faith? Would I ever find what I was looking for? Was I asking too much? Was I destined to be single forever?*

I was drawn to the combination of rugged good-looks, patience, kindness, a sense of humor, an ability to lead, and a humility to live under God's authority. *Was I even the kind of woman that kind of man wants?*

Once the angry boss learned that I had driven all the way from the Portland Airport that morning, he calmed and warned me that it better not happen again. Giving him a wry look, I pointed out that Keith's visit was not the kind of thing that happens twice in a lifetime.

As I thought about it, I realized the summer had been full of firsts, some wondrous and full of delight. Others, incomprehensible, tragic, and laced with a pain that never seemed far from the surface. It had been a summer full of events I'd never forget.

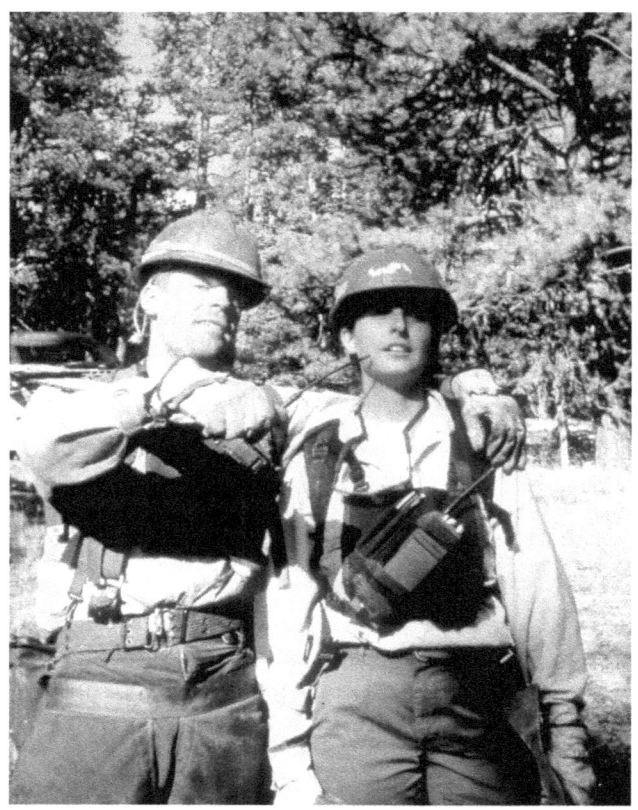

*Ochoco Engine Crewmate Arne Stemsrud and me
in the Ochoco National Forest 1994*

Wonders
Chapter 30

My boss, Jim, knew the wilderness of the Ochocos. He knew where to go for the perfect vista to watch eagles or where to go for the best view of a lightning storm or where to find a herd of elk. Jim was aware of nature's wonders and secrets. One afternoon, he and I drove our engine on one of the barely used Forest Service roads. After numerous twists and turns, the gravel ended at a barbed wire fence gate. I opened it and we continued along two tire tracks that all but disappeared into the grass. He drove cautiously, navigating potholes. The snail's pace kept the dust down and we drove with our windows open.

On the north face of a wooded slope, the grass grew green and tall. It was several degrees cooler on this shady side and an elk cow stood in the road grazing. She studied us as we approached and then casually moved upslope, disappearing through the trees. Jim let the engine coast to a stop and cut the motor. Putting his finger to his lips, he slowly opened his door, stepped out, and waved at me to follow. He pointed up the hill. We started to hike, careful of our steps and quiet as possible. Near the top of the hill, we dropped to our hands and knees. The last ten yards we crawled through the grass and peeked over the ridge.

Spread out below us across the far side of the ridge was a large herd of elk. I hadn't seen elk since my summer, six years earlier, in

Yellowstone. It's not that elk are rare in the Ochocos, but I had been far from wild places while living in Modesto. It was good to be back in elk country. Goosebumps covered my arms. Unaware of us, they were just living their lives. We lay there for several minutes sharing time with them, until the breeze shifted. Once they caught our scent, the ground rumbled as they scattered into the dense growth on the far side of the meadow.

Nature again smiled at us several days later, while we worked a small, local fire. While putting in a hose line toward the top of the ridge, we met smokejumpers who had flanked the fire on the opposite side. They told us we should check out the top of the ridge—that there would be a surprise up there that people almost never get to see. I asked if we needed to hurry, or would it still be there when we finished? They grinned and said it could wait. Dennis and I hustled to finish the hose line, and then hiked toward the top of the ridge where several smoke jumpers were still milling about.

"Tell me what's so amazing that I hustled all the way up here?" I asked, trying to catch my breath.

One of them held out his hand to display a fist-sized piece of agate crystal. It had a hint of a lavender hue and looked like amethyst.

I gasped. "Holy smokes! Where'd that come from?"

"Right here! It was sticking out of the dirt. Look, the ground is littered with others just like it."

He was right. If one looked carefully, the ground sparkled. Smoke jumpers compared rocks while I looked around for a piece of agate for myself. I found one about three inches long. It was not quite as pretty as the smoke jumpers' rocks, but still amazing. I vowed to return one day when we didn't have to put out a fire. Somewhat of a rockhound, I grew up in a place where every summer the town hosts what was known as the Rockhound Pow Wow. I remember

as a kid walking through the outdoor aisles full of stalls showcasing dazzling pieces of obsidian, agate, and tiger's eye. I saw almost every kind of pretty rock mined from the earth. As a kid, I'd spend my lawn-mowing money on hand sewn fabric "grab bags" of polished rocks, filled with a surprising array of colors and textures. I always had a hard time believing those beautiful rocks came out of the dirt, but now I saw it with my own eyes.

One evening, after a day of no fires, Jim pounded on the bunkhouse door just as I was climbing into bed. I stood in the doorway and could hear thunder rumbling in the distance. Strong gusts of wind tossed the treetops back and forth. Lightning was coming. Fires, too. He insisted I get dressed and come with him. For the first time, I lacked my usual enthusiasm for a coming summer storm. I climbed into the cab where Dennis was already waiting and the three of us drove to a high point. We looked out over Big Summit Prairie and watched for lightning strikes.

The cab of the truck was a perfect place from which to watch a storm. Because we were at a fairly high altitude, the hair on my arms stood up and my heart pounded as we watched lightning shoot across the black sky. When the thunder seemed to crash directly above us, the three of us yelled out, but barely heard each other over the din. The storm moved closer. The lightning struck the ground all around us. I could hear the actual buzz and snap. It was awesome and terrifying, and the rig shook from the reverb of thunder. Jim had to assure me several times that we were safe. Both he and Dennis were adrenalized, yelling things like, "Yeah, baby!" and "Bring it on!"

Tears welled in my eyes, overwhelmed by my own unguarded response to the power and majesty of the storm. Nature's magnificence left me filled with awe. Hail crashed down upon the truck: we were submerged in a baptism of white. When it finally

stopped, we rolled down the windows. A pungent-sweet fragrance wafted in on the breeze of the drenched earth.

Later that night, back at the bunkhouse, Jim suggested I pack an extra sandwich for the next day; even with the rain, we'd be busy putting out smokes. His eyes danced with enthusiasm. It signaled his complete embrace of the job—an embrace that firefighters *must* have. My lack of enthusiasm was a sure sign it was time to take off my fire boots. Fire money was no longer the draw it had been. The cost was too great. When I told Jim I was not returning after this fire season, he was not surprised. It was obvious I had lost my love for the work. I finally shelved my old boots. My dance with fire was done.

That fall, unemployed once again, I stayed with my sister and spent time with her kids, playing hide-and-seek, building forts, and reading stories. I used my fire money to pay for night school tuition for classes to get my teaching credentials. I had decided to be a teacher.

Despite my lack of experience, the first high school I applied to hired me. Later, I learned that the selling point of my resume was the word "hotshot." The principal figured I had dealt with a degree of challenge on fire crews that would prepare me for the chaos of teaching a class of forty freshmen.

I later confessed to him that *nothing* prepares a person for a class of forty freshmen.

I've had time to think about the day the smokejumpers showed us the agate crystal embedded in the dirt on a ridgeline high in the Ochocos. Unlike agate or amethyst, which emerges from the ground naturally beautiful and shiny, most rocks need polishing to shine. They get dropped into a tumbler with other rocks and a good amount of grinding grit. A stretch of time passes while those rocks tumble and spin round and round. The harder the rock, the longer

it takes to polish. Dull layers are scraped away and rough edges are knocked off until finally, it becomes smooth and pretty.

I had been a hard rock with rough edges. My mom had been the first to tell me. Over the years, others would couch it with more kindness, saying I had a "strong personality." I suspect they meant I was too independent; I struggled with vulnerability and didn't know how or when to ask for help. Coupled with a fear of rejection, a guarded heart, and a devout sense of what God wanted from me, I was slow to enter a loving relationship. My hard edges slowly began to soften with life experience. I've learned the hard way not to lose hope and let doubts, discouragement, and fear ruin trust. Sometimes we must fight for good people and relationships.

Once I started teaching, it was another eight years before I met the man I married. I had assertively asked God to bring a good, available man through the doors of my small church. In walked Sazon, a welder and self-made businessman. My friend Maria, one of his nine(!) sisters introduced us. He sat in the church pew with a straight face wearing a black leather jacket. He watched me as I sang in the choir. I didn't mind.

What's he like? He's Russian. He thinks big. Most of us start fires in our woodstoves using matches and maybe a little paper. Saz uses a blow torch. He'll order a vegetarian pizza because we've agreed to be healthy, but then he'll lower his voice and add, "Yeah… and throw some meat on it."

He works hard for the things he's passionate about. He didn't finish high school. Instead, he started his own company in his dad's garage when he was 18. Years later, when he realized his company would benefit if he had a contractor's license, he sat in front of the computer for hours every night to take night classes for it. He taught himself AutoCAD and how to draft. Now he uses that skill every day. When he sees a need, he acts.

When we met, Saz was divorced, with full custody of his three children. I didn't realize the degree of difficulty I'd embrace when we married and instantly became a family of five. Any stepparent knows the whirlwind of challenge that can involve. I have since learned how to compromise and ask for help. Having been a hotshot, I already knew God would provide the strength I needed. Today our kids are a delight and married to good people. My grandson graces my refrigerator with his art while my granddaughter sings to me. I am blessed.

One day, not long into our marriage, Saz found me in the garage, inspecting the head of a shovel as I ran my thumb across its edge.

"What are you doing?"

"There's no blade on this thing."

"You need a blade on your shovel?"

"Well, yeah! Where's a file?" I rifled through an assortment of tools scattered across his tool bench.

"Give me that."

He took the shovel and secured it in a vice grip. He turned on his grinder and scrunched his green eyes against the flying sparks. In less than two minutes, he gave the shovel back with a near perfect blade.

"Wow! It took me forever to sharpen shovels by hand. And they had to pass inspection of my squad bosses!"

"Darlin, I think those guys were messin' with you."

I smiled at the distinct possibility.

As life goes on, I'm still forced to wrestle with the sorrow and mystery of why good people die young. The deaths we faced during my years as a hotshot, stay with me still. I don't blame God. Sometimes good people die. It may not be more complicated than that. Grief can cause us to rise toward God. We live in a broken world; stories

of trauma abound. Grief and loss is everywhere. Even Jesus wept over death. God asks us to trust. Remembering that life is short, and death will intrude upon all of our lives, all we can do is love each other the best we can.

Through my firefighting years of constant change, one thing stayed the same: my conviction that I prayed to a loving Being who heard me. Sometimes while trail riding with Vertigo or Apache, I'd think of the times God provided for me in ways that defied coincidence. On Sundays at church, when we sing "Amazing Grace," tears come to my eyes at the third verse:

> *Through many dangers, toils and snares,*
> *I have already come;*
> *'Tis grace hath brought me safe thus far,*
> *And grace will lead me home.*

I'm grateful for the opportunity I had to dance with fire. I met beautiful people who taught me about life and caring and fellowship. I developed a growing faith, resilience, and determination to do the next hard thing. As I watch devastating forest fires burn entire towns and millions of acres, I become restless, longing to do something helpful. I hope my story will inspire readers and encourage the next generation to be strong and fight the good fight.

Sherie Jones and I in Hubbard, Oregon, with Apache & Vertigo. 1991 – 2021
Photo by KaiLee Jones

Afterword

I'm grateful that every hotshot crew I worked with had excellent leadership. I never doubted that the crew's safety was their first priority and I trusted their decisions and assignments. Wildland firefighting has changed since the late 1980's and early 90's. The most glaring difference is the level of extreme wildfire behavior and the dangers involved in fighting it. Standardized safety protocols have improved methods of training to better prepare firefighters for potentially deadly outcomes and to prevent the tragic loss of life.

As fires get bigger, hotter, and faster, the risks to firefighters loom greater as well. I witnessed extreme fire behavior, but it's more common now. I mentioned watching the occasional little fire tornado (aka fire devil) because they were cool to see and eerie to hear. A smokejumper friend told me that now, especially in drought stricken and arid terrain, it's much more common to witness fire tornados that are "big, unpredictable, and scary as hell."

The Beachie Creek Fire in 2020 in the Santiam Canyon here in Western Oregon stunned us locals with its ferocity. For scale, Oregon lost 93 homes to wildfire between 2015 and 2019. In 2020, wildfires in Oregon destroyed an unprecedented 4,009 homes.[1]

In 2019, I had the privilege of attending the Forest Service's Storm King Staff Ride in Glenwood Springs, Colorado. During that event, I was pleased to watch firefighters of every experience level, from the rookie to the most experienced, as they each voiced their

perspectives with valid observations. This open communication improves learning and promotes higher standards among the next generation of public land stewards.

Our nation's wildlands are our greatest resource. Finding and keeping that delicate balance of land use and protection has always been a challenge. Whenever the subject comes up among professional firefighters, the buzzword that rings alarms is "urban interface": trying to fight fires among homes and towns surrounded by forest and wildlands. The Forest Service has invited volunteers to help maintain trails and participate in educational services, but lately there's been more discussion suggesting the use of local volunteers to assist with reducing fuel levels with methods such as thinning.

When volunteers are invited to help, how many former firefighters, hikers, hunters, ranchers, equestrians, mountain-bikers, birders, skiers, boaters, and campers would be willing to help maintain the wildlands we enjoy? If you are interested in volunteering to protect our wildlands, visit www.volunteer.gov or your nearest public land agency for more information.

Glossary

Air tankers	Large aircraft that drop fire-retardant chemicals.
Backfire	Fire set to purposely influence the direction or rate of fire spread.
Blowup	Catastrophic fire behavior, rapid spread, mass ignition of large areas.
Burnout	Fire set to burn areas between control lines and main fire; denies main fire fuel. A tactic used once control lines are established.
Cat line	Fire line constructed with bulldozers-aka Dozer line.
Contained	When a fire's spread has been stopped by control lines or natural barriers.
Controlled	When enough work has been done to ensure the fire will not escape.
Crown fire	A fire burning hot enough to continuously spread through tree tops.
EMT	Emergency Medical Technician.
Firebrands	Large embers or burning, airborne material
Fire devil	Whirlwind of fire.
Firestorm	A mass conflagration of fire, a blowup.

Flank	Side boundaries of a fire looking from the tail toward the head
Fusee	Railroad/Emergency flares used to light burnouts or backfires
Helitack	Crews of wildland firefighters transported by helicopters
Helibase	Location where helicopters can park, refuel, be maintained, and loaded for missions.
Initial attack	First effort to stop a fire
Mop-up	Final stage of firefighting-digging out burning material, putting out the last embers
PT	Physical training. Hotshots do one or two hours of PT each morning
Pulaski	Firefighting tool. An ax with a grub hoe on the opposite end.
Rookie	First year firefighter and/or first year on a hotshot crew

End Notes

Chapter 1: Hamberger Down
1. "Interagency Hotshot Crews," *Forest Service - U.S. Department of Agriculture*, accessed March 15, 2024, https://www.fs.usda.gov/science-technology/fire/people/hotshots.

Chapter 2: First Fire
1. "The Big Burn," American Experience, directed by Amanda Pollak, (Portland, Oregon: PBS, 2022), TV Documentary Film, https://www.pbs.org/wgbh/americanexperience/films/burn/#film_description.

2. Timothy Egan, *The Big Burn: Teddy Roosevelt and the Fire that Saved America* (Boston: Houghton Mifflin Harcourt, 2009), 154 – 157.

3. James G. Bradley, "Stories of the 1910 Fire," 1910Fire.com, U.S.D.A. Forest Service, March 20, 2024, http://1910fire.com/Fire%20Stories/Bradley/Bradley%20article.htm.

4. Timothy Egan, "The Great Fire of 1910," Forest Service - U.S. Department of Agriculture, accessed March 15, 2024, https://www.fs.usda.gov/Internet/FSE_DOCUMENTS/stelprdb5444731.pdf, 4.

Chapter 3: My Maverick
None

Chapter 4: Bad Boots & Bladder Bags
1. By Wallace Turner, "Idaho Emergency Declared in Fires," *New York Times*, The New York Times Company, Aug. 13, 1986, March 21,2023, https://www.nytimes.com/1986/08/13/us/idaho-emergency-declared-in-fires.html.

Chapter 5: Early Influencers
1. Henry David Thoreau, *The Works of Thoreau* (New York: Black's Readers Service), 1942, 115.

Chapter 6: Wrong, Wrong
1. "Beachie Creek Fire Story & Data," Forest Service - U.S. Department of Agriculture, accessed March 15, 2024, https://arcg.is/ivH8i.

2. Britannica, T. Editors of Encyclopedia, "Chernobyl Disaster," Encyclopedia Britannica, March 11, 2024, https://www.britannica.com/event/Chernobyl-disaster.

Chapter 7: Cowboys
None

Chapter 8: Cinderella
None

Chapter 9: Brothers In Arms
1. Susan Krohn, "Wildfires Raging in Oregon and California have Blackened a...," *UPI Archives*, September 14, 1987, https://www.upi.com/Archives/1987/09/14/Wildfires-raging-in-Oregon-and-California-have-blackened-a/4973558590400/.

2. Charles Hillinger, "Once the Blazes Are out, Klamath Forest Will Face New Tests," *Los Angeles Times*, October 7, 1987, https://www.latimes.com/archives/la-xpm-1987-10-07-mn-8245-story.html.

3. Bushy, Judy, "Fire Siege of 1987 Remembered," *Happy Camp News (blog)*, July 26, 2015, https://happycampnews.com/fire-siege-of-1987-remembered/.

4. "The Nation: Rains Douse Massive Oregon Forest Fire," *Los Angeles Times*, November 2, 1987, https://www.latimes.com/archives/la-xpm-1987-11-02-mn-11967-story.html.

5. "Largest Oregon Wildfires," *Oregonlive.com*. Accessed April 15, 2024, https://projects.oregonlive.com/data-points/bootleg/table.html.

6. "Biscuit Fire of 2002," *The Oregon Encyclopedia*, May 16, 2023, https://www.oregonencyclopedia.org/articles/biscuit_fire_of_2002/.

7. "Wildfire: Information on Forest Service Response, Key Concerns, and Effects of the Chetco Bar Fire," *Government Accountability Office*, April 24, 2020, https://gao.gov/products/gao-20-424.

Chapter 10: Femininity
None

Chapter 11: Helitack

1. Mary Ann Franke, *Yellowstone in the Afterglow: Lessons from the Fires* (Mammoth Hot Springs, WY: Yellowstone Center for Resources, Yellowstone National Park, 2000), 26.

2. "Fire," *National Parks Service*, accessed April 2, 2024, https://www.nps.gov/yell/learn/nature/fire.htm.

3. "Blazing Battles: The 1910 Fire and Its Legacy," *National Forest Foundation*, accessed April 3, 2024, http://www.nationalforests.org/our-forests/light-and-seed-magazine/blazing-battles-the-1910-fire-and-its-legacy.

4. Dan Whipple, "Yellowstone Ablaze: The Fires of 1988," *Wyoming Historical Society*, June 27, 1988, https://www.wyohistory.org/encyclopedia/yellowstone-ablaze-fires-1988.

5. Stephen Pyne, "Indian Fires: The Fire Practice of North American Indians Transformed Large Areas from Forest to Grassland," *Natural History*, 2 February 1983:8, accessed March 15, 2024, https://scholarworks.umt.edu/cgi/viewcontent.cgi?article=10347&context=etd.

6. "1988 Fires," *National Park Service*, updated February 2, 2021, accessed March 15, 2024, https://www.nps.gov/yell/learn/nature/1988-fires.htm.

7. "1988 Fires," *National Park Service*, updated February 2, 2021, accessed March 15, 2024, https://www.nps.gov/yell/learn/nature/1988-fires.htm.

Chapter 12: Old Faithful

1. Ruth Quinn, "Old Faithful Inn," *Yellowstone National Park Lodges*, May 11, 2020, hhttps://www.yellowstonenationalparklodges.com/connect/yellowstone-hot-spot/old-faithful-inn/.

2. Alison Harford, "Who Were the Most Conservation-Minded US Presidents?," *Sierra Club*, February 19, 2024, https://www.sierraclub.org/sierra/who-were-most-conservation-minded-us-presidents.

3. Mary Ann Franke, *Yellowstone in the Afterglow: Lessons from the Fires* (Mammoth Hot Springs, WY: Yellowstone Center for Resources, Yellowstone National Park, 2000), 30.

4. "Yellowstone National Park, 1988: A 25th Anniversary Retrospective," *National Parks Service*, August 20, 2013, https://www.nps.gov/articles/wildland-fire-yell-1988-25th-anniv-retrospective.htm.

5. Dan Whipple, "Yellowstone Ablaze: The Fires of 1988," *Wyoming Historical Society*, June 27, 1988, https://www.wyohistory.org/encyclopedia/yellowstone-ablaze-fires-1988.

6. Bill and Russ Finley, "Yellowstone Aflame DVD - National Parks," *YouTube*, February 14, 2009, https://www.youtube.com/watch?v=VsUnCctaxfI.

7. "Yellowstone National Park, 1988: A 25th Anniversary Retrospective," *National Parks Service*, August 20, 2013, https://www.nps.gov/articles/wildland-fire-yell-1988-25th-anniv-retrospective.htm.

8. Paul Schullery, "Yellowstone Fires: A Preliminary Report," *Northwest Science*, 63, no. 1, https://rex.libraries.wsu.edu/esploro/outputs/journalArticle/Yellowstone-Fires--A-Preliminary-Report/99900501675701842#file-0.

Chapter 13: Cover Girl
None

Chapter 14: White Snake
None

Chapter 15: Bad Bug

1. Ben Westcott and Mohammed Elshamy, "Tiananmen Square

Massacre: How Beijing Turned on Its Own People," *CNN*, June 3, 2019, https://www.cnn.com/2019/06/02/asia/tiananmen-square-june-1989-intl/index.html.

2. Michael Ray, "Tank Man," *Encyclopedia Britannica*, May 18, 2023, https://www.britannica.com/biography/Tank-Man.

3. Associated Press, "Fire Burns 81,100 Acres in Everglades Park," *Washington Post,* May 25, 1989, https://www.washingtonpost.com/archive/politics/1989/05/26/fire-burns-81100-acres-in-everglades-park/ef7d0d34-d644-4edb-8937-83024c535182/.

4. "Preserving Everglades National Park: Peat Soils as a Key to Understanding Climate Change and Saving 'River of Grass'," *Department of Geosciences, Florida Atlantic University*, June 2023, https://geosciences.fau.edu/news/preserving-everglades-national-park/index.php.

5. "National Interagency Coordination Center," accessed March 15, 2024, https://www.nifc.gov/nicc.

6. "Kings Canyon National Park," *Global Alliance National Parks*, Accessed March 20, 2024, https://national-parks.org/united-states/kings-canyon.

Chapter 16: Killing Time
1. Roger Bennett, "Western Wildfires Blazing over 50,000 Acres," *UPI Archive*s, July 7, 1989, https://www.upi.com/Archives/1989/07/07/Western-wildfires-blazing-over-50000-acres/7072615787200/.

Chapter 17: The Burn
1. "Utility Firearms: Flare Gun or Very Pistol," Firearms History, Technology & Development (blog), March 6, 2011, http://firearmshistory.blogspot.com/2011/03/utility-firearms-flare-gun-or-very.html.

Chapter 18: Spain
1. Carol King, "Catedral de Sevilla," *Encyclopedia Britannica*, July 14, 2023, https://www.britannica.com/topic/Catedral-de-Sevilla-.

Chapter 19: Gypsy Girl
None

Chapter 20: Misfit
None

Chapter 21: Bad Moon
1. "This Day in Wildland Fire History," *NWCG*, August 2023, https://www.nwcg.gov/committee/6mfs/dude-fire.

2. "Know Your Fire Shelter," *National Wildfire Coordinating Group*, accessed March 15, 2024, https://www.nwcg.gov/publications/pms411/know-your-fire-shelter.

3. "Know Your Fire Shelter," *National Wildfire Coordinating Group*, accessed March 15, 2024, https://www.nwcg.gov/publications/pms411/know-your-fire-shelter.

4. "Staff Ride to the Dude Fire," *National Wildfire Coordinating Group*, accessed March 15, 2024, https://www.nwcg.gov/wfldp/toolbox/staff-ride/library/dude-fire.

5. Tom Story, "Remembering the Dude Fire," *The Arizona Republic*, June 26, 2015, https://www.azcentral.com/story/behind-the-lens/2015/06/26/dude-fire/28981819/.

6. "Staff Ride to the Dude Fire," National Wildfire Coordinating Group, accessed March 15, 2024 , https://www.nwcg.gov/wfldp/toolbox/staff-ride/library/dude-fire.

7. "Staff Ride to the Dude Fire," National Wildfire Coordinating Group, accessed March 15, 2024, https://www.nwcg.gov/wfldp/toolbox/staff-ride/library/dude-fire.

8. Richard Ruelas, "1990's Dude Fire Stands as Example of Extreme Blaze," *USA Today*, July 1, 2013, https://www.usatoday.com/story/news/nation/2013/07/01/dude-fire-1990-arizona/2479201/.

Chapter 22: Black Clouds, Brown Bears
None

Chapter 23: Zion
None

Chapter 24: Trigger Points
None

Chapter 25: Modesto
1. Sarah Williams, "Khemosabi Superhorse of the 20th Century," *SLO Horse News*, March 14, 2014, https://www.slohorsenews.net/khemosabi-superhorse-of-the-20th-century/.

Chapter 26: Goodbyes
None

Chapter 27: Blessings
None

Chapter 28: Lightning Strikes
1. John N. Maclean, *Fire on The Mountain: The True Story of the South Canyon Fire* (William Morrow and Company, Inc.: New York, 1999), 4.

2. Ibid, 235.

3. Ibid, 85.

4. Ibid, 142.

5. Ibid, 210.

Chapter 29: Passion

None

Chapter 30: Wonders
None

Afterword
1. Zach Urness, "Oregon's 2020 Wildfire Season Brought a New Level of Destruction. It Could Be Just the Beginning," *Statesman Journal*, May 6, 2021, https://www.statesmanjournal.com/story/news/2020/10/30/climate-change-oregon-wildfires-2020/6056170002/

Photo Credits

Chapter 18: Spain
1. Fernando Domínguez Cerejido, Seville Cathedral, September 29, 2023, Commons.Wikimedia.Org, September 29, 2023, https://commons.wikimedia.org/wiki/File:Catedral_de_Sta._Mar%C3%ADa_de_la_Sede_y_de_la_Asunci%C3%B3n_de_Sevilla_--_07.jpg.

Chapter 19: Gypsy Girl
1. Village of El Rocio in Andalucia, Spain, Photo By: Rafale Tovar, via Flicker.

Chapter 24: Trigger Points
1. Me with my camera. Photo by Dave Hunter.

Chapter 25: Modesto
1. Modesto Welcome Sign, Photo by: Carl Skaggs, Public domain, via Wikimedia Commons https://commons.wikimedia.org/wiki/File:Modesto_Arch.JPG.

Chapter 26: Goodbyes
1. P-3A "Orion" Aircraft, Catalog #: USN 1112645, National Archives.

Chapter 27: Blessings
1. Vertigo and me. Photo by Kelly James Photography.

Acknowledgments

It took 30 years to write *Dances with Fire*. Life kept getting in the way. These generous people encouraged me to keep moving forward:

- My editor, Katie Hall, brought out the best in the manuscript in the limited time she had.

- Jill Kemerer for her help with the publishing process.

- Lisa Davis for her outstanding cover design and help in the formatting/publishing/marketing process.

- Those 40 people who graciously consented to the use of their actual names.

- Sarah Roegner and Lorraine Olivia Hamberger for website/photo help.

- Natalie Serber and her Memoir Bootcamp class every Sunday evening in Portland, OR. Her encouragement made a book seem possible.

- Rhonda Hadlock, Marv & Anita Kelso, OSU's Former Women's Rowing Coach Roger Payne, Larry & Susan, Nicole Falzone, Marty Brown, Alison Wonderland Tucker, Candice Christensen, Katherine Binford, Donna Hues, Barbara Hettwer, Jason and Melissa Wolfer, Cheryl Hauser, Jean Zinn, Lori Desjardins, Jeanette Yates, Darcey McAllister, Kris and David Nelson, Becca Frazier Avila, Terri Brentano, Pat and

Mary Lou Brock, John & Jackie Mills, Cheryl Grey Bostrom, Jesse Rivas, and Murry A. Taylor. Thank you all for your invaluable critiques and support.

- My sisters, Amy & Emily, who read rough drafts and still believed in it.

- My literary agent, Janet Grant, who saw potential in my story and waited (many years) while I finished it.

- My husband, Sazon Yakis, without whom none of this would be possible.

About the Author

Photo by Sarah Roegner

Kate Hamberger is a former wildland firefighter, massage therapist, and high school language arts teacher. She enjoys exploring interesting places, reading interesting books, and hearing peoples' stories. She also enjoys volunteering with a local school's reading program and hiking in the forests of the Pacific Northwest. She lives with her husband in Silverton, Oregon.

Visit Kate and find her songlist for *Dances with Fire* on her website: www.katehamberger.com.

www.ingramcontent.com/pod-product-compliance
Lightning Source LLC
Chambersburg PA
CBHW020148090426
42734CB00008B/741